HOW TO PHOTOGRAPH ABSOLUTELY EVERYTHING

LONDON, NFW YORK, MUNICH, MELBOURNE, DELHI

for Wendy

Project Editor Nicky Munro
Project Art Fditor Jenisa Patel
Designer Sarah-Anne Arnold
Production Editor Vānia Cunha
Production Controller Melanie Dowland
Managing Fditor Stephanie Farrow
Managing Art Editor Lee Griffiths

Produced on behalf of Dorling Kindersley by **Sands Publishing Solutions** 4 Jenner Way, Eccles, Aylesford, Kent ME20 7SQ

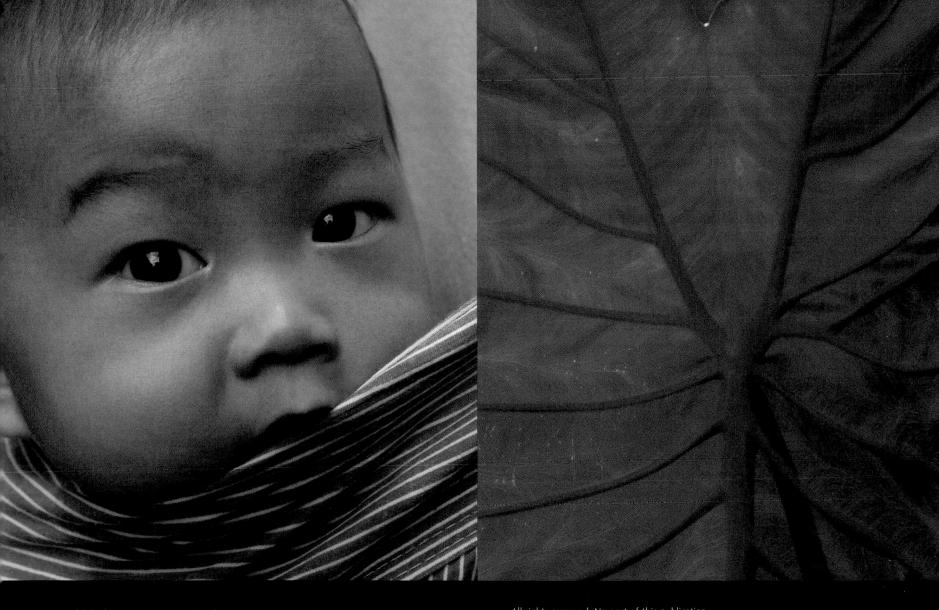

First published in Great Britain in 2007 by Dorling Kindersley Limited 80 Strand, London WC2R ORL

A Penguin Company

2 4 6 8 10 9 7 5 3 1

Copyright © 2007 Dorling Kindersley Limited Text copyright © 2007 Tom Ang All rights reserved. No part of this publication may be reproduced, stored in a retrieval system, or transmitted in any form or by any means, electronic, mechanical, photocopying or otherwise, without the prior written permission of the copyright owners.

ISBN: 978 1 4053 1985 0

Printed in China by Leo Reproduced by MDP in the UK

See our complete catalogue at **www.dk.com**

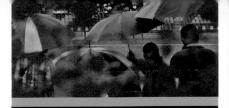

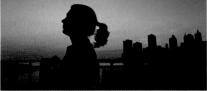

08 Introduction

Elements of photography

- **12** Introduction
- **14** Which digital camera do I choose?
- 16 What else to consider?
- **18** Camera settings
- 20 Finding focus
- 22 Judging exposure
- **24** Zoom settings
- **26** Framing images
- **30** Picture space
- 32 Time tips
- **34** Capturing light
- **36** Using colour
- 40 Brightness and levels
- 42 Colour balance and saturation
- 44 Contrast and tone
- **46** Removing distractions and sharpening
- 46 Cropping and resizing

People

- **52** Introduction
- **54** Portraits on sunny days
- **56** Children at play
- 58 People in action
- 64 Holiday highlight
- 66 Creating a silhouette
- 68 Informal child portraits
- **70** Candid snaps
- **74** Using dramatic lighting
- 76 Posed child portraits
- 80 Alternative portraiture
- 82 Beautiful baby pictures
- 84 Children year by year
- 88 Family self portrait
- 92 Informal family portraits
- **94** Formal portraiture
- **96** Capturing the party spirit
- 98 Nude study
- **100** Character-driven portraits
- 104 Characters in a scene
- 106 Gallery

Landscapes and nature

- 112 Introduction
- **114** A mountain view
- **116** Gardens in bloom
- **118** Flowers in close-up
- 120 Flowers and foliage
- **126** A rustic landscape
- **128** Panoramic views
- 130 Landscapes in black and white
- **132** Sunlight through trees
- 134 Misty woodlands
- **136** Seasons and weather
- **142** Reality and reflection
- 144 Colours of the seashore
- **146** Crashing waves
- 148 Fast-flowing water
- **150** A tranquil scene
- **154** A city waterscape
- **156** The colours of sunset
- **158** An alluring moonlight
- **160** Cloud formations
- **162** Gallery

Animals

- **170** Introduction
- **172** Posed pet portraits
- 174 Fun pet portraits
- **176** Equine elegance
- 180 Birds in flight
- **182** Exotic birds in close-up
- **184** Garden birds
- **186** Wildlife close to home
- **192** The natural look
- **194** Wildlife from a car
- **198** Around the animal park
- 202 At the aquarium
- 204 Movement underwater
- **206** Gallery

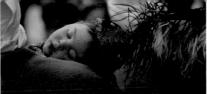

Architecture

- 212 Introduction
- **214** Focusing on details
- 216 Form and space
- 220 The postcard look
- 222 Night-time illuminations
- 224 Romantic ruins
- 226 Abstract views
- 228 Large enclosed areas
- 230 Dimly lit interiors
- 232 Modern interior spaces
- 236 Iconic city landmarks
- 238 World landmarks
- 242 Radiant stained glass
- 244 City fountains
- 246 Bridge life
- 250 Contrasting old and new
- 252 An unusual city skyline
- 254 City streets
- **258** A nocturnal cityscape
- **260** City skyscrapers
- 264 Reflected city
- 266 The city by night
- 268 Black-and-white street scene
- 270 Cityscapes from a vehicle
- **272** An urban landscape
- 276 Gallery

Events

- 282 Introduction
- 284 An explosion of colour
- **286** Milestone moments
- 288 A children's party
- 290 Wedding photography
- **292** Wedding-day details
- **296** The spirit of carnival
- **300** A street demonstration
- **302** The magic of Christmas
- **304** Festivals around the world
- 308 Intimate music venues
- 310 On-stage drama
- **312** The thrill of the race
- 314 A theatrical production
- 318 Gallery

Artistic expression

- 324 Introduction
- 326 Exploring art
- 330 Sharpness and blur
- 332 Light trails at night
- **334** Abstracting the everyday
- 336 Colour and light
- 338 Reflections
- 344 Impromptu still lifes
- **346** Still lifes
- **350** Patterns from chaos
- **352** Exploring textures
- 354 Art on the street
- 358 Gallery

Other applications

- 364 Introduction
- 366 Practical photography:
 Photography for online
 auctions
 Promoting a business
 Selling your car
 Recording your belongings
 Charting a building project
 Photographing home interiors
 Campaign photography
 Scrapbooking

Cataloguing collections

- 372 What the eye can't see:
 Strobe lighting
 Satellite imaging
 Kirlian photography
 Space photography
 Galaxy photography
 Infrared imaging
 X-ray photography
 High-speed photography
- **376** Glossary
- **379** *Index*
- **384** Ackowledgments

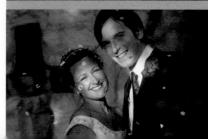

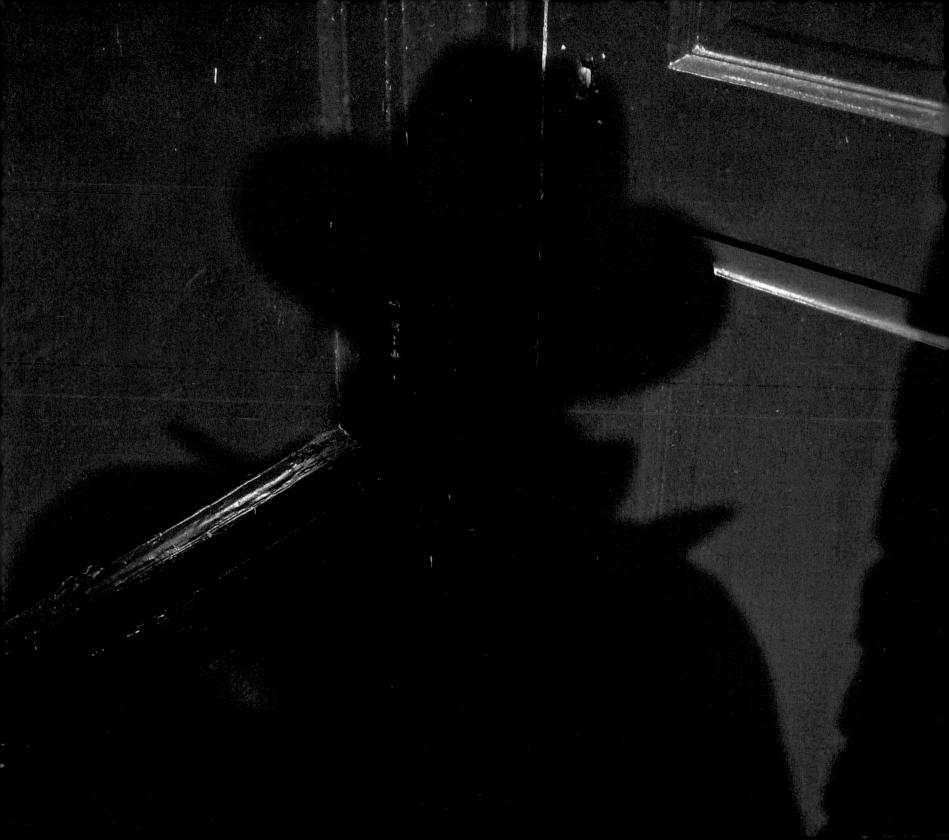

Introduction This is a unique book, with a unique aim and daring ambition. I want to help you to know how to photograph any subject or situation you may encounter. Of course, it is essential to learn the basic techniques of photography. But that is like learning basic cooking techniques such as chopping, stir-frying, boiling. You have nothing edible until you add the ingredients. And to make a tasty meal you have to follow a recipe which works with and responds to the character of the ingredients to make the best use of them. This is a photographic recipe book. It shows how to create pictures by working with the basic ingredients of colour, light, and space - then "cooking" them up using techniques such as exposure, framing, and focus. By following the step-by-step recipes, you will steadily gain the ability to photograph absolutely everything. At the same time, the book brings together numerous tricks and tips that you may apply to a vast range of photographic challenges, empowering you to make the most of every photographic opportunity.

Elements of Photography

12345678

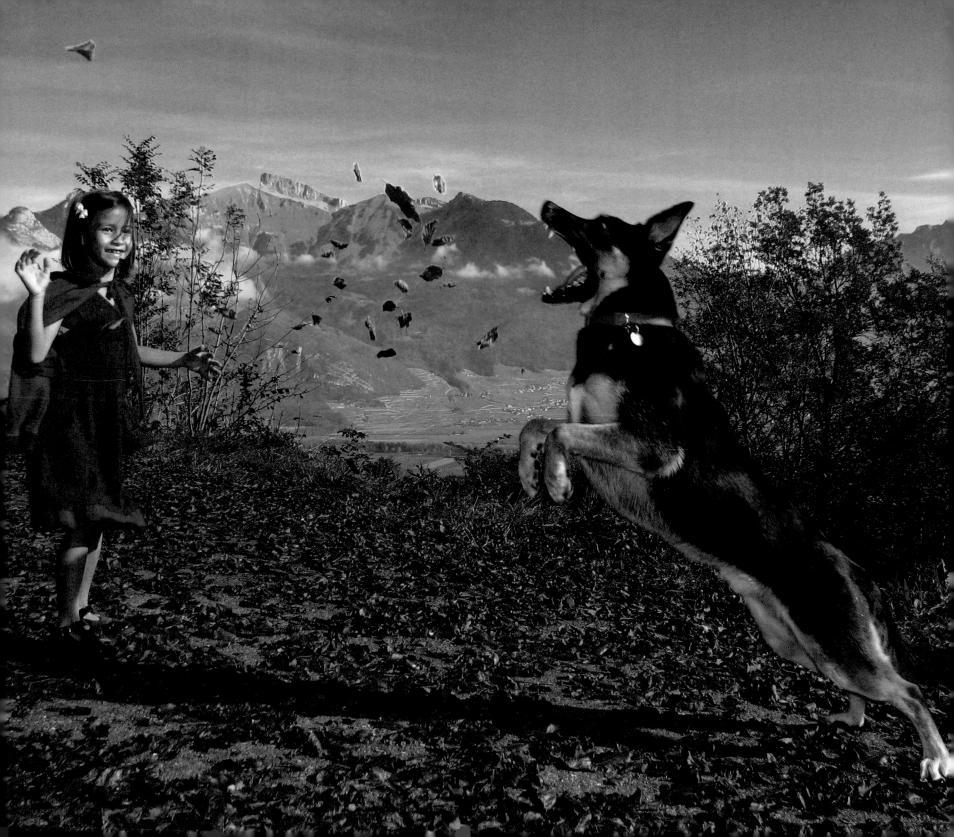

Elements of photography describes the building blocks that make up all photographs. Whether snapped on the simplest camera, crafted in the finest professional model, or made with scientific instruments, all photographs are created with light. And to create any image you must control the quantity of light and bring it into focus, while composing and timing the shot with precision. Here you will learn how to combine focusing, exposure, zooming, and framing with the ingredients of space, time, light, and colour, discovering how to make your camera work for you. You will also see how software can enhance your images by refining their shape, exposure, colour balance, contrast, and sharpness.

Which digital camera do I choose?

Today's digital cameras are universally capable of producing excellent results and offer a wide range of controls designed to make photography easy and fun. Cameras for the beginner fall broadly in to the simple point-and-shoot cameras with 3–4 megapixels and basic controls. Next up are those offering greater resolution – 5–7 megapixels –

with more advanced controls and faster operating speed. Some of these models concentrate on quality with a zoom lens of limited range, while others offer a greater zoom range with a reduction in other features. More costly cameras will offer even greater resolution as well as more flexible camera and image controls or better lenses.

CONTROL SWITCH for changing camera mode or zoom setting (varies with camera model).

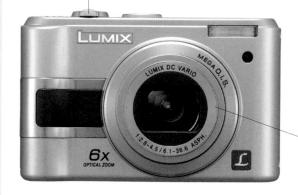

LCD SCREEN is the main interface with the camera, controlling framing as well as display of menu options.

INTERFACE HATCH

covers the sockets for connecting to a computer or TV screen.

with versatile zoom range.

SHUTTER BUTTON initiates the exposure sequence; good cameras respond quickly to pressure on the button.

NAVIGATION ROSETTE

is used to move through the menu and make settings.

FUNCTION BUTTONS

are used to select display modes and delete images (varies with camera model).

MID-RANGE COMPACT

Modern compact cameras offer zoom lenses with at least 3x range (the longest focal length is 3x longer than the shortest) with sensors carrying 6 or more megapixels. In addition, all offer auto-focus, have a built-in flash, removable memory, LCD viewfinder (some have see-through viewfinders too), and a choice of different auto-exposure modes.

ADVANTAGES

- >> Compact and light-weight
- >> Easy to use
- >> Capable of high-quality images
- >> Inexpensive to run

DISADVANTAGES

- >> Battery life may be limited
- >> Display may be difficult to read
- >>> Range of accessories limited
- >> Zoom action may not be smooth

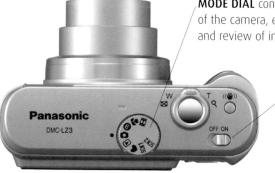

MODE DIAL controls the operational mode of the camera, exposure metering, set-up and review of images.

POWER SWITCH for turning camera on and off; good models turn on quickly.

FREQUENTLY ASKED QUESTIONS

WHAT KIND OF VIEWFINDER IS BEST FOR ME?

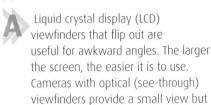

and does not rely on batteries.

one that is easy to use in bright light

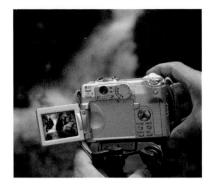

WHAT EXACTLY ARE MEGAPIXELS?

Pixels are the picture's elements the more you have available, the greater the capacity to record detail. The image sensor is made up of individual picture elements, so an 8-megapixel sensor is covered with 8 million individual elements.

HOW MANY PIXELS DO I NEED?

3–5 megapixels are ample for web use and for average-sized prints. while 8 or more megapixels are sufficient for many professional uses. However, the number of pixels does not quarantee good image quality much depends on the lens quality and image processing.

MODE DIAL sets scene modes and other functions.

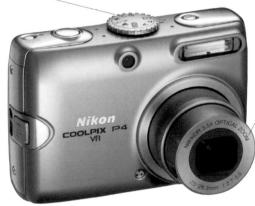

ELECTRONIC VIEWFINDER is a small

LCD screen under a magnifier.

ZOOM LENS with limited zoom range.

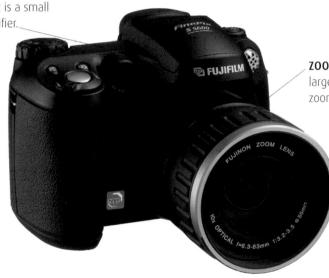

ZOOM LENS is much larger and offers greater zoom range and quality.

BEGINNER'S COMPACT

Modern entry-level compacts suitable for the beginner represent exceptional value for money. They combine very good image quality with real ease of use in extremely compact and stylishly designed bodies. Some models offer moisture-proof bodies, some are extremely thin, others are chunkier for the larger hand. The range is broad and you can select with confidence.

ADVANTAGES

- >> Inexpensive to purchase
- >> Inexpensive to run
- >>> Very easy to use
- >> Very light-weight and compact

DISADVANTAGES

- >>> Zoom range may be limited
- >> May not accept accessories
- >> May be slow in operation
- >> May limit you as you progress

PROSUMER

Cameras that bridge the consumer and professional ranges - the prosumer are capable of professional quality images, and offer a good range of photographic controls. They sacrifice sturdy construction in order to keep weight low and reduce size. Prosumer cameras accept flash and lens accessories as well as featuring highperformance lenses.

ADVANTAGES

- >> High-quality images
- >> Wider zoom range
- >> Accepts accessory flash unit
- >> May be rapid in operation

DISADVANTAGES

- >>> Bulkier and heavier than pointand-shoot compacts
- >> More costly to purchase
- >> More complicated to use

What else to consider?

As your photographic experience grows, you may want to extend the range of your photography. As your confidence in your skills grows, you may start to stretch the capabilities of your camera. This is when you will begin to think about adding accessories to your camera. Some, such as a tripod or data storage, can be applied to any camera. Others, such as an accessory flash or a larger zoom lens, will depend on the facilities of your camera.

USING AN EXTRA FLASH

If you want to take photographs at parties or other events that take place indoors or at night, you will need an accessory flash. Your camera must have a way to connect the flash – usually through a hot-shoe in the top. Flash units with heads you can swivel and point in different directions provide the most control of the quality of light.

INCREASING ZOOM RANGE

If your camera has a modest zoom range – between 3x and 5x – it will not be long before you wish for an extension of this range. Just as with digital SLRs, in many cameras, zoom range may be extended by screwing on lens adaptors: wide-angle adaptors increase the field of view; tele adaptors increase the telephoto end of the range.

WIDE ANGLE

TELEPHOTO

STANDARD

EXTENDED TELEPHOTO

USING A TRIPOD

There is no doubt that a tripod is the best way to ensure sharp, high-quality images. Tripods also reduce the strain when you are waiting for a photographic moment, whether it is a setting sun or an animal moving across a landscape. A ball-and-socket head (above right) is light and easy to use, but a 3-way head (far right) gives the most control. Purchase the sturdiest tripod you can comfortably carry.

STORING DATA

The more you photograph, the more you will want to store. Modern data storage is amazingly affordable. You can back-up images onto CDs or DVDs using inexpensive writers (above right) and disks. For more rapid access, store images on portable hard-disk drives (right).

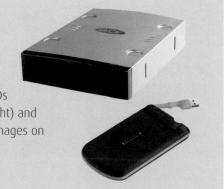

MEMORY CARD OPTIONS

Digital cameras store images on removable memory cards. The cards supplied with cameras are usually adequate for only a handful of images, so you will need to buy your own. Get the largest capacity you can afford, but you do not have to purchase the fastest cards as these are designed for professional cameras. It's a good idea to keep a spare card – deleting images as you go in order to make space is a practice quaranteed to result in you losing important pictures.

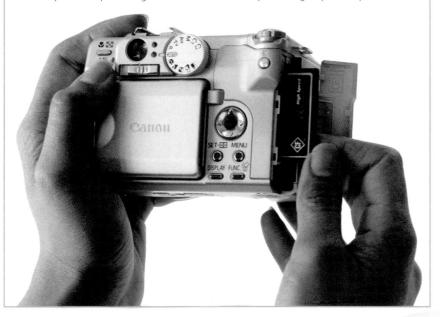

FREQUENTLY ASKED QUESTIONS

HOW CAN I BACK UP IMAGES WHILE TRAVELLING?

Use portable hard-disk drives with built-in card readers.
Insert your memory card, press a button, and the drive copies the contents of the card. When the operation is over, you can erase the card's data and start again.

HOW DO I DOWNLOAD PHOTOS?

One method is to install the camera's software on your computer, then you will be able to connect it via a cable to transfer data. Alternatively, connect a card reader to the computer: remove the card from your camera, insert it into the reader and copy the files to the computer.

Create a 'Pictures' folder if you do not already have one. Then create another folder named according to the location and date. Copy your pictures to that folder. When you open a picture to alter it in any way, immediately "save as" under a different name so you always preserve the original image.

PRINTING

Modern printers produce superb quality images and are inexpensive, but printing materials are often costly. Some printers connect directly with cameras, others read the memory cards. Both methods eliminate the need for a computer.

» DYE SUBLIMATION PRINTERS produce small prints of excellent quality very quickly and easily.

» INK-JET PRINTERS (above right) can produce very large prints but require you to prepare the image. Also, colour control may be tricky.

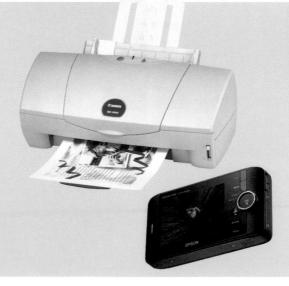

PRESENTING

There are numerous ways in which you can show your pictures to family, friends and, indeed, the whole world. Picture viewers (below left) store numerous images and display them on a screen.

» PICTURE-SHARING SITES allow you to upload images from any part of the world for storage and for others to view.

» PERSONAL WEBSITES can be constructed to show off your photographs in ways that you personally design and control.

Judging exposure

Modern cameras and image manipulation techniques are close to making exposure problems a thing of the past. Many cameras actually analyze the scene and compare it with a database of known scenes to work out the best exposure. The result is that badly under-exposed images (too dark) or heavily over-exposed images (too light) are now much less common than before. But that is no consolation if one of your images has been incorrectly exposed. The key is to learn how to help the camera get the result you want.

IN TRICKY LIGHTING CONDITIONS, learn to obtain the exposure from the part of the scene you want exposed correctly, such as the face. Select the section of the image in the viewfinder, then hold the reading and re-compose the shot. This is the fastest way to ensure correct exposure.

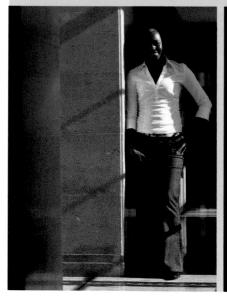

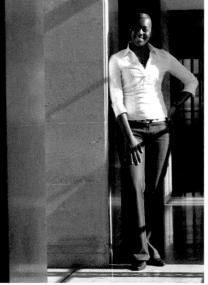

IF IN DOUBT, MAKE THE EXPOSURE ANYWAY. It is better to have something that is not perfectly exposed than no image at all. You can always adjust the image later using editing software.

THE EASIEST LIGHTING SITUATION to expose for is when the subject is lit from the front, and the sun is behind you. However, such lighting does not give the most interesting textures.

WITH DIGITAL CAMERAS IT IS BETTER TO ERR ON THE SIDE OF UNDER- EXPOSURE. While even slight over-exposure tends to make colours look faded and washed-out, under-exposure can actually make colours (especially paler colours) look richer in tone.

TO REFINE YOUR EXPOSURE TECHNIQUE, use the centre-weighted or spot-metering mode to determine exposure. These read only a limited part of the scene, and you will learn by evaluating the results and making adjustments.

IN SUNNY SITUATIONS,

try to position yourself so that the sun is to one side, so that you see your subject partially lit and partially in shadow. An exposure that takes in both the sunny and the shadowy areas is likely to be correct.

THE MOST DEMANDING LIGHTING CONDITIONS – against the light or high-contrast lighting, for example – make it difficult to obtain the correct exposure. If you have the opportunity, check the image and repeat the shot with extra or reduced exposure (using the override controls or manual exposure settings) as you need.

WHEN SHOOTING IN POOR LIGHT CONDITIONS, or if you or your subject is moving, you can reduce exposure times by adjusting your camera's sensitivity – the ISO setting. Raising it may enable you to take pin-sharp photos with little reduction in image quality.

EXPOSURE METERS WORK BEST MEASURING FROM

MID-TONES – roughly half-way between lightest and darkest. Learn to recognize what midtones look like – lightly tanned Caucasian skin, green grass in half-shade, deep blue sky – and measure from that.

WHETHER AN IMAGE IS PROPERLY EXPOSED OR NOT

depends on the type of image you want to create. You will have a key tone – a face, or flower, or patch of landscape, for example – that must look right, so expose for that. The rest of the image can fall in where it will.

Zoom settings

The combination of low price, top performance, and compact design in modern zoom lenses is one of the corner-stones of the success of modern photography. They put great optical powers into your hands, with the exciting prospect of being able to take command of all picture-making possibilities.

THE BEST WAY TO USE THE

200M is to decide what kind of picture or what part of the scene you want, then set the zoom to suit. Often you will want either the widest or the longest setting, but when you compose the image you can make small adjustments if you have time.

WALKING TOWARDS OR AWAY FROM THE SUBJECT IS OFTEN BETTER THAN ZOOMING IN OR OUT. It helps you to experience and explore changes in perspective, and keeps you actively looking for the best picture.

IF YOU HAVE A DIGITAL SLR, ADD MOVEMENT TO YOUR IMAGES by experimenting with the zoom effect. Set your camera to a slow shutter speed and, while the shutter is open, either zoom in to or out from the subject. For best effects, you will need to keep your camera as still as possible so that the motion lines are straight.

TRY SETTING THE ZOOM TO A FAVOURITE FOCAL LENGTH, for example, very long or very wide or half-way between, and leave it there for the day if your camera allows. You will find you can photograph more quickly and decisively when you are not always adjusting the zoom.

WHEN USING THE LONG END OF A ZOOM, be extra careful to hold the camera steady, since the chance of camera shake grows as focal length increases.

IF IN DOUBT, SHOOT AT A WIDER ANGLE and take in more of the scene. You can always crop an image afterwards, but you can't add to it once you leave.

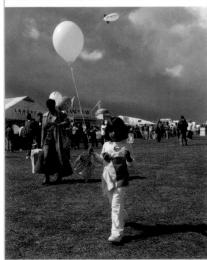

AVOID USING THE DIGITAL ZOOM WHENEVER POSSIBLE. This is where the camera zooms as far as the lens will go, then increasingly small sections of the centre of image are enlarged for greater zoom. The results from digital zoom may disappoint, as the resolution is reduced.

IF YOU WANT THE LINES IN AN IMAGE TO BE AS STRAIGHT AS POSSIBLE, for example, when photographing buildings, use the lens at around the middle of the range of zoom settings. Lenses tend to distort (bend) lines less at mid-range settings.

IN DIM LIGHT, USE THE WIDEST ZOOM SETTING AVAILABLE as zoom lenses can gather more light (have a larger maximum aperture) at wide settings than at longer settings.

KEEP YOUR ZOOM LENS CLEAN.

The lenses of modern compact cameras are very small, so the slightest smudge can have a significant effect on the quality of the image projected by the lens.

WHEN SHOOTING LANDSCAPES, try pointing the camera high so there is only a narrow strip of land in the bottom of the picture this helps give a sense of open space. Don't be afraid of exaggerating the difference in proportions in your picture.

ELEMENTS OF PHOTOGRAPHY

Picture space

Photographs are records of scenes that occupy three-dimensional space. As a photograph – whether it is on paper or on a screen – stretches only over two-dimensions, photographers must somehow capture a sense of depth and space for the viewer. The tricks of composition help you to convey a sense of space in your pictures, while choosing your viewpoint carefully can help the viewer to interact with your picture.

"NEGATIVE SPACE" is a photographic term for empty space that contains no subject matter. You can use common examples of negative space, such as sky or water, to help define or give a backdrop to the main subject of your photographs.

ENCLOSE YOUR MAIN SUBJECT IN A FRAME such as an archway, window, or branches of a tree. In this way you will guide the viewer's eyes towards the main subject. Because your subject is shown to be further away than the frame, this will give an impression of travelling through the picture.

THE EASIEST WAY TO SHOW THAT ONE OBJECT IS CLOSER THAN

ANOTHER is to capture it overlapping and partially covering the furthest object. Control of overlap is a powerful way to convey space and describe spatial relationships.

ANOTHER WAY TO SHOW DIFFERENCES IN DISTANCE – and hence the space between subjects – is through differences in focus. Focusing on the main subject in the midground, and throwing the background and foreground out of focus, helps locate the subject.

LINES CURVING THROUGH THE IMAGE SPACE lead the viewer's eye on a journey through the picture. This helps give a lively sense of composition, and keeps the viewer's attention.

WHEN PHOTOGRAPHING A
DISTANT OBJECT, such as a
building or structure, one
effective trick is to find
something very close to you and
position yourself so that the
nearby object is in frame and
out of focus, with the main
subject in focus. Creating
foreground interest in this way
helps exaggerate the sense of
space and distance.

YOU CAN REDUCE THE SENSE

OF SPACE between elements in your picture by using the longest focal length setting. This gives a magnified view of a distant part of the scene, which compresses space, making objects appear to be almost touching when, in fact, they are far apart.

USE RECEDING LINES such as railings, a road, a wall, or a railway line to lead the eye from the foreground to the background. The convergence of parallel lines gives very strong clues about depth in the picture.

WHEN TAKING LANDSCAPE PHOTOGRAPHS YOU CAN EVOKE WIDE-OPEN SPACES and the majesty of the landscape by filling most of the frame with an open sky.

FOR SOME SUBJECTS, SUCH AS BUILDINGS OR MONUMENTS, IT CAN BE USEFUL TO ALLOW SPACE ON ALL SIDES OF THE PHOTOGRAPH

to frame your image. Too tight a crop on the subject's outline can make it feel trapped and have an unpleasing effect on the eye. By giving your subject space to breathe you can also add context to your image.

Time tips

Photographers are masters of time: we use and control time at two levels. There is the broader, larger time-scale of days, weeks, and months that determines the seasons of our photography. The low light either side of winter offers soft effects and long shadows, but short days. In contrast the long days of high summer sun give us hard light and high contrasts. Then there is the small-scale time – the fractions of a second that determine whether our images are sharp, or catch the smile or peak of action. Some photographs depend on waiting long hours or even months for the right lighting, but the precise timing is not so vital. Other photographs depend entirely on split-second timing for their success.

THE BEST TIME TO TAKE PHOTOGRAPHS IS WHEN YOU FIRST SEE THE OPPORTUNITY.

Many modern digital cameras are so small and light that you can carry them with you everywhere. You can be ready to take photographs at any time, without delay, without having to promise yourself that you will return the next day with your camera.

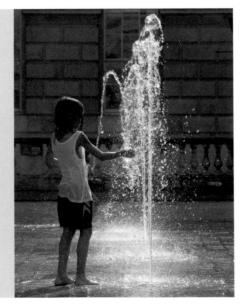

WHEN YOU TAKE ANY PHOTOGRAPH YOU ARE FREEZING A MOMENT IN TIME, but this is particularly evident in action shots. To capture sharp images of moving subjects your exposure should be as short as possible – no longer than 1/250 second, but preferably 1/500 second for subjects like action sports or moving animals.

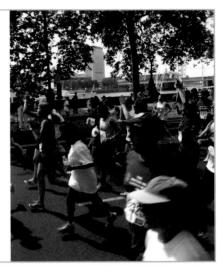

THE BEST TIMES OF DAY FOR TAKING PHOTOGRAPHS OUTSIDE ARE THE "GOLDEN" HOURS

just after sunrise and just before sunset. At these times the sunlight is softened by the atmosphere, giving it a warm hue that makes landscapes and buildings glow.

TRY SHOOTING MOVING WATER AT SLOW SHUTTER TIMES. You will find that scenes of waterfalls, mountain streams, or lapping tides are transformed from being frozen and static to being alive and evocative.

EACH TIME AND SEASON OFFERS ITS OWN KIND OF LIGHT. Work with whatever light is offered to you: whether it is hard or soft, coloured or neutral, plentiful or scarce, all light is wonderful.

USE THE "BULB" SETTING ON YOUR CAMERA TO ACHIEVE VERY LONG EXPOSURE TIMES. These are particularly effective when taking photographs at night, when over a period of a few minutes you can capture star trails as they move across the sky, forked lightning during storms, or fireworks as they explode one after another.

YOUR CAMERA MAY BE SLOW TO RESPOND to being turned on or to the press of the shutter button. You may need to account for any delays by leaving the camera on stand-by rather than turning it off, or by releasing the shutter a little before you want the exposure.

WHEN TRYING TO CAPTURE A MOMENT OR EVENT, your sense of timing is vital. Try to anticipate the action by watching and learning repeated or regular patterns of behaviour or occurrances.

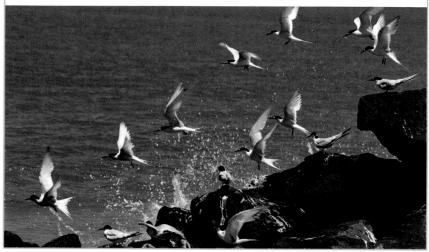

WHEN TAKING PHOTOGRAPHS OF A MOVING SUBJECT, you can capture the sense of movement by choosing a longer shutter time. As the subject moves through the frame its image will blur in the direction of its path. Alternatively, using the same shutter setting, you can pan along with your subject, so that it remains sharp but the background is blurred.

Capturing light

For some people, photography is primarily about capturing light itself, and the subject comes second. In some instances light can turn even the most mundane scene into a visually captivating image. While you may not be able to control the weather, nor position the sun to order, you can wait for the light, or position yourself to make the best of it. Lighting is intimately linked to camera exposure: correct exposure brings out the best in dull lighting but inaccurate exposure can ruin great lighting.

HIGH-CONTRAST LIGHTING -

where the difference between light and dark areas is great – can give you striking results, but is tricky to expose for. Shoot lots of frames at different exposure settings to learn which give the best results.

FOR THE MOST INTERESTING

LIGHTING, try facing the light and place your subject in between. In these contre-jour ("against the day") situations you can obtain dramatic silhouettes, place the sun in shot for flare effects, and experiment with dramatic, dark skies.

SHAFTS OF LIGHT, such as those cast through a forest canopy, create natural spotlights that you can use to capture subjects with dramatic effect.

USE STRONG SHADOWS

produced by harsh sunlight to create interesting patterns or to balance your compositions. You can also use shadows to create an impression of depth or space, and to lead the eye.

WHEN SHOOTING

PORTRAITS, it is very little trouble to ask the subject to move close to a window or out of the direct sun. Soft but directional light gives the most satisfying results in portraiture.

IN VERY BRIGHT CONDITIONS, USE THE FLASH TO REDUCE SHADOWS.

Set the fill-in flash or synchro-sun mode (modern point-and-shoot cameras do this automatically) and turn the flash on. This can help reveal details and colours that would have been otherwise hidden.

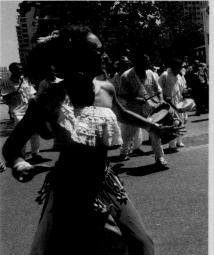

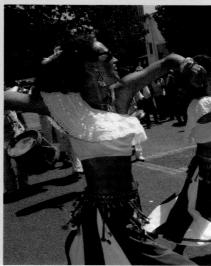

USE YOUR HAND TO CAST A SHADOW OVER YOUR LENS.

This reduces the effect of the sun shining into the lens, which causes flare – distracting reflections in the image. This may be necessary as many point-and-shoot cameras do not have effective lens hoods. But make sure your hand does not intrude into wide-angle shots.

WHEN THE LIGHTING IS TRICKY, and it is important that you have the correct exposure, try different settings to make sure you get the shot. You can take a look at the images after each exposure and delete those that you are not completely happy with.

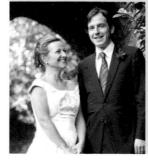

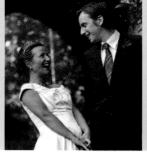

WHEN TAKING CLOSE-UP PHOTOGRAPHS

in full sunlight, use a piece of paper to diffuse and soften the light. This helps to deliver rich colours and delicate textures.

PHOTOGRAPHS CAN BE TAKEN IN THE DULLEST LIGHT. Even if the scene looks unpromising and too dark, have a go. The results may surprise and delight you because the camera can see more colours at night than you can.

Using colour

One of the steps to being able to photograph anything is being able to separate your experience of colour from the recording of colour in a photograph. This will help you to appreciate that the way in which a camera senses and records colours differs from the way that we see them – a captured image is never quite the same as we perceive it. But, more importantly, your versatility as a photographer improves the more you see colour as a subject in itself, not something that is only a feature of your subject.

COLOUR CAN BE ONE OF THE STRONGEST COMPOSITIONAL TOOLS IN PHOTOGRAPHY. Try isolating a strong colour against a muted background to emphasize the shape of an object or the perspective in a scene. You might also try picking out a small area of colour within a sea of contrasting colours and use it as a focal point.

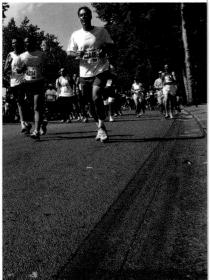

COMPOSE YOUR IMAGE SO THAT THE RANGE OF COLOURS IS LIMITED to similar hues – different shades of green, or a variety of warm colours, for example. The colours will compose your image and give it internal harmony.

IF YOU PHOTOGRAPH A SCENE CONTAINING A RIOT OF DIFFERENT COLOURS,

try to organize it so that very strong lines of composition run through it, or try to group the colours together. Alternatively, capture colours against a dull background such as grey or black – this is particularly effective in city scenes.

COLOURS ARE USUALLY AT
THEIR MOST VIVID or saturated
in semi-diffused light, such as
that on a partially cloudy day.
This is because the diffused
light prevents strong highlights
or glossy surfaces from causing
a reduction in colour richness.

SLIGHT UNDEREXPOSURE CAN IMPROVE COLOURS in photographs taken using a digital camera. This applies particularly to light, bold colours such as yellows and reds, which can otherwise appear washed out and faded.

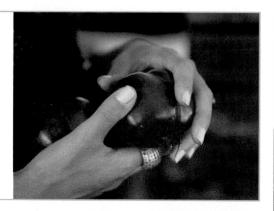

ALTHOUGH YOU CAN CORRECT THE COLOUR BALANCE of your photographs using image manipulation software, try to use the white balance setting on your camera to avoid either yellow-orange or bluish hues.

YOU CAN STRENGTHEN COLOURS – that is, make them more saturated – using a camera setting. This setting may be called "Enhanced" colour. However, some cameras produce strong colours by default, so it is best to experiment with the settings to find the results you like most. If you can get it right "in camera" this will save you having to work on the images on a computer later.

COLOURS ARE KEY TO CONVEYING MOOD AND EMOTION.

A limited, muted colour scheme, such as cool blues and greens, can give an overall feeling of peace and tranquility. Highly contrasting bright colours can give an instant impression of highenergy and excitement.

THE JUXTAPOSITION OF PRIMARY COLOURS

can provide your images with great visual potency. Mix swatches of blue, red, and yellow to produce dramatic images that make a statement.

AN IMAGE. This is because when our eyes are adapted to night vision they are not able to distinguish colours easily, but neither film nor digital cameras have problems with picking out different colours.

Brightness and Levels

Exposure controls the overall brightness of an image. Ideally you should not need to alter this using image manipulation software as the camera should have got it right in the first place. But the way you want the image to look often does not match what the camera has produced. So you need the Levels adjustment to make the broad changes in overall brightness. The Levels control also enables you to adjust the contrast – how quickly grey changes to white or to black.

IT IS ACCEPTABLE FOR SOME IMAGES TO LOOK VERY DARK OR NEAR

BLACK. These include night shots, of course, but also shots that emphasize a focus of light on small areas of an image, such as a face, for example.

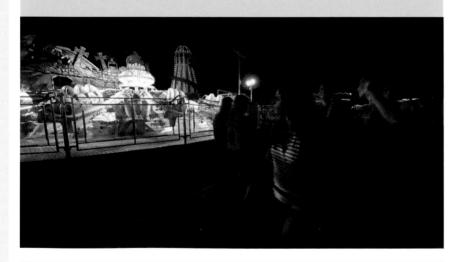

THE AUTO LEVELS COMMAND CAN OFTEN FIX AN IMAGE INSTANTLY, but manual levels adjustments will yield more controlled results.

LEVELS CAN CONTROL THE MID-TONE CONTRAST

by changing the relationship between black and white. This either compresses white and black close together to give you high-contrast or spreads them out to give you more gentle tonal transitions.

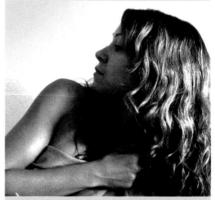

HIGH CONTRAST

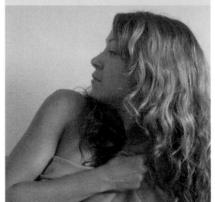

LOW CONTRAST

MANY CAMERAS CAN DISPLAY A HISTOGRAM

when pictures are reviewed, and all image manipulation applications show a similar display in the Levels control. It represents what proportion of the picture is at different tonal ranges, which helps you work out what to do with the image. Here, to compensate for any overexposure you would move the middle slider towards the peak of the histogram.

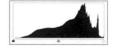

IF THE HISTOGRAM SHOWS MANY INDIVIDUAL

NARROW BARS, like the teeth of a broken comb, the image is of poor quality. Further manipulation will not improve it, and it may print with colours markedly different from those on screen (neither your printer nor screen is faulty in this case).

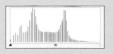

IT IS ACCEPTABLE FOR SOME IMAGES TO LOOK VERY BRIGHT

or near white. Pictures such as a bride in her white outfit, white pottery on a white background, or snow scenes, are naturally light and not necessarily over-exposed. However, for very bright images it is always a good idea to experiment with contrast and brightness, to see if you can improve the image.

AN UNDER-EXPOSED IMAGE LOOKS DARKER THAN AVERAGE. Shadows will show little detail and highlights may not be bright. Colours may look grey and dark, but colours in bright light may look deep and rich.

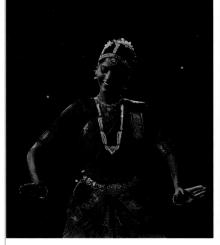

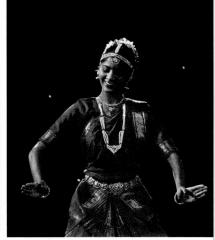

ORIGINAL IMAGE

ADJUSTED IMAGE

AN OVER-EXPOSED IMAGE LOOKS BRIGHTER THAN AVERAGE.

Shadows will show a lot of detail but bright parts of the image will look bleached out, offering weak colours. Note that after adjustment, the white areas still look too bright.

ORIGINAL IMAGE

ADJUSTED IMAGE

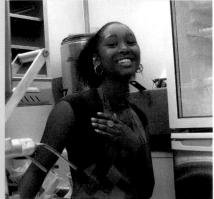

ADJUST THE BLACKS SO THAT THEY LOOK BLACK. This ensures that you have nicely solid shadow densities when you print out the image. Lack of good blacks makes a print look washed-out.

Colour balance and saturation

Balancing colours is important as it helps ensure that the colours in your image are true to life. The key is to ensure that colours which everyone can recognize are accurate. Of these, the most important is skin colour: any visible variation from what is expected will make the whole image look wrong. The other key colours are the so-called "achromats": white, black, and grey. As the name suggests, these tones should be without colour or tint for colour reproduction to be accurate.

MODERN COMPUTER MONITORS ARE FAIRLY ACCURATE AT REPRODUCING COLOURS, but if you find that the prints from your printer are very different from the image as seen on your monitor you will need to use the monitor control panel or system preferences in your computer's operating system to calibrate the screen.

SKIN TONES, IF PRESENT, ARE THE KEY TO COLOUR BALANCE.

If skin appears too cold or too warm you can be sure the rest of the image is unbalanced. Adjust the balance control in your software until skin appears natural.

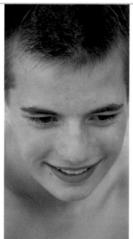

ORIGINAL IMAGE

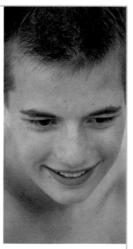

ADJUSTED IMAGE

DECREASING SATURATION BRINGS COLOURS CLOSER TO SHADES OF GREY, BLACK, AND WHITE. Reducing colour saturation completely leaves you with a black-and-white or monochrome picture.

ORIGINAL IMAGE

ADJUSTED IMAGE

THE EASIEST WAY TO ADJUST COLOUR BALANCE IS TO USE THE VARIATIONS

COMMAND. This shows, at a glance, the effect of different settings. All you have to do is click on the one that looks most natural or closest to the colours as you remember them.

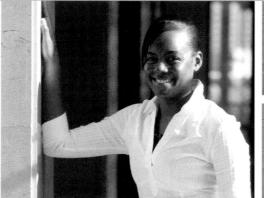

COLOURS OR HUES CAN BE DELIBERATELY DISTORTED to give a strongly graphic effect. All colours are distorted by the same degree, so, for example, blues become greens and reds turn mauve.

ORIGINAL IMAGE

ADJUSTED IMAGE

TRY TO SET THE CAMERA UP SO THAT YOU HAVE TO DO AS LITTLE COLOUR ADJUSTMENT AS POSSIBLE AFTER MAKING THE EXPOSURE.

Many digital cameras allow you to adjust colour richness, as well as the contrast and sharpness that is applied to the image when it is saved on the memory card. Use these features to optimise your pictures for viewing or printing to save time and effort.

COLOURS LOOK MORE LIVELY

AND PUNCHY when you increase their saturation. However, colours that are too highly saturated may look brilliant on a monitor screen but cannot be printed accurately. Prints on paper may appear pale because some printers cannot reproduce the brightest colours.

ORIGINAL IMAGE

OVERSATURATED

YOU CAN REMOVE COLOUR FROM PICTURES BY USING THE SATURATION (OR SPONGE) TOOL TO DESATURATE – that is to reduce the strength of colour. This is effective at reducing the impact of a busy or colourful background that distracts from the main subject.

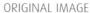

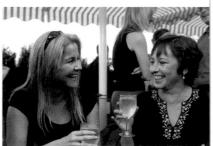

ADJUSTED IMAGE

Contrast and tone

Contrast is the relationship between the middle greys and the whites and blacks – how the middle tones relate to the lightest and darkest tones in a picture. Contrast is largely the product of the lighting at the time you make the exposure, but it is also something that is easily altered on a computer, using image manipulation software. The careful adjustment of contrast and its suitability for the subject is a hallmark of fine photography.

MOST PICTURE-EDITING SOFTWARE PROGRAMS have a contrast menu option with a slider for adjusting the contrast. However, you can alter the contrast and tone with more control by adjusting the Levels settings.

IMAGES WITH NORMAL

CONTRAST show mostly middletones – greys about half-way between white and black – with some bright white tones plus some deep black, and with transitional tones in between.

LOW-CONTRAST IMAGES show large areas of middle or grey tones, with little that is either very dark or very bright – the look of a foggy day, for example. These images are said to be flat.

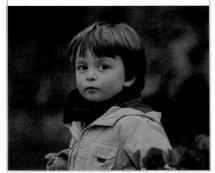

HIGH-CONTRAST IMAGES
SHOW AREAS OF DEEP
SHADOWS and areas of bright
white, with sharp transitions
in-between. These images exhibit
hard lighting, such as when
directly lit by bright sun.

SOFTEN THE CONTRAST of images shot on brilliantly sunny days to bring back details into the brighter mid-tones and lighter shadows. This will make the printed image look more natural.

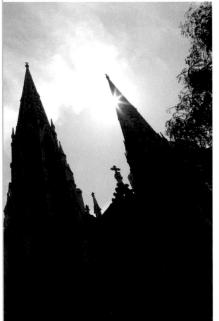

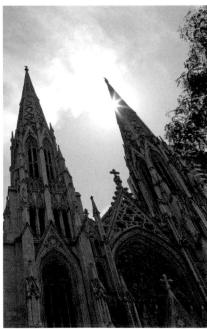

ADJUSTED IMAGE

INCREASE THE CONTRAST IN BLACK-AND-WHITE IMAGES

to produce a stronger, more graphic picture. If the original is in colour, first convert it to black and white. Then increase the contrast until you achieve the desired effect. This technique works well with silhouettes with clear outlines, and with objects with geometrical shapes or strong patterns.

ORIGINAL IMAGE

BLACK-AND-WHITE IMAGE

ADJUSTED IMAGE

INCREASE THE CONTRAST IN IMAGES SHOT IN DULL OR OVERCAST

CONDITIONS to restore tonal depth and richness. You will find that, as well as making colours bolder and brighter, this will increase definition and bring out details in your subject.

ADJUSTED IMAGE

ORIGINAL IMAGE

ADJUSTED IMAGE

IF YOU INCREASE THE BRIGHTNESS OF AN IMAGE, you alter the relationship between greys, blacks, and whites, so a compensation in contrast may also be necessary. Look at each image on its own merits, and adjust the brightness and contrast until you are happy with the result.

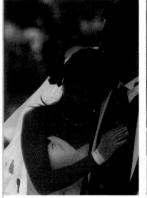

ORIGINAL IMAGE

BRIGHTER IMAGE

ADJUSTED IMAGE

AN IMAGE THAT IS HIGH IN CONTRAST, will appear to be sharper than one that is lower in contrast. This is because the margin between a white and a black area is seen as an edge, so the more marked the difference, the sharper the edge appears to be.

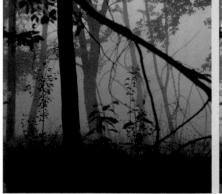

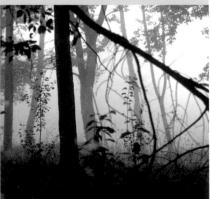

ORIGINAL IMAGE

ADJUSTED IMAGE

Removing distractions and sharpening

The best way to deal with distractions in your pictures is, of course, to avoid them in the first place. Care taken when you position yourself and point the camera to compose a picture will save you much effort later. But image manipulation software usually offers powerful tools for removing unwanted objects or unsightly elements. Once you have removed distractions, you may wish to sharpen the image, as this can help improve the appearance of your photograph, even if you have focused it correctly.

A STANDARD FEATURE IN MOST IMAGE MANIPULATION SOFTWARE IS A CLONE OR CLONE STAMP TOOL. This is one of the best ways of removing unwanted elements or distractions from your images. It works by copying or sampling one part of an image and pasting it onto another. For example, you can place a sample of sky onto tree branches or electricity pylons to make them disappear.

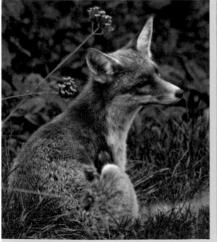

ORIGINAL IMAGE ADJUSTED IMAGE

INSTEAD OF SPENDING TIME REMOVING DISTRACTIONS, try blurring them (using a blurring or smudge tool) in order to make them less sharply delineated and obvious. This is effective because the eye favours objects with sharp contours or edges. To blur a section of an image, first you will need to select it using one of the selection tools.

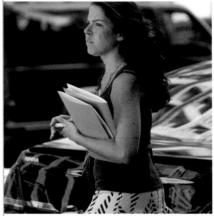

ORIGINAL IMAGE

ADJUSTED IMAGE

ANOTHER KIND OF DISTRACTION IS NOISE, which is a by-product of setting very high sensitivities (high ISO ratings such as 800 or greater). It gives a grainy look to the image. Many image manipulation software packages contain filters that can remove noise from an image, including dust and scratches.

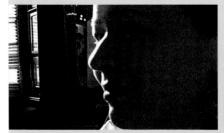

ORIGINAL IMAGE

ADJUSTED IMAGE

IF YOUR IMAGE IS A LITTLE SOFT OR BLURRED, USE A SHARPEN FILTER TO INCREASE ITS SHARPNESS. You can sharpen the picture by as much or as little as you like by adjusting filter settings.

ORIGINAL IMAGE

ADJUSTED IMAGE

IF YOUR CLONING PRODUCES
AN UNNATURALLY SMOOTHLOOKING AREA, you may need
to introduce some noise to make
it look more natural. Select the
area to be worked on and apply
the noise filter. Alternatively try
changing the settings on the
clone tool such as the hardness of
the brush edge and also the
opacity – how strongly the clone
is applied to the image.

GENERALLY, SHARPENING
SHOULD BE THE VERY LAST
FILTER YOU APPLY – following
other manipulations such as
cropping, resizing, and adjusting
levels – because of its very strong
effects on image data. After
applying the sharpening, check
the image at 100 per cent
magnification for any defects
that the sharpening may
have revealed.

WHEN SHARPENING AN IMAGE FOR PRINTING, it should look slightly over-sharpened on the screen, so that artefacts such as exaggerated borders are only just visible at full size (viewing at 100 per cent). For on-screen use, for example, in websites, sharpen your images only until they look right on screen.

INCREASING THE CONTRAST OF AN IMAGE GIVES AN IMPRESSION OF INCREASED SHARPNESS. Ensure that the image is at the correct contrast before using a filter to increase sharpness.

ORIGINAL IMAGE

ADJUSTED IMAGE

USE SHARPENING FILTERS
SPARINGLY. These filters sharpen pictures in a magical way, and reduce the effect of mild blur, but too much of a good thing can cause artefacts, such as contrasting haloes and exaggerated borders, to appear around your subject. It can also increase noise, making the image look as if it is composed of rounded grains of sand.

Cropping and resizing

One of the most basic things you do with a digital image, either before or after making any other adjustments, is ensure that it is the size you need it to be. Changing the size does not alter its appearance, but can make it easier to send by wireless or email, or to ensure that it comes out the right size for your printing paper. You will also need to crop the image a little if you need to straighten out horizons that are not quite level.

CROPPING REDUCES THE SIZE OF AN IMAGE, and throws away information, so severe crops should be reserved for large images.
When you crop an image and then try to view it at the same size as it was before it was cropped you will notice that the pixels are larger.

ORIGINAL IMAGE

ADJUSTED IMAGE

THE FIRST THING TO DO WITH YOUR IMAGE BEFORE YOU WORK ON IT IS TO MAKE A COPY. Duplicating your image before you make any changes prevents you from accidentally saving any changes on to the original file and closing it, which loses the original forever.

CROPPING IS AN EFFECTIVE AND SIMPLE WAY TO ENLARGE PART OF

AN IMAGE. In this way you can focus attention on the main subject if there is too much space around the edges.

ORIGINAL IMAGE

ADJUSTED IMAGE

YOU CAN CROP AN IMAGE TO REDUCE FILE SIZE, particularly if you are sure you do not need the elements you are removing. Even removing a narrow margin from a large image can offer a significant saving in file size.

CROPPING AND STRAIGHTENING CAN CORRECT TITLED HORIZONS.

Draw a narrow crop near the horizon and rotate the crop so that it lines up with the horizon. Then extend the corners of the crop to the edge of the picture – two of the corners will meet the picture edge, but the opposite corners will be inside the picture. When you crop, the picture will be rotated correctly.

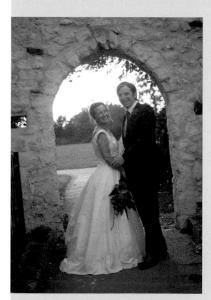

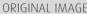

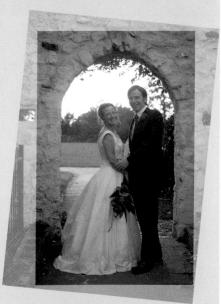

ADJUSTED IMAGE

TO MAINTAIN THE ORIGINAL PICTURE'S SIZE RATIO, choose the crop tool, click and drag over the whole image (as if you want to crop the entire image), then hold down shift key and drag the crop box to the desired size. (This trick works for most image manipulation programs.)

CROP OUT DISTRACTING ELEMENTS or anything that doesn't add to the image, such as dominant colours, as the eye is drawn to bright objects first.

ORIGINAL IMAGE

ADJUSTED IMAGE

IF YOU CHANGE THE SHAPE OF YOUR IMAGE expect large borders – especially if you're having your pictures printed at an outlet – as these generally print only in standard shapes and sizes.

ADJUSTED IMAGE

ORIGINAL IMAGE

RESIZE THE IMAGE TO SUIT THE TASK. If you want to share images, either on the internet or by email, they seldom need to be more than 500 pixels wide, and at most 1280 pixels wide. This will give you very high quality for viewing on monitors. If you wish to make prints, you need to ensure that two settings are correct. Firstly, make sure that you have enough pixels for the size: a rule of thumb is to have around 300 pixels for every 1 inch of print. For example, a 12 x 10cm (5 x 4in) print needs an image measuring about 1500 x 1200 pixels – well within the capacity of all modern digital cameras. The other measure you need is the output size. This should be the size of print that you want, and it should fit the paper that you're using. Check this measurement in the image software.

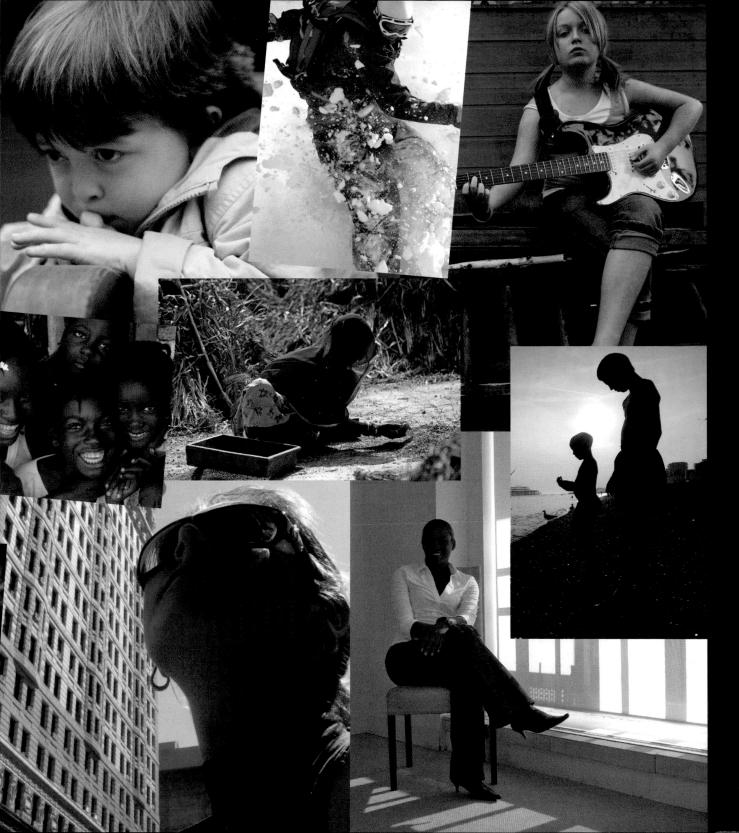

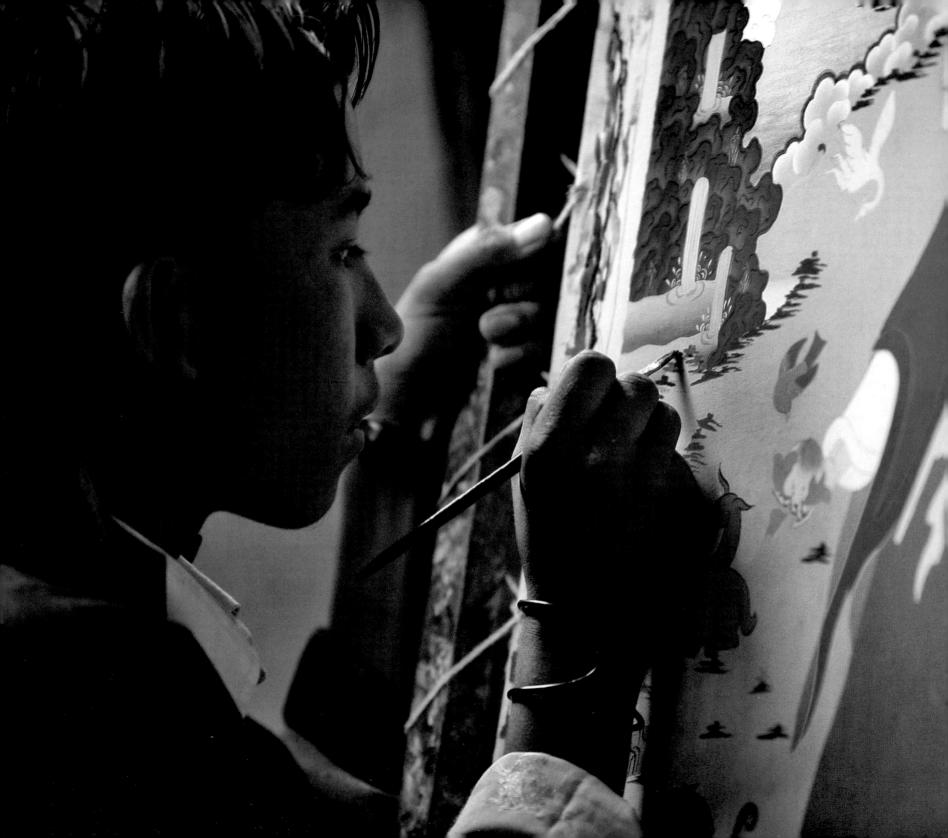

People are the most rewarding and richest – and by far the most popular - subjects for photography. Perhaps because they mean so much on a personal level, when pictures of people disappoint, the impact is usually greater than with other subjects. This chapter shows you how to utilize the basic elements of photography to make satisfying, sensitive, and engaging pictures of people. You will work with light and exposure, use composition and zoom settings, choose backgrounds, and learn how to relax and pose your subject. You will also discover the different approaches for photographing children and older people, and for formal portraits and candid shots.

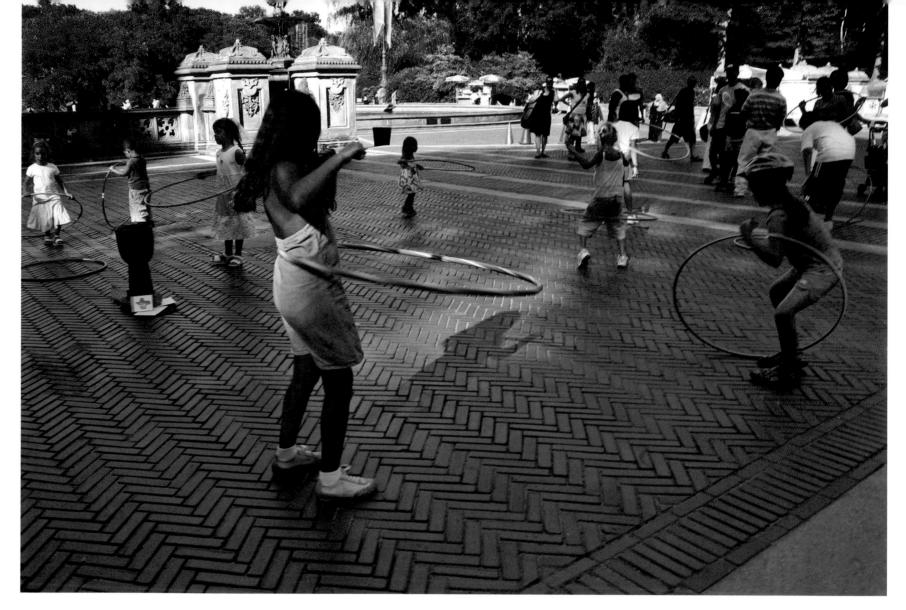

Children at play

Unstructured activities, such as children getting together to play in a city park, offer the chance to capture beautiful, and sometimes amusing, moments. However, the window of opportunity is usually small: there is an early stage when the

activity grows as more and more people take part; then the interest peaks before tailing off. At the right moment, light and motion come together to create interesting compositions. Here, one girl had just worked her way into the light.

*

FOR THIS SHOT

The wide-angle setting was the natural choice, but a normal setting can also be very effective, since it concentrates the view more. I achieved a short shutter time and maximum depth of field with a high sensitivity setting.

CAMERA MODE

Set your dial to Sports mode

LENS SETTING

Zoom to Wide Angle

SENSOR/FILM SPEED

Use a **High** or **Medium** ISO setting

FLASH

Force the flash Off

USE LIGHT AND SHADE

Depending on the time of day and location, there may be patterns of light and shade falling on the scene. This interplay can make it hard to balance exposures between bright and dark, but it also brings some structure to the composition.

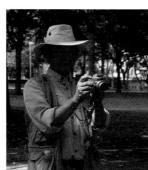

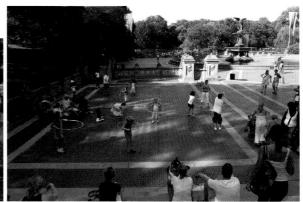

SET YOUR CAMERA

In order to freeze rapid movement, you should set a high ISO. Do this despite the bright natural light. A wide-angle setting and large aperture will help to keep shutter times short.

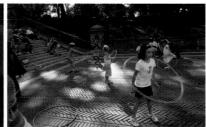

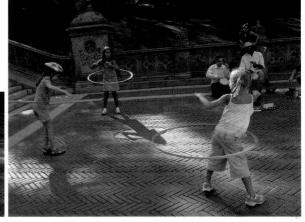

CONSIDER COMPOSITION

Bring your composition to life by selecting a group of characters. From within that group, you can then single out a main protagonist. In this case, this little girl had begun to distinguish herself with her hula-hoop skills.

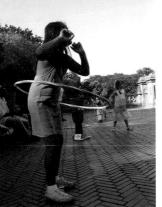

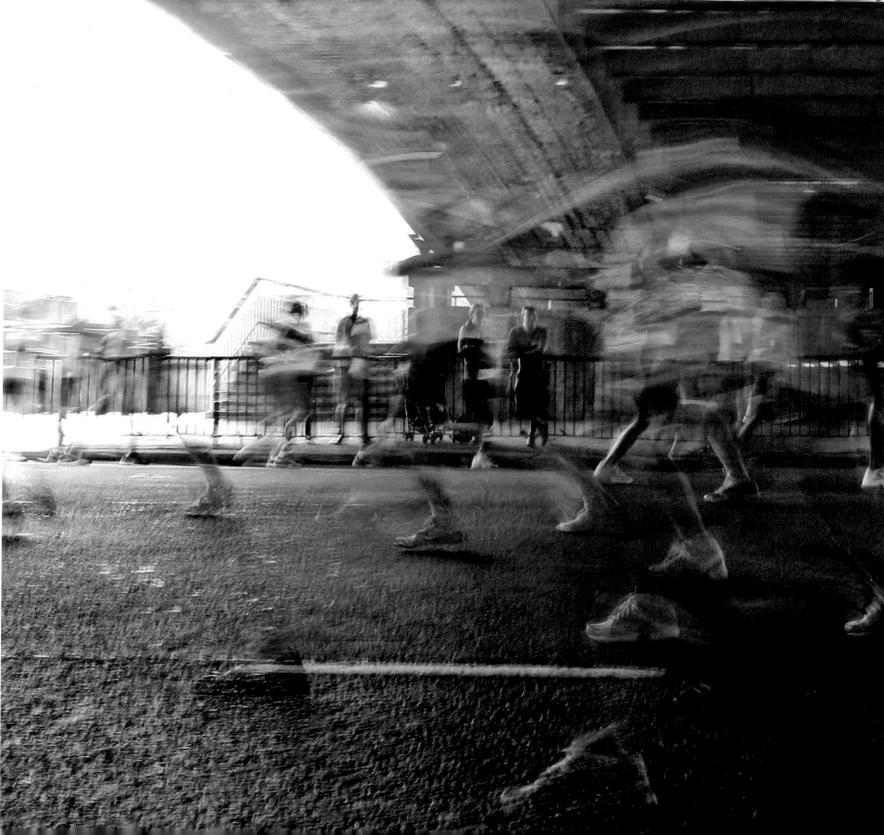

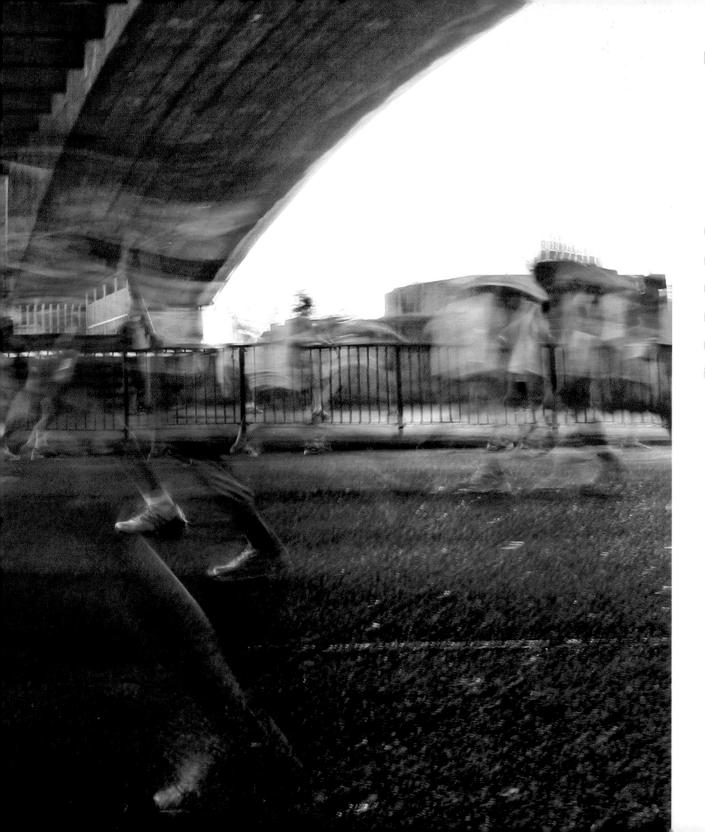

RUNNERS IN MOTION

You can push movement blur to convey the pace of people in motion. Setting a longer-than-normal exposure reduced these runners to a mere blur. However, the feet, which were momentarily on the ground during exposure, are much more defined.

Holiday highlight

For many, the most important holiday picture is the one that says, "I was there", positioned in front of a famous landmark or view. It may not matter that it is not a great photograph, so long as the record is made. However, it is more satisfying to create a picture that stands on its own merits. One approach is to combine the landmark in a visually organic way with your subject. You can do this through pose, viewpoint, or perspective.

BE CREATIVE

Popular locations attract many people, all looking for the perfect shot. If the landmark is in the centre of the town, the issue is further compounded by passing traffic. If you don't wish to include the crowds in your shot, you need to find creative solutions.

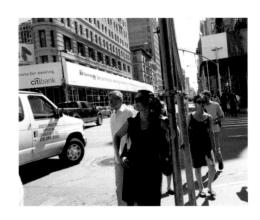

ZOOM IN

To eliminate the crowds, you can try zooming in close to your subject, throwing the background out of focus. However, this technique has an obvious drawback: you lose the sense of location.

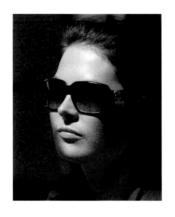

LOSE THE FOREGROUND

The usual way to remove surrounding crowds from the composition is to point the camera upwards, crouching close to your subject.

However, you will need to look out for other elements entering the picture, such as street furniture or overhanging foliage.

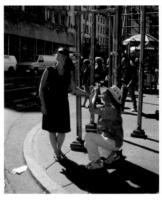

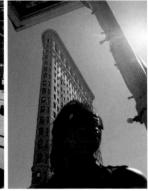

AVOID DIRECT SUNLIGHT

Another problem with shooting upwards arises if the sun is behind the subject. From the camera's point of view, the subject's face will be in shadow. Setting the exposure for the girl would leave the building too bright, while exposing for the building would produce a silhouette-like effect on her. Fill-in flash would leave her face unnaturally bright. This issue can be overcome by having her lift her face upwards.

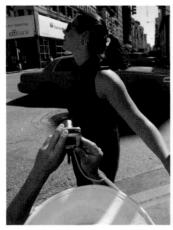

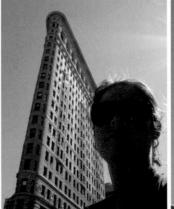

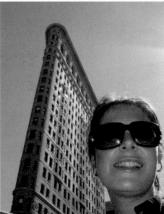

FOR THIS SHOT

I asked my model to tilt her face in order to catch as much light as possible. For the greatest depth of field, I set the smallest aperture and chose the widest-angle zoom, which also allowed me to get the entire building into the shot.

CAMERA MODE

LENS SETTING

SENSOR/FILM SPEED

Use a **Medium** to **High** ISO setting

FLASH

Force the flash to Fill-in mode

GET THE SETTINGS RIGHT

Make sure that the camera settings give you enough depth of field to keep both the subject and the landmark sharp.

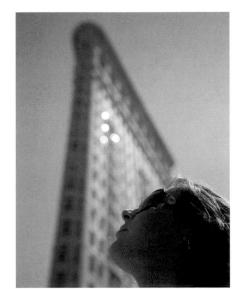

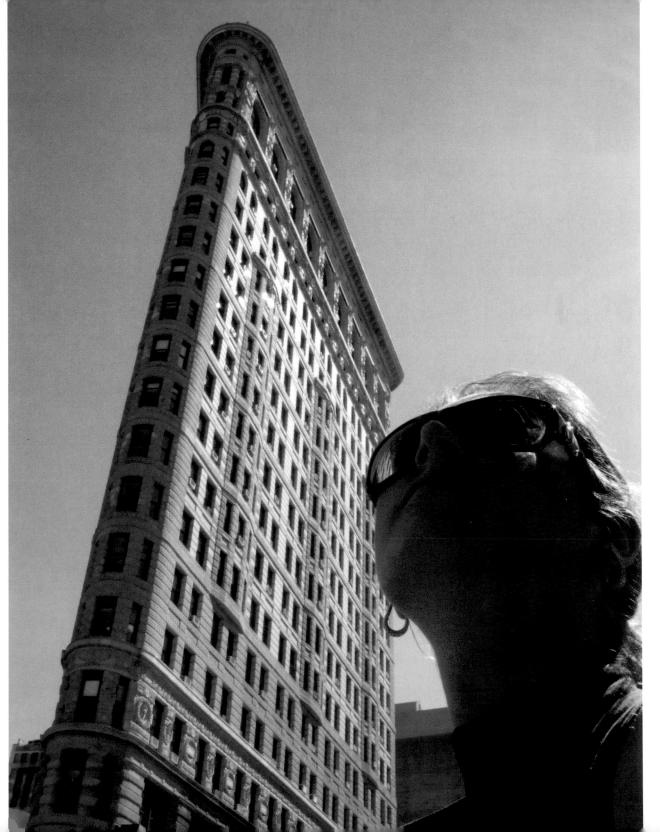

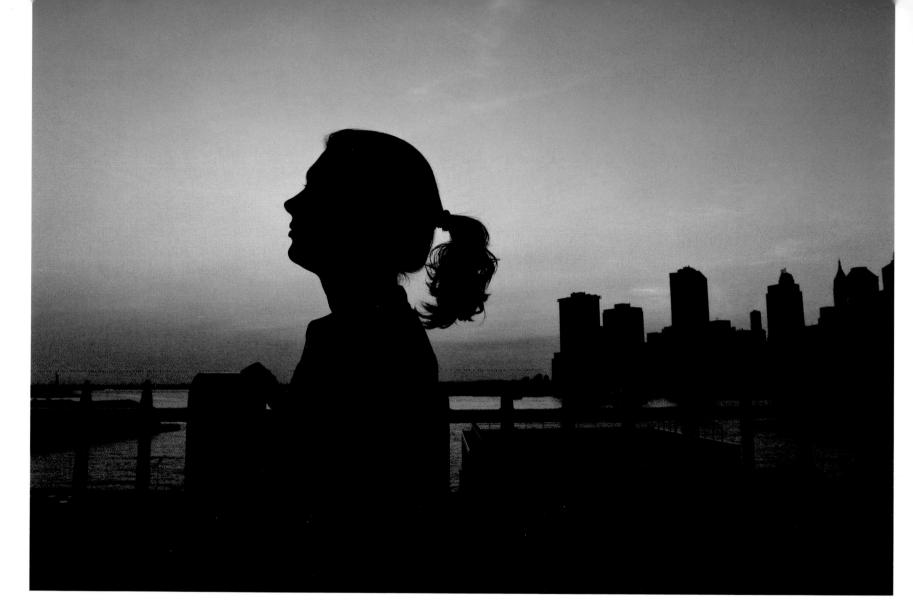

Creating a silhouette

Before the days of photography, the painted silhouette was a classic way to depict a profile. Silhouette portraits look simple, stripped as they are of any unnecessary detail, yet dramatic and strong. Achieving this effect in photography

depends on a combination of lighting, exposure control, and careful choice of subject. Sunset is a good time for such a shot, since the sun is low in the sky, allowing the background to be lit without light falling on the foreground.

*

FOR THIS SHOT

I chose a moderately wideangle setting to take in both the silhouette of the face and that of the city skyline. I also wanted a good expanse of sky, which I exposed for, to make the foreground completely black.

CAMERA MODE

Set your dial to any exposure mode

LENS SETTING

Zoom to Normal to Wide Angle

SENSOR/FILM SPEED

Use a Medium to High ISO setting

FLASH

Force the flash Off

POSITION YOUR SUBJECT

For the best silhouettes, place your subject directly between yourself and the light source. If the subject is too far to one side, you can see light on her face; if she stands too far back, the sun will creep into the picture.

2

GET THE PROFILE RIGHT

Make sure you get the entire profile of the subject in your picture. A silhouette portrait is one of the few situations in which you need to pose your subject and get them to stay still. Here, a slight movement of the head ruined the effect.

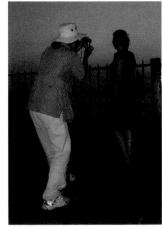

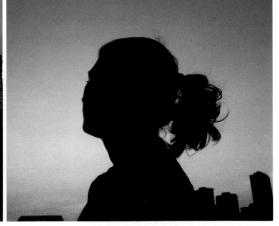

TRY DIFFERENT EFFECTS

The choice between pinning long hair up or letting it loose can have quite an impact on the image. Be also aware that the sun is a distraction when visible in a silhouette portrait, as are other elements, such as buildings. Make sure there is some empty space between your subject and any background elements.

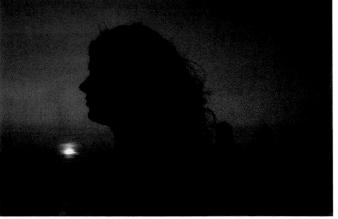

Informal child portraits

The best portraits of children are those that are taken in an informal setting, but you need to have patience, stamina, and quick reflexes. In order to avoid having to run around after the child, try to find something that they are interested in doing so you can take photographs while they happily entertain themselves. This gives a lovely, natural feel to the photograph and also reveals something of the child's character at the same time.

KEEPING CHILDREN HAPPY

Before you start the photo session, make sure the child has had something to eat and drink. A hungry child is less willing to cooperate. It is a good idea, however, to avoid sugary or fatty foods and fizzy drinks, since these are likely to make the child overactive or drowsy.

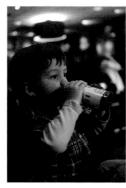

ENGAGE WITH THE CHILD

Children can be shy around cameras, especially if a fuss is made about them being the sole subject of the shoot. Get them to cooperate by making the exercise fun and involving them – for example, show them their picture on the LCD screen, or allow them to take a picture of you.

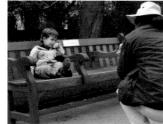

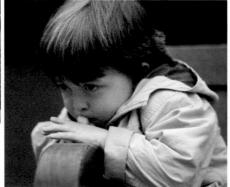

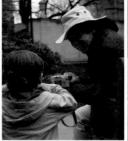

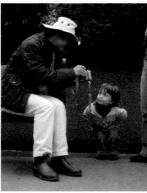

DIRECT THE CHILD

Use fun pursuits to direct the child and divert his attention from the photography. Tell them what you are trying to achieve. Even young children will enjoy being part of a team effort.

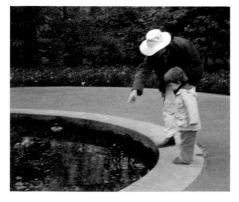

LET THE CHILD GET USED TO THE CAMERA

If you wait until a significant moment, the camera may distract the child. Make sure you take lots of pictures before you start the actual shoot. This will get the child used to the sounds of the camera. Soon, he'll be ignoring you and what you're doing.

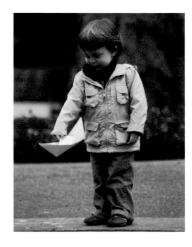

FOR THIS SHOT

I set a long focal length to zoom in on the child and to throw the background out of focus. Knowing he wouldn't stay still for long, I set the sports mode to give the short shutter times and quick camera responses needed for capturing action.

CAMERA MODE

Set your dial to Sports mode

LENS SETTING

Zoom to Maximum Telephoto

SENSOR/FILM SPEED

Use a **Medium** to **High** ISO setting

FLASH

Force the flash Off

By taking pictures of the child from a distance and zooming in, you are more likely to obtain natural poses. Ensure an adult is standing by to watch over the child; they don't have to be in the shot.

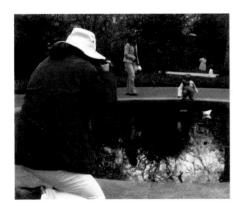

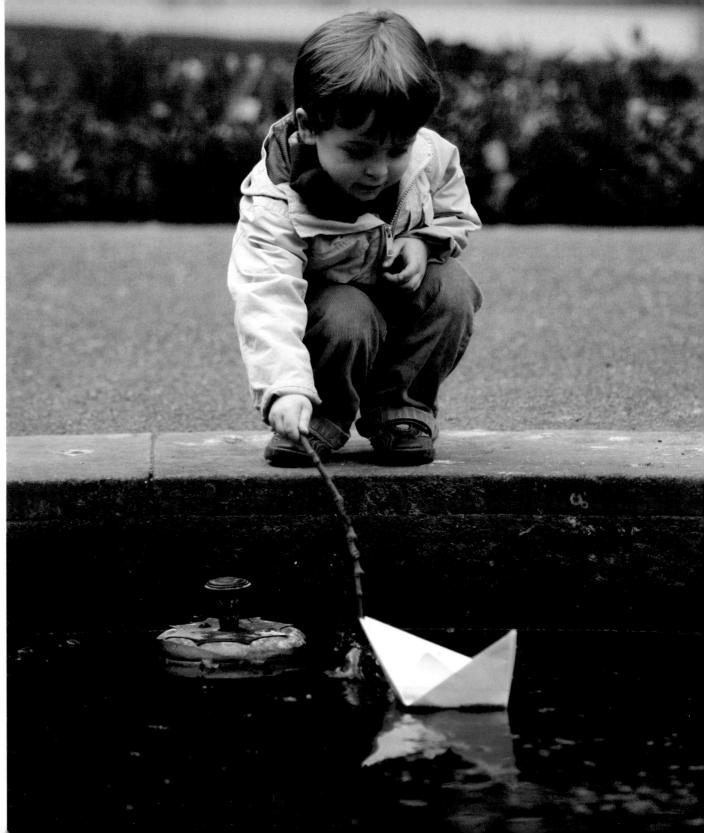

PEOPLE AT WORK

Candid photography aims to record people unposed and natural, going about their business without altering their normal behaviour because of the camera. This does not mean, however, that they have to be unaware of you.

- In many resorts, people are used to being photographed, so don't be nervous about it.
- A small digital camera is ideal since it is not intimidating to those being photographed.
- If anyone looks at you, just smile and make eye contact. You can still make the picture.

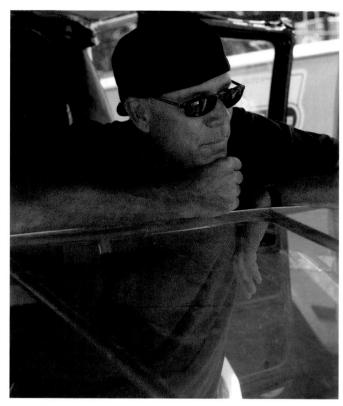

CONVERSATIONAL PORTRAIT

Don't feel shy about asking people for permission to photograph them. Most will agree and simply carry on with their conversation or activity.

- A normal to moderately long zoom works well for portraits.
- Turn off unnecessary camera noises to avoid distracting your subjects.
 - Use the surroundings to frame and contain the subject of your photograph.

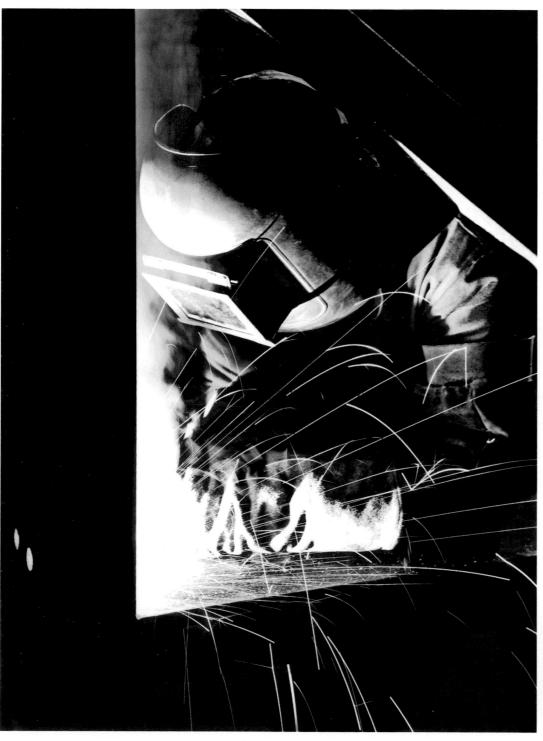

INDUSTRIAL PORTRAIT

Skilled people at work are often inspiring to watch and to photograph. This welder makes a particularly photogenic subject, thanks to the flying sparks and dramatic light of his working environment.

- Follow all safety rules when working in industrial sites, and watch where you step.
- Experiment with different shutter times to catch the action in the most effective way.
- Look for areas with interesting contrasts in lighting to add drama to your composition.

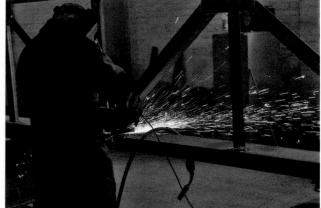

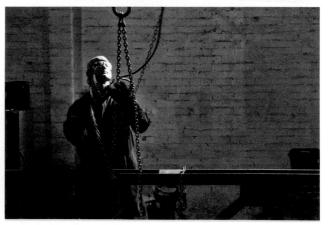

Using dramatic lighting

Being adventurous with lighting when shooting a portrait can be very rewarding, creating effects that you might not have anticipated. All you need to do is work a little with positioning and framing. Some harsh lighting from a street lamp may appear unflattering at first, but a few moments' posing and fine-tuning can reveal its real potential. Often the result is dramatic and cinematic in character. A long lens setting can throw unwanted background into blur.

MOODY MONOCHROME

Where the light falling on your sitter is very harsh or dramatic – creating hard shadows and extremes of contrast – colour recedes in importance to give way to shape; texture, and tone. Try turning your image into a black-and-white shot. Drama may be heightened, the tonal gradations more subtle.

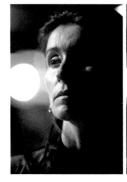

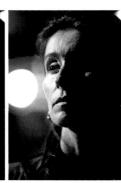

EXPERIMENT A LITTLE

The situation may not look ideal, but sit your subject comfortably while you experiment with various camera settings. Explore positions carefully to work out how to make the best use of the available lighting.

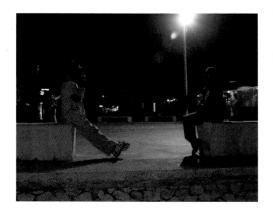

CHANGE ISO SETTINGS

If the light levels are very low, as they are here, set the highest ISO for maximum sensitivity. The resulting image may be "noisy", with a grainy look, but you can use that to help give character to the image.

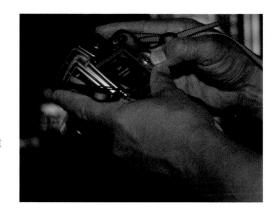

VARY THE POSES

Try out various positions and angles. In this kind of lighting, even small changes in the position of the face in the frame can make a big difference. Try to keep a solid stance. My position, here was unsteady and led to unsharp images.

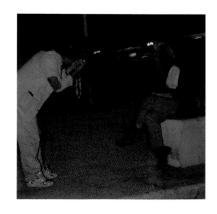

GET IN CLOSER

Zoom in close so that you emphasize the chiaroscuro – that is, the subtle changes in shade between light and dark – of the face.

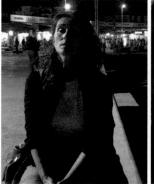

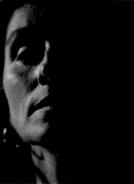

FOR THIS SHOT

I zoomed to a mid- to telephoto length to find a comfortable perspective on the face, and used the available light to sculpt the face. The maximum aperture allows the background to be blurred.

CAMERA MODE

Set your dial to Night mode

LENS SETTING

Zoom to Medium Telephoto

SENSOR/FILM SPEED

Use the **Maximum** ISO setting

FLASH

Force the flash Off

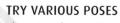

Changing the position of the head is like moving a lamp around: here, a tiny change lights up the whole face but loses the chiaroscuro.

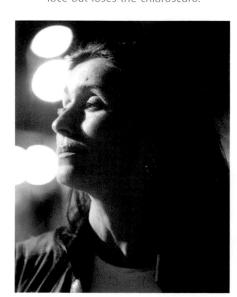

Posed child portraits

Any formal portrait benefits from an investment in effort. The resulting images will be perceived as having greater value if they have been, literally, taken seriously. When working with children, the effort must come from both the photographer and the subject, who may not be used to sitting quietly for any length of time. Your responsibility is to reward the child's patience with a picture that captures their essence without subduing their character.

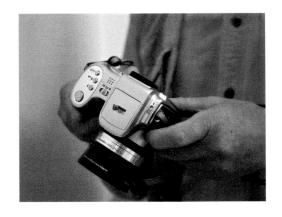

In the majority of homes, space is fairly limited. Give yourself as much working space as possible by photographing from one corner of the room to the one diagonally opposite.

GET THE POSE RIGHT

Slight adjustments to a pose can make a huge difference. Here, by simply turning the chair around, the child's posture is greatly improved. It also allows her hands to be part of the portrait.

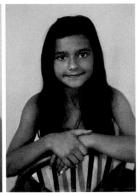

POSE AND COMPOSE

If possible, try to maintain eye contact with your subject. However, if the child feels self-conscious, suggest that she looks slightly to one side. It may be helpful for her to focus on a friend or relative nearby.

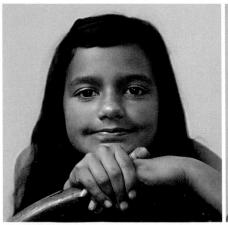

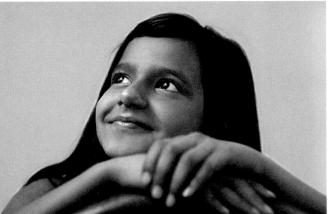

FOR THIS SHOT

I set up on a tripod so that I could direct and communicate with the sitter without having to hold the camera. I turned off the flash, selected high image quality, a low ISO setting, and a medium to long telephoto on the zoom.

CAMERA MODE

Set your dial to Aperture Priority

LENS SETTING

Zoom to **Medium** to **Long Telephoto**

SENSOR/FILM SPEED

Use a **Low** ISO setting

FLASH

Force the flash Off

FOCUS ON THE EYES

In the vast majority of portraits, the crucial area of focus is the eyes. Unless you have a very good reason – such as to make a statement about the sitter's hands – the eyes should always be sharp.

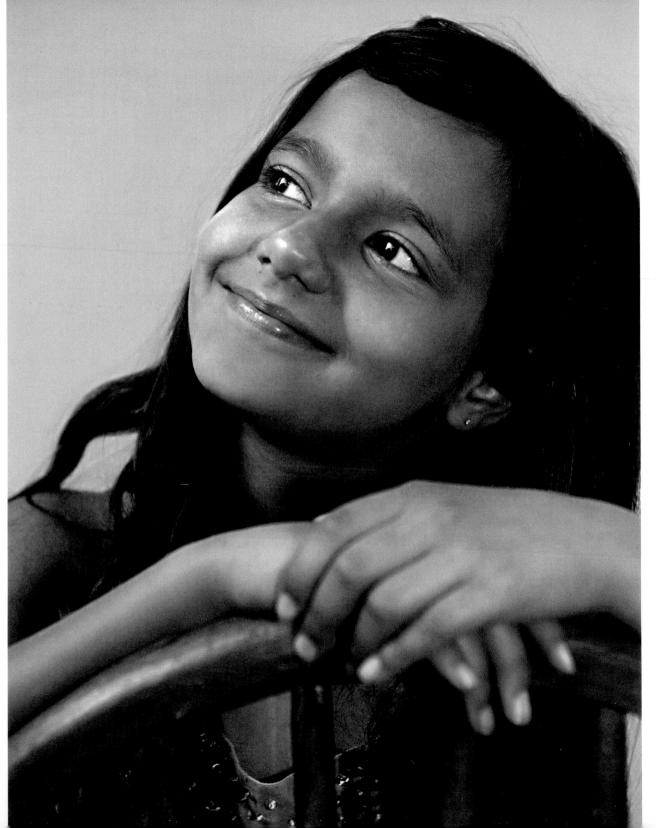

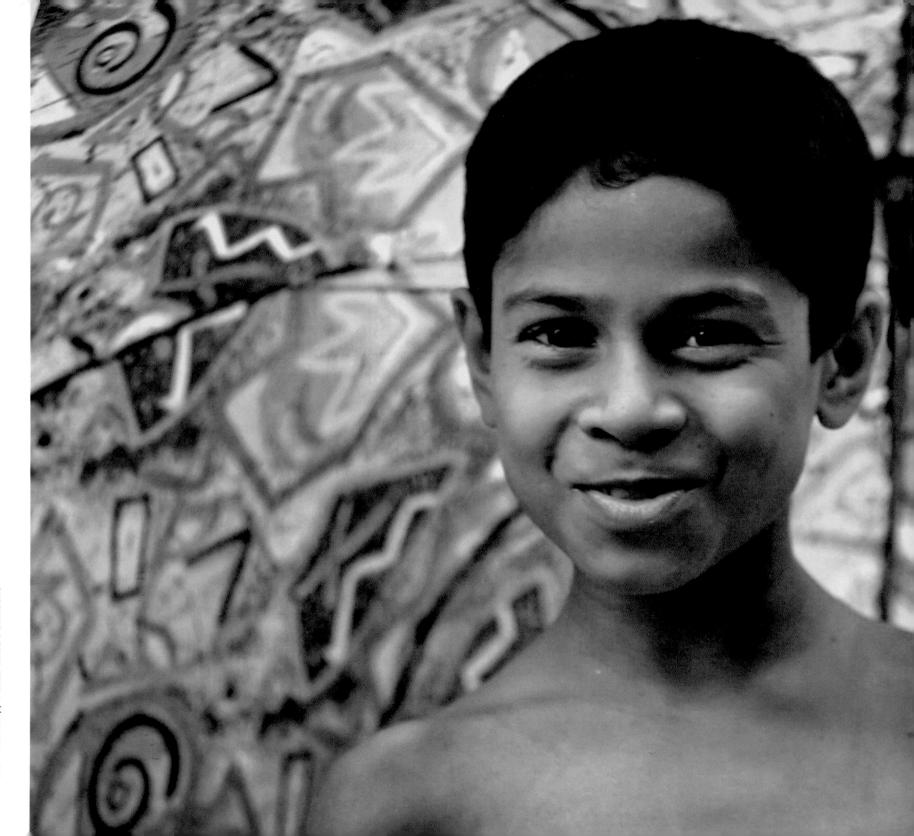

SMILING EYES

Black-and-white photography is perhaps the natural medium for portraits. In colour, the patterned umbrella provided a brilliant backdrop, but in monochrome, attention is drawn immediately to the boy's friendly, smiling face.

- A long focal length crops the image so that the umbrella entirely frames the face.
- In very bright sunlight, set the flash to automatic in order to fill in shadows.
- Shoot black-and-white portraits if you wish to remove the distractions of colour.

Alternative portraiture

Some physical details, such as hands, can reveal as much about the character and lifestyle of a person as their face. When taking a portrait shot, it is worth considering this approach, especially if the sitter is not confident in front of the camera. These henna-decorated hands are obviously highly photogenic, but all hands are expressive - whether they belong to a baby or to an aged farmer. Giving the hands something to hold makes for a more natural pose.

TRY A FULL PORTRAIT

Start with a conventional portrait. This might bring to light individual aspects that are worth focusing on. In this case, for example, the background of the dark shirt is perfect for the flowers and clearly suggests an alternative approach.

MOVE CLOSER

Experiment with closeup views with a short focal length, as well as from a greater distance with a longer lens setting to decide on what works best for the subject. Use a low ISO setting for the best image quality.

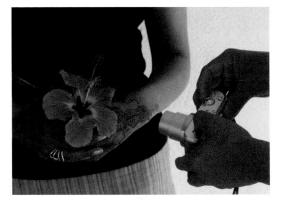

VARY THE BACKGROUND

For subjects with delicate textures and subtle tones. try to work in subdued lighting. Try different backgrounds, too. Here, the warm tones of a wall complement the flowers and hands, but it is clear that an even simpler approach will be best.

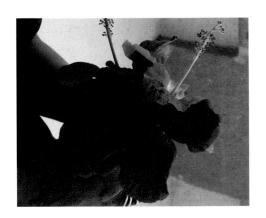

DIRECT YOUR SUBJECT

Try the hands with jewellery and without, and ask the sitter to change the position of their hands, but to do so slowly. Meanwhile, keep shooting: the hands will look most natural when they are not deliberately posed.

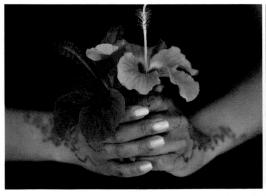

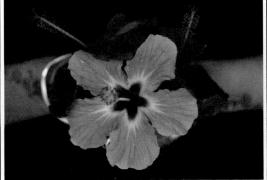

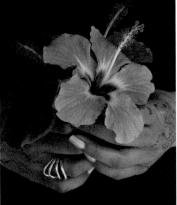

FOR THIS SHOT

I zoomed in to create a slightly distant look. Low sensitivity gives high quality and a short shutter time offers sharpness. I made many exposures in a short time to ensure that I achieved a graceful, telling composition.

CAMERA MODE

Set your dial to any exposure mode

LENS SETTING

Zoom to Maximum Telephoto

SENSOR/FILM SPEED

Use a **Low** to **Medium** ISO setting

Force the flash Off

USE AVAILABLE LIGHT

Here, the subject of the portrait is standing in semi-shade, with light bouncing off the floor to illuminate her hands from below.

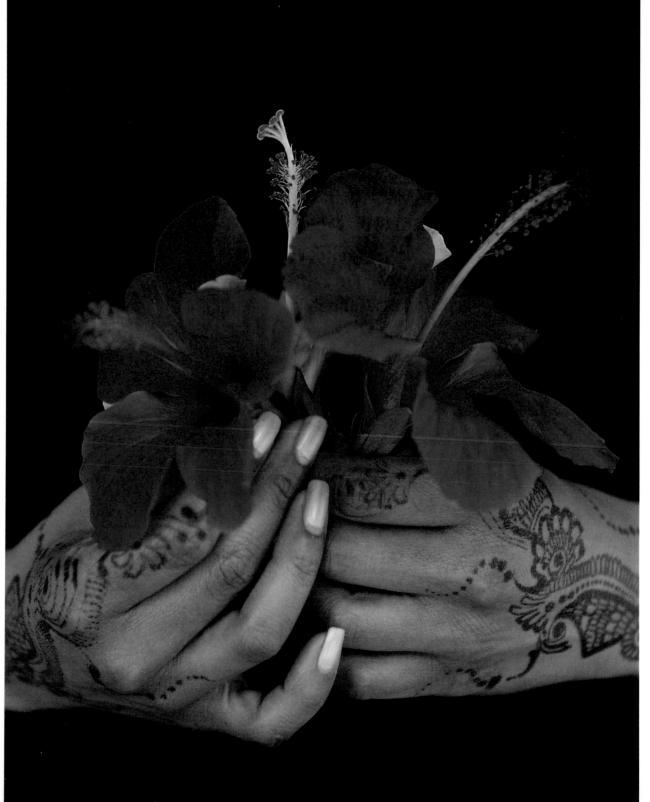

Beautiful baby pictures

Every parent longs for a picture that perfectly captures their baby's personality. However, babies and small children can be challenging subjects to photograph. Their movements are often unpredictable, as are their moods, which can switch from smiles to tears in the space of a few seconds. Careful and patient preparation will allow you to work quickly when the circumstances come together, creating a picture you will treasure forever.

1

PREPARE THE SET

Babies will benefit from being photographed against a neutral background and bathed in diffused light, which is kindest to soft features. A white sheet reflects light to fill the shadows under your subject. It also reflects in the baby's eyes.

INVOLVE THE BABY

Let the baby touch the camera – after all, you are playing with it, so why shouldn't the baby? Let them get used to the camera. It will not be long until they lose interest in it.

CHOOSE A POSITION

Try the baby in different positions. Some are likely to be more comfortable than others, depending on the child's age and inclination. You need to discover which one works best.

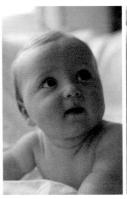

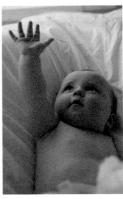

KEEP SHOOTING

You may not notice the subtleties in expression while shooting, so don't waste time reviewing your shots at the time, especially if the baby is cooperating. If you take your eye off a rapidly changing situation to check your images, you are sure to miss a great shot.

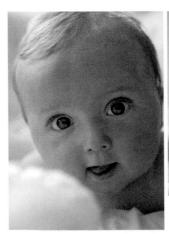

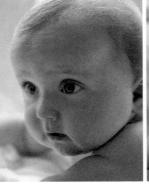

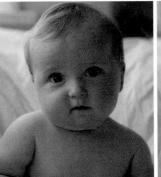

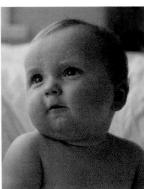

FOR THIS SHOT

I set the zoom to medium telephoto and close-up mode, so that the baby's face filled the frame. By quick-firing I took some 100 pictures in 6 minutes, giving a good choice of expressions. (For this you may need to set a small image size.)

CAMERA MODE

Set your dial to Portrait mode

LENS SETTING

Zoom to **Medium Telephoto**

SENSOR/FILM SPEED

Use a **Medium** to **High** ISO setting

FLASH

49

Force the flash Off

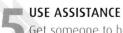

Get someone to help keep the baby entertained and smiling. However, if you want the child to look directly into the camera, you might have to do a little entertaining yourself, as well as taking the photographs.

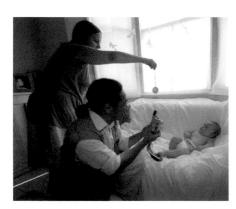

Children year by year

Most parents experience a similar pattern when it comes to photographing their own children: they dive in with great enthusiasm at the start, taking hundreds of photos of the new-born baby. Then, as the child grows, the number of pictures drops dramatically. One way to keep up a consistent photographic record is to think of your child's development as a project whose key stages need to be documented.

FOCUS ON THE DETAILS

While, of course, you will want to record the varied and ever-changing facial expressions of your newborn, remember that other parts of the baby's body undergo equally rapid – and astonishing – changes.

- Take the baby close to a window to avoid having to use the flash.
- 2 Use close-up mode to zoom as close as possible to the baby's tiny hands and feet.
- Try a range of backgrounds. Pastel tones complement the baby's skin, while dark tones offer contrast.

BABY STEPS

A child's first faltering steps are an emotionally charged moment for any parent: as well as being inordinately proud of their achievements, you are also aware that with growing confidence come mobility and freedom.

Avoid using the flash: it might distract the child, who is trying hard to concentrate on their balance.

If possible, work outside in good light, keeping to open shade and avoiding direct sunlight.

CANDLES AND LOW LIGHT

Different societies celebrate children's birthdays in different ways. The largely European tradition of the birthday cake symbolizes good wishes to ensure a healthy year ahead.

If the celebration takes place in low light, use all the available light.

Use a tripod to steady the camera, since flash would ruin the candlelit effect.

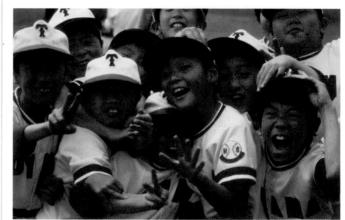

TEAM SPIRIT

Your child's growing social life is reflected in their taking part in team sports at school and outside. They will treasure your pictures as records of their team mates.

Encourage the team to pose, but don't make the shot too formal – it should be fun.

Take several pictures in rapid succession to ensure that you catch everyone.

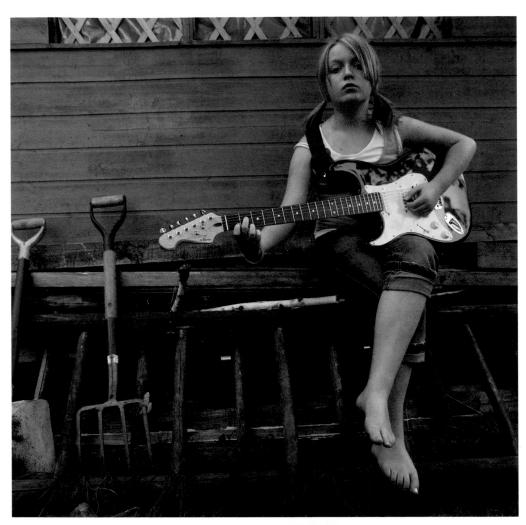

FAVOURITE HOBBY

Many children who are shy around the camera will agree to pose to show off something they are proud of or passionate about, such as their musical instrument.

Try formal as well as informal poses, with different zoom settings from different positions.

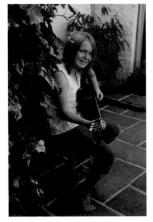

GROUP PHOTOS

Children feel more relaxed in front of the camera if they are surrounded by their friends. They are more likely to reveal their personalities if you let them pose together.

- Go along with the kids' pranks and sense of fun for the session, it's the most natural approach.
- Instead of lining them up on a bench, look for a spot where you can experiment with grouping.
 - Work rapidly. Children bore easily, and once they've lost interest, it will be almost impossible to persuade them to cooperate.

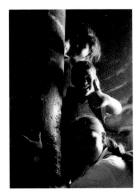

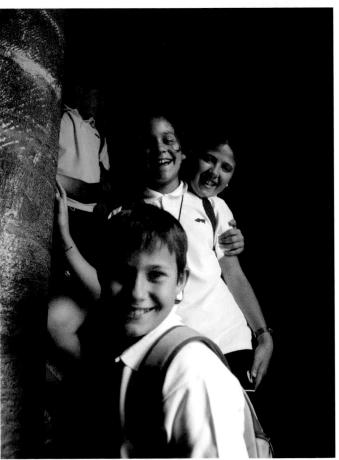

DEEP IN THOUGHT

The toughest portrait subject is the reluctant subject, and teenagers are notoriously reluctant to pose for the family album. The key is to accept them as they are: they do not have to pose, they do not have to smile; in fact, they do not have to make any effort at all.

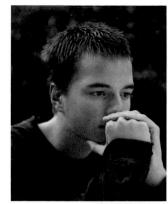

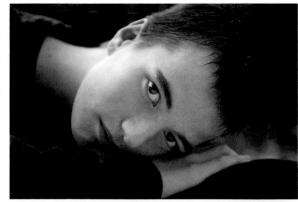

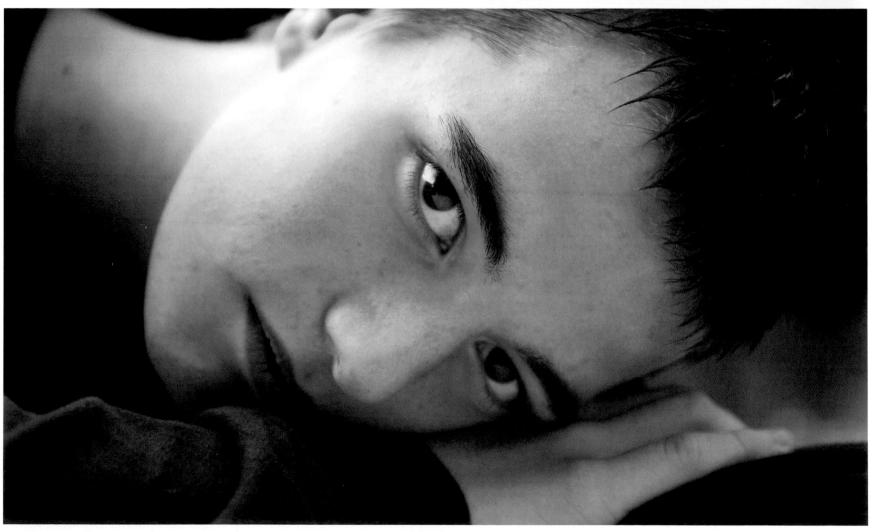

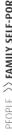

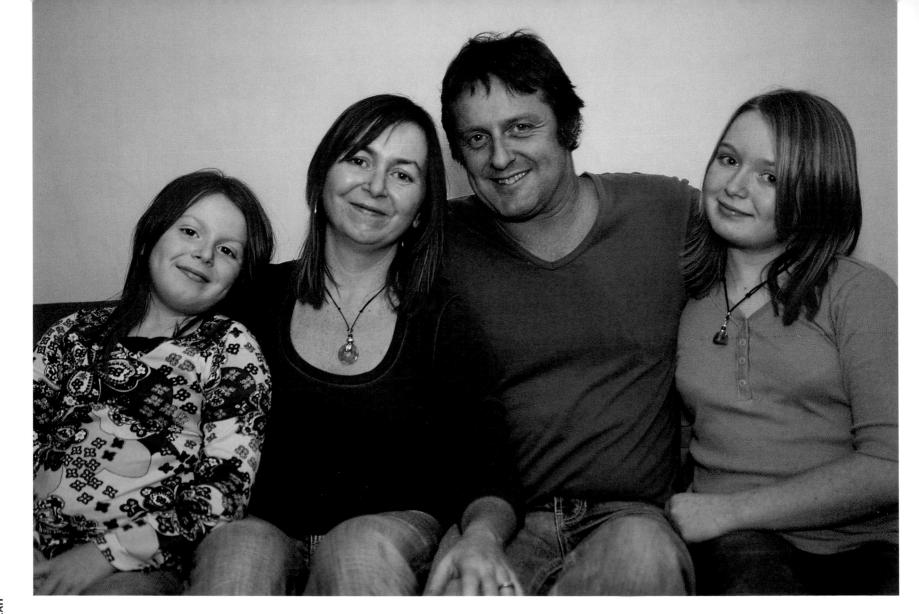

Family self-portrait

A family self-portrait - to send to distant relatives and friends, for a Christmas card, or just for yourself – can be surprisingly difficult to organize: it may take time to get everyone in the same place and in the right frame of mind to sit for a group shot. It is helpful that digital cameras allow you to see the image straight away. This not only gives immediate feedback on your settings, it also encourages everyone to work together to make an appealing picture.

K F

FOR THIS SHOT

The camera was set to a moderate zoom and a low ISO then placed on a tripod. Flash was used to fill in dark areas, creating a mixture of ambient lighting and flash to give a softer effect.

CAMERA MODE

Set your dial to Program mode

LENS SETTING

Zoom to Medium Telephoto

SENSOR/FILM SPEED

Use a **Low** ISO setting

FLASH

Force the flash **On**

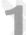

WEAR THE RIGHT

Brightly coloured garments may make the skin appear pale and wan. You should also make sure that the clothing of any one person doesn't dominate the picture. Consider your clothes in advance, and try to keep the tones similar.

2

PREPARE YOURSELVES

Apply a little face powder – even to male members of your family – otherwise the light from the flash will accentuate any shiny areas. Encourage everyone to comb their hair, if possible.

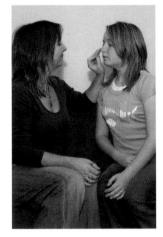

GET THE LOCATION READY

If you are going to sit on a sofa, move it away from the wall: this ensures there will be no harsh shadows on the wall directly behind you.

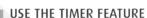

Set the camera on a tripod, line it up, and arrange the pose, remembering to leave room for yourself to be included. Set the self-timer to give yourself time to occupy the vacant space. Selftimers usually give you a warning a few seconds before the exposure, so you do not have hold frozen grins for long periods of time.

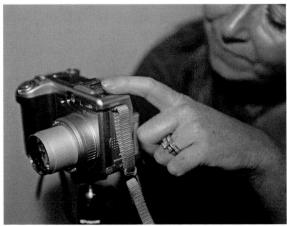

Informal family portraits

If a portrait of a single person is tricky, your problems will be multiplied when you try to create an informal shot of the whole family together doing something they enjoy. One of the keys to success is to make sure every member of the family feels that they contribute something to the image. They should be allowed to choose their own clothes, for example, so that they feel comfortable. Your aim, after all, is to create a relaxed, natural-looking portrait.

CHECK EXPRESSIONS

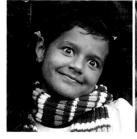

One of the difficulties of taking group portraits is that many shots will include individuals pulling funny faces, talking, blinking, or looking away from the camera. Check your pictures by enlarging them on the LCD before ending the session.

D To

DECIDE ON A LOOK

To avoid losing the children's interest, before you start, experiment with backgrounds and setups, using just the parents. Consider where to place the members of the family.

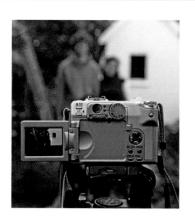

2

CONSIDER LIGHTING

If you are working outdoors, bear in mind that the lighting may change during the time you are setting up. For groups of people, it's easiest to work with even lighting. Avoid having some people in the sun and others in shade, since this is very tricky to get right.

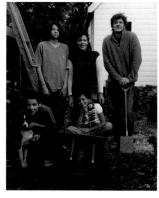

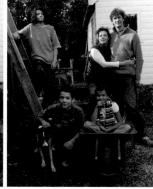

POSE AND COMPOSE

With the camera on a tripod it is easy to get your subjects to move while you take the pictures. Keep talking and directing, but carry on shooting. Only review your shots at the end, or you'll miss opportunities.

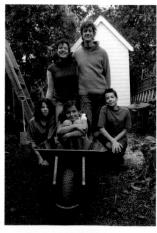

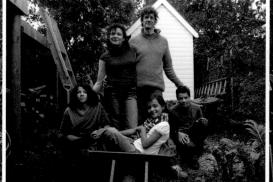

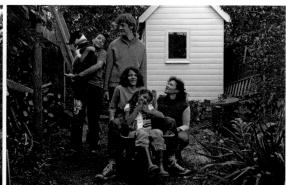

FOR THIS SHOT

I set the zoom to a moderate wide angle to capture the garden and the whole group. I ensured a good depth of field by setting the minimum aperture. Low sensitivity and maximum image size gave good image quality.

CAMERA MODE

Set your dial to **Aperture Priority**

LENS SETTING

Zoom to **Moderate Wide Angle**

SENSOR/FILM SPEED

Use a **Low** ISO setting

FLASH

Force the flash **Off**

SET YOUR FOCUS

Symmetrical compositions usually make the most satisfying family portraits, but whatever composition you opt for, focus on the central person of the group.

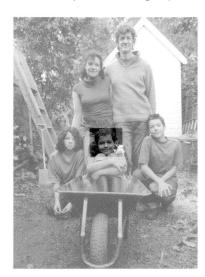

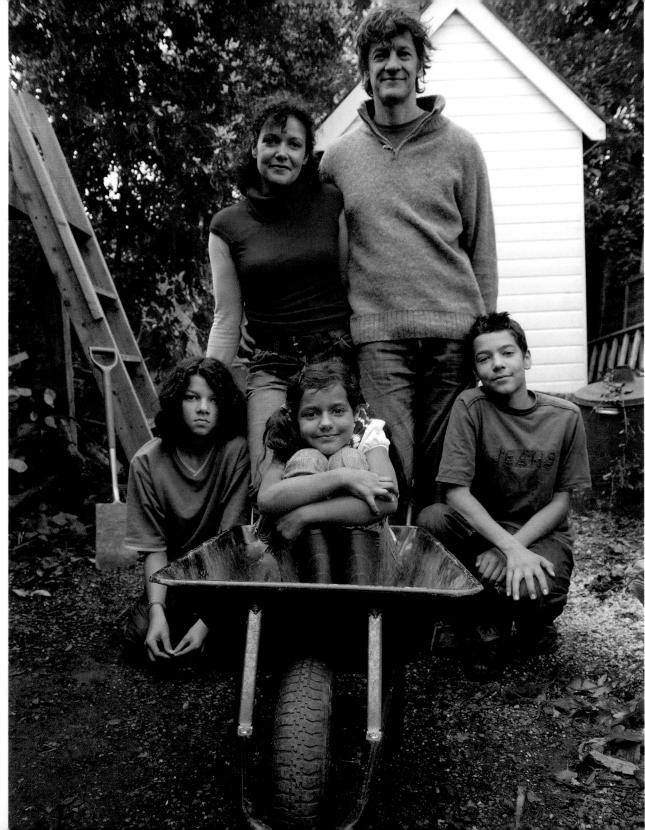

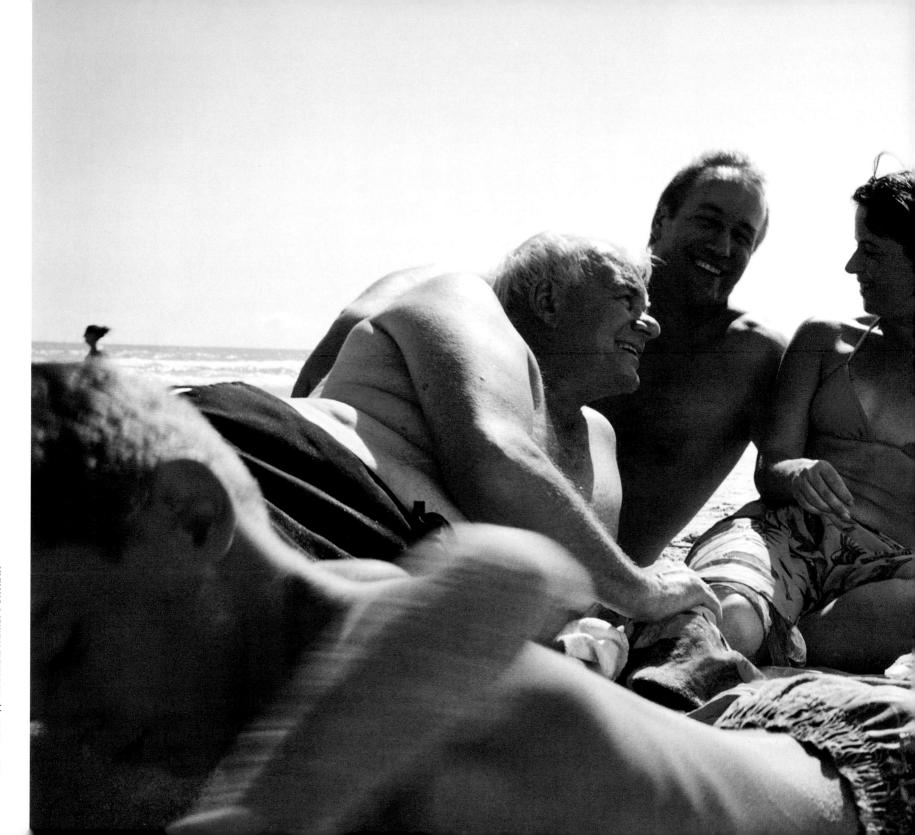

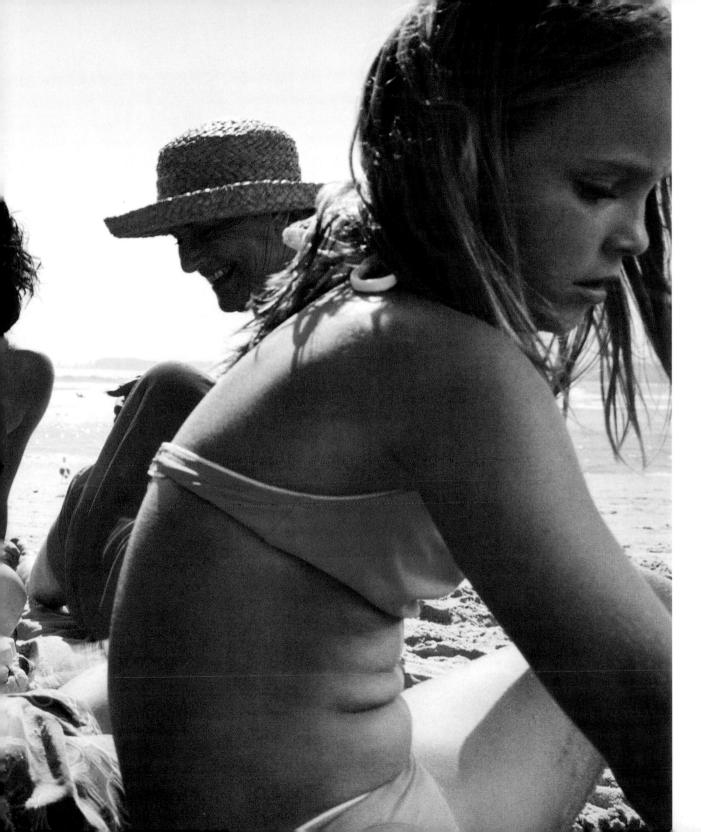

ON THE BEACH

All too often, family holiday pictures look stilted or forced because they have been posed. On the other hand, an unposed picture may be too chaotic to compose well. The secret is to look out for candid but interesting arrangements of people.

- Keep your zoom at a wide setting and your camera on stand-by.
- On brilliantly sunny days, use fill-in flash to help bring light into shadows.
- Don't be afraid to crop in and lose parts of some of the subjects. Not everyone has to be on the same plane.

Formal portraiture

The call for formal portraits is as strong now as it was in the early years of photography, yet few non-professionals ever try their hand in this area. This is a pity, because portraiture is a highly rewarding field. The best portraits are those that reveal something about the sitter. Start by asking family or close friends to sit for you: the rapport you already have will help them overcome any reluctance at being thrust into the limelight and help you capture aspects of their personality.

RELAX YOUR SUBJECT

Involve your subject in what you're doing from the outset. You can usually get them to relax and to trust you by taking a few informal shots and showing them how good they look. That will give them the confidence to go through a more formal shoot.

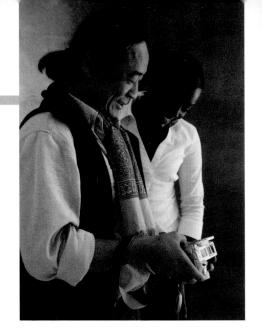

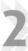

SCOUT LOCATIONS

Walk around with the sitter, identifying the best spot for the shoot: you'll need good light and an interesting background that is not too loud or busy. Try out a few different places to see what works best.

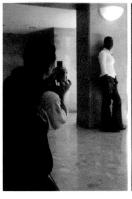

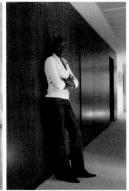

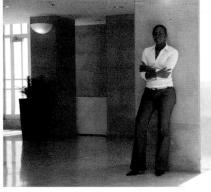

INSTRUCT YOUR SUBJECT

Encourage the subject to sit or stand straight while still looking natural. Once you begin taking pictures, keep giving instructions, but don't hold a conversation, since that can be too distracting. Think about the subject's position in the frame, and try different zoom settings from various distances

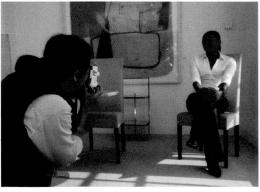

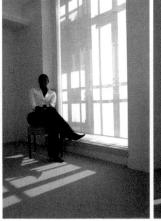

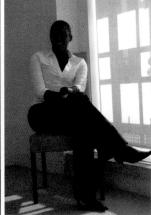

FOR THIS SHOT

I set the zoom to medium, with a low sensitivity and large file size for the best quality. I compensated exposure to ensure the bright areas remained bright.

CAMERA MODE

Set your dial to Portrait mode

LENS SETTING

Zoom to **Medium**

SENSOR/FILM SPEED

Use a **Low** ISO setting

FLASH

Force the flash Off

INTRODUCE SMALL CHANGES

If you're happy with your exposure settings, fire a sequence. Ask your sitter to make small adjustments to her pose and expression.

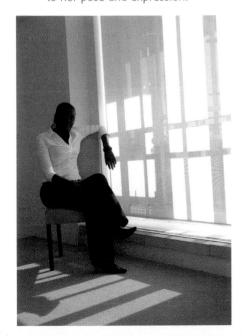

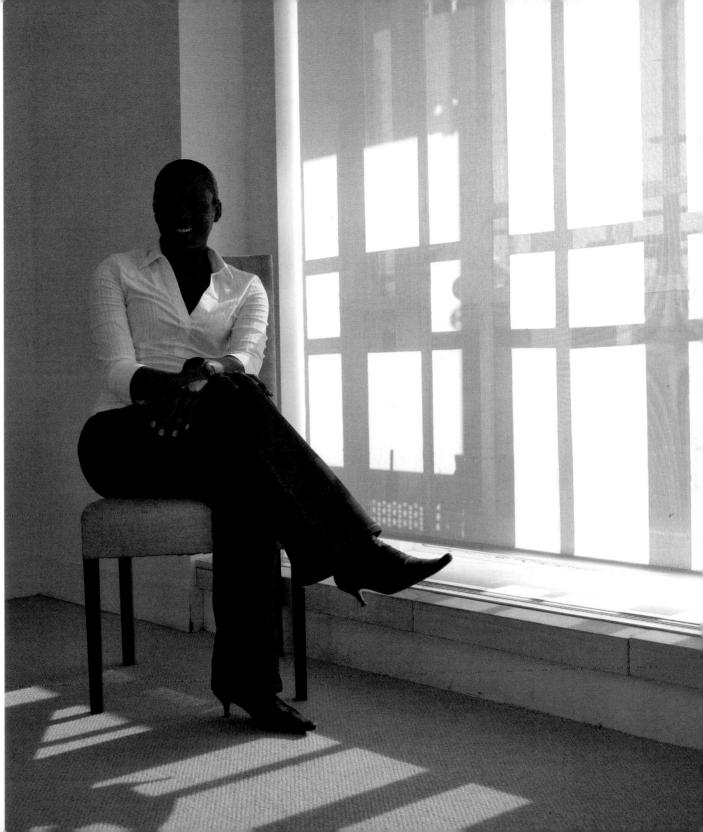

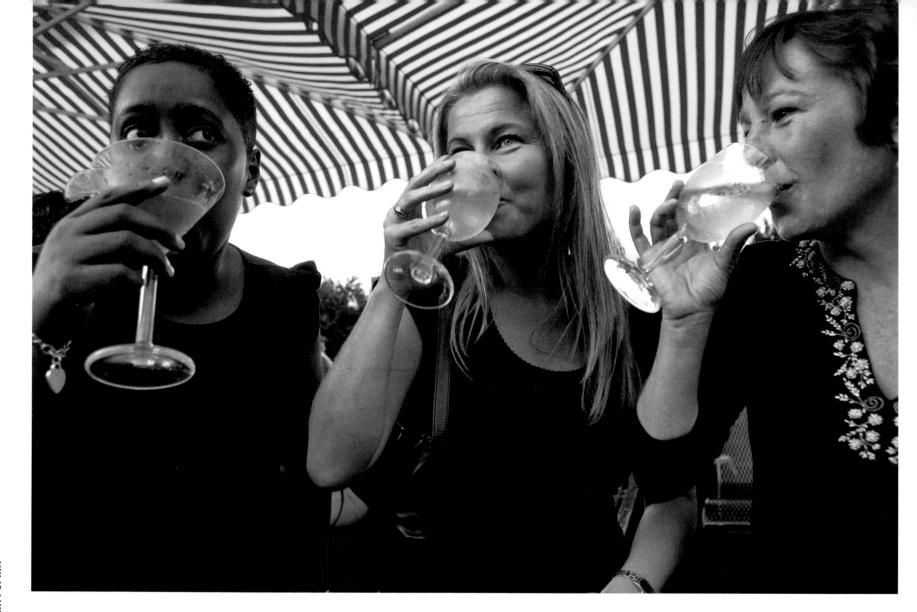

Capturing the party spirit

The jovial atmosphere of a party is a relatively easy subject to photograph: most participants are likely to be enjoying the company of a familiar social circle, relaxed, and ready with a smile. If you wish to elevate the party snap to something

with an element of surprise, humour, or style about it, you need to take yourself out of the party, if only for a short time, and become an objective observer. You will then be able to concentrate on catching unposed, revealing gestures.

FOR THIS SHOT

I selected the sports mode and a high ISO, then forced the flash off to preserve the scene's natural light. I used a wide zoom from a low viewpoint to catch the overhead parasol patterns, which contrasted with the dark clothing.

CAMERA MODE

LENS SETTING

Zoom to Wide Angle

SENSOR/FILM SPEED

Use a High ISO setting

FLASH

Force the flash Off

ALTERNATIVE VIEWPOINT

While at a party, keep your eyes open for potential photographic subjects other than just the people present. A big element of most parties is the number of drinks consumed: pictures made at the bar - such as abstract close-ups of glasses holding different-coloured drinks - are visually arresting, as well as providing a comment on the party.

FIND A VANTAGE POINT

In order to capture the crowds gathered together at a party, you need to take yourself above the scene. A general view with the zoom at wide angle and camera held above the head gets everyone in, and gives a sense of the occasion.

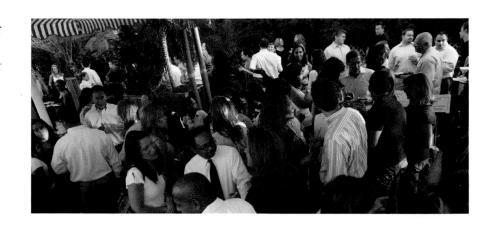

FOCUS ON A SMALLER GROUP

Find a small group of friends and engage with them. Show them the photographs you have taken so far and get them involved - they will be more willing to cooperate in future shots.

WORK WITH YOUR SUBJECTS

Once you have the group's cooperation, you can try different viewpoints, perspectives, and framing from mid-length wide to extreme close-ups. At the same time, they will be relaxing and getting into the fun of it all. That is when the photographs will start to work for you.

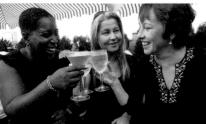

PEOPLE >> NUDE STUDY

Nude study

The human body in all its rich variety – different shapes, colours, and ages – is a wonderful subject for photography, and one that anyone can handle. The secret lies in working with people you trust and who trust you. You may be surprised at how easy it is to find a subject, especially if you reassure them that the shots will be tasteful and discreet. Don't feel constrained by techniques: the subject is inherently beautiful, and approaches to it are varied.

1

AVOID BUSY BACKGROUNDS

Start by using plain backgrounds, since these show off the body best. Once you have more experience, you can experiment with the complicated visual language of busy backgrounds.

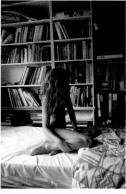

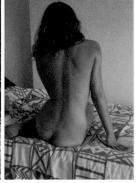

MONOCHROME COMPOSITION

When colour is removed from images of the body, the result is more abstract, almost objectified. Try setting your camera to black and white, or change the image to monochrome on a computer later. If you are shooting in colour and are dissatisfied with the way skin tones appear in your image, turning the picture into a black-and-white portrait might help.

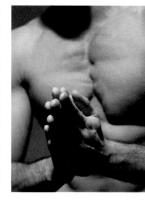

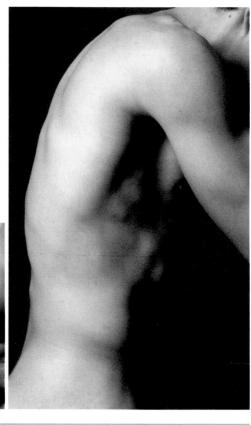

DIRECT YOUR SITTER

Ask your model to assume simple, natural poses. In nude studies, big gestures easily look unnaturally exaggerated.

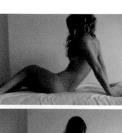

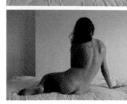

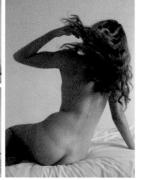

INTRODUCE PROPS

Props – hats, shawls, and other accessories – may help your model to relax by giving her something to handle.

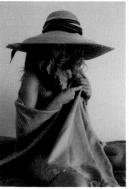

FOR THIS SHOT

I zoomed in with a long focal length setting from a medium distance, with no flash, for a tight composition and to lose the background. I set all the quality settings at maximum, including a low ISO.

CAMERA MODE

LENS SETTING

SENSOR/FILM SPEED

Use a **Low** ISO setting

FLASH

CONSIDER ZOOM AND CROPS

Ask your model to move smoothly and steadily, as if in a dance. Then try different zoom settings to show more or less of the body.

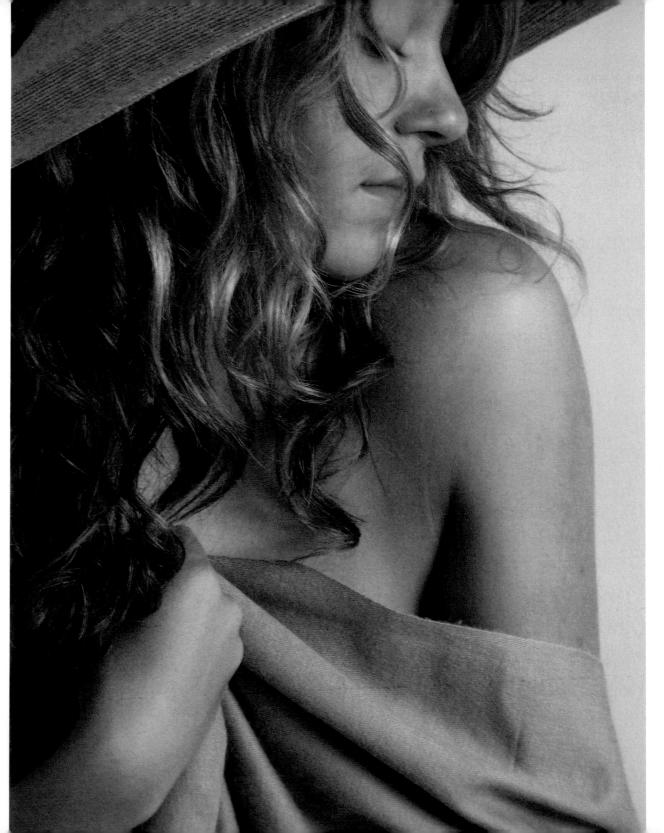

Character-driven portraits

Some people's faces are so full of character, they beg to be photographed. The key to informal portraits is to understand that sitters are likely to be nervous or self-conscious. This can result in awkward, tense poses, or in a tendency to play up to the camera. Get your sitter to relax. For a close-up portrait, instead of standing close to them, set a long focal length. An alternative approach is to use a wider focal length and step back a little to show the sitter within their environment.

GET THE LIGHT RIGHT

Start by placing your sitter in good light for example, next to a window that is not in direct sunlight. This light source is not too harsh and allows shadows to define features. Move closer to the sitter as they grow more relaxed.

Your sitter will be more relaxed if they have something to do with their hands, such as holding a drink or a tool of their trade, rather than trying to strike a pose. Keep chatting and taking photographs the whole time.

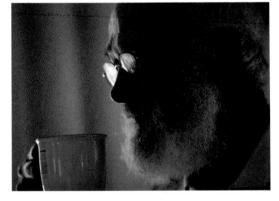

SHARE THE RESULTS

Show your sitter some of your shots so they can tell you what they like and can see what vou are trying to achieve. This can be helpful for both of you.

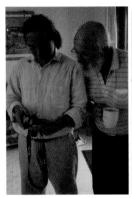

KEEP SHOOTING

Take lots of pictures to help the sitter grow more confident in front of the camera, and to catch the elusive expression that best encapsulates their character. Be aware that small adjustments of position will affect the lighting.

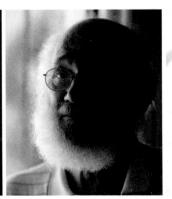

FOR THIS SHOT

I zoomed in from a distance of about 2 m (6 ft) to give a comfortable perspective to the subject. I used the highest quality setting and aperture priority to set the maximum aperture to ensure reduced depth of field.

CAMERA MODE

Set your dial to Portrait mode

LENS SETTING

Zoom to Medium Telephoto

SENSOR/FILM SPEED

Use a Medium to High ISO setting

FLASH

Force the flash Off

Make sure that the closest eye is sharply in focus. The rest of the image can be slightly unsharp and still be acceptable.

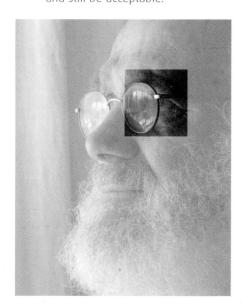

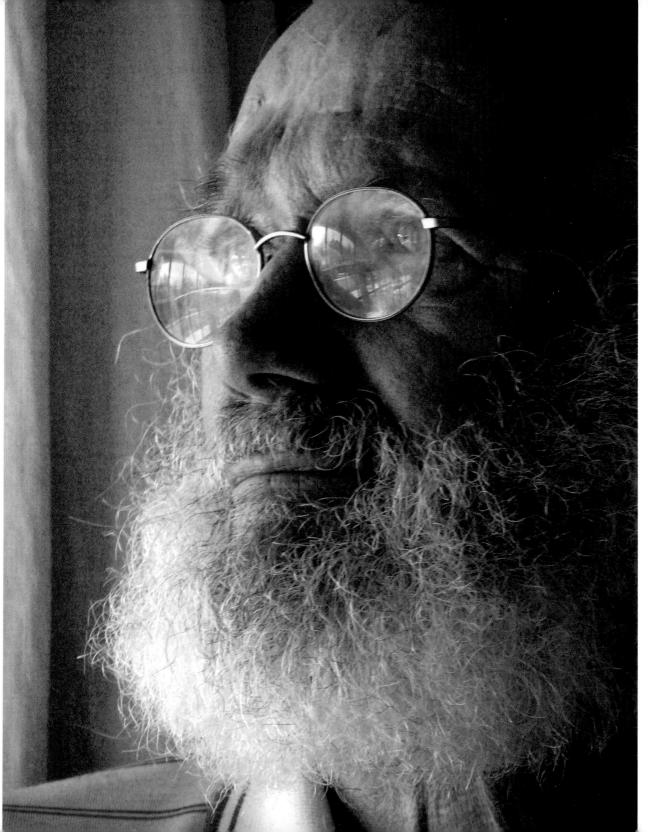

SUNNY RURAL SCENE

Brilliantly sunny days pose a challenge, because it is not easy for the camera to judge the right exposure. For this working scene in Rajasthan, India, I positioned myself with the sun to one side to catch both lit and shadowed parts of the subject.

- Watch and wait for a telling moment before you release the shutter.
- Zoom into the scene to reduce the amount of information in direct sunlight.
- Expose for the colours that matter the most – in this case, those of the woman's clothes.
- To bring out the colours, such as the vivid red of the scarf, position yourself so that the light shines directly on them.

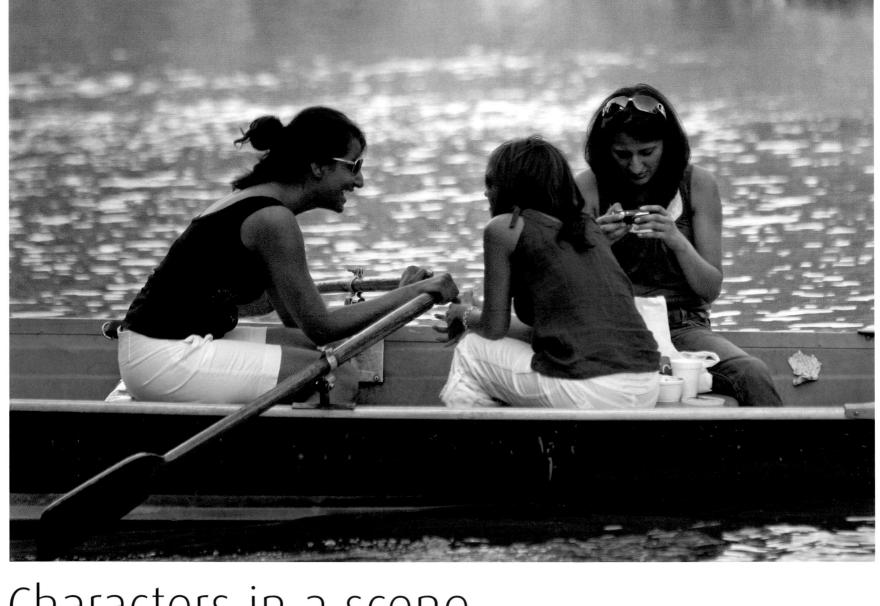

Characters in a scene

Parks are a rich arena for photography, especially those that include lakes or rivers. As well as the scenery, you can take pictures of local wildlife, and people. The boating lake, with its constantly changing array of faces, is a

rewarding place to capture informal shots of people enjoying themselves. A long-lens zoom setting ensures you can photograph people from the shore without making them feel self-conscious about being in your picture.

<<

FOR THIS SHOT

I had to zoom to maximum telephoto and set series exposure, or motor drive. Three frames were shot in just over a second in order to capture this light-hearted moment between friends.

CAMERA MODE

Set your dial to any exposure mode

LENS SETTING

Zoom to Maximum Telephoto

SENSOR/FILM SPEED

Use a Low to Medium ISO setting

FLASH

Force the flash Off

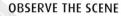

There will be a lot going on all around you, so take the time to absorb the scene and to notice the subjects that seem to have most promise. Here, there were lots of groups of people rowing on the lake, chatting, laughing, and having fun.

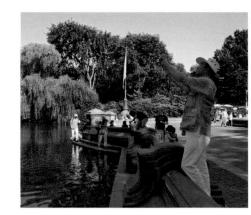

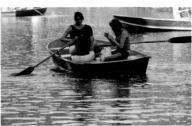

TAKE LOTS OF PICTURES

As you record life on the lake, you will find certain subjects attract your attention more than others. It may be their looks, their boating prowess, or the colours of their clothes. Take lots of shots of them, trying different formats and compositions.

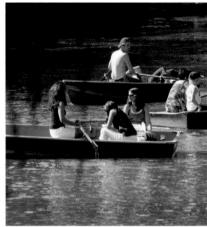

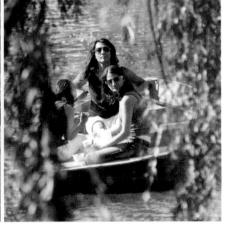

BLOCK BRIGHT LIGHT

If the sun is shining very brightly, position yourself in shade. Subjects taken in diffused light will give you better colours. If your camera has no viewfinder and only an LCD screen, shade it with a hand to improve the clarity of the image.

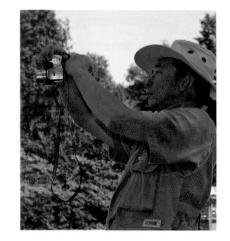

CATCH THE MOMENT

If your chosen subject is in a good position, do not hesitate to get your shot. Take pictures in quick succession as the scene composes itself to ensure you catch the moment.

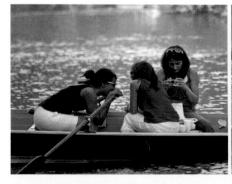

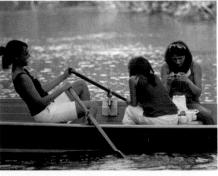

People

We point cameras at the faces of friends, family, and acquaintances more than at any other subject. A person's character is usually all that is needed to make a photograph striking or memorable. But the addition of another element – such as a balanced moment of emotion and composition, or simply a revelation of the sitter's personality – will lift your people photography to another level.

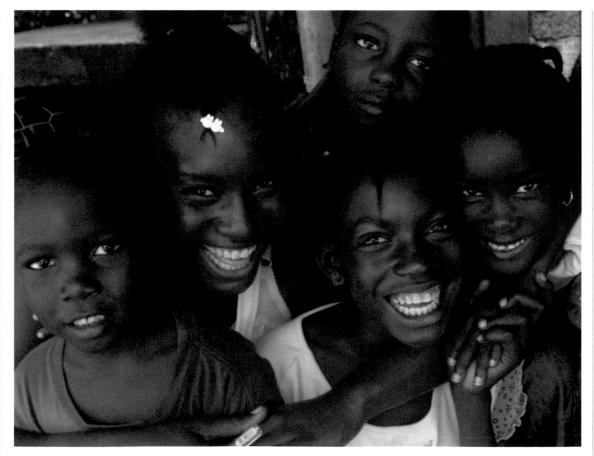

FAMILY GROUP

If you can turn a picture of the family into an enjoyable session full of love and laughter, the photograph will create itself for you.

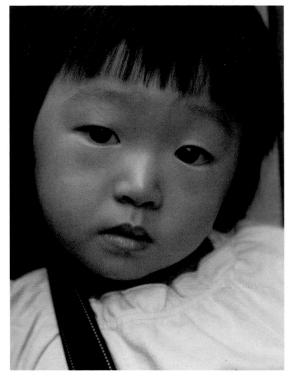

FACE TO FACE

Children are often shy around cameras, but also intrigued by what you are doing: just be sure to make and keep eye contact with them through the shoot.

ADDING CONTEXT

What could have been a simple shot of a couple dining looks like a documentary picture thanks to inclusion of the waitress and the restaurant environment.

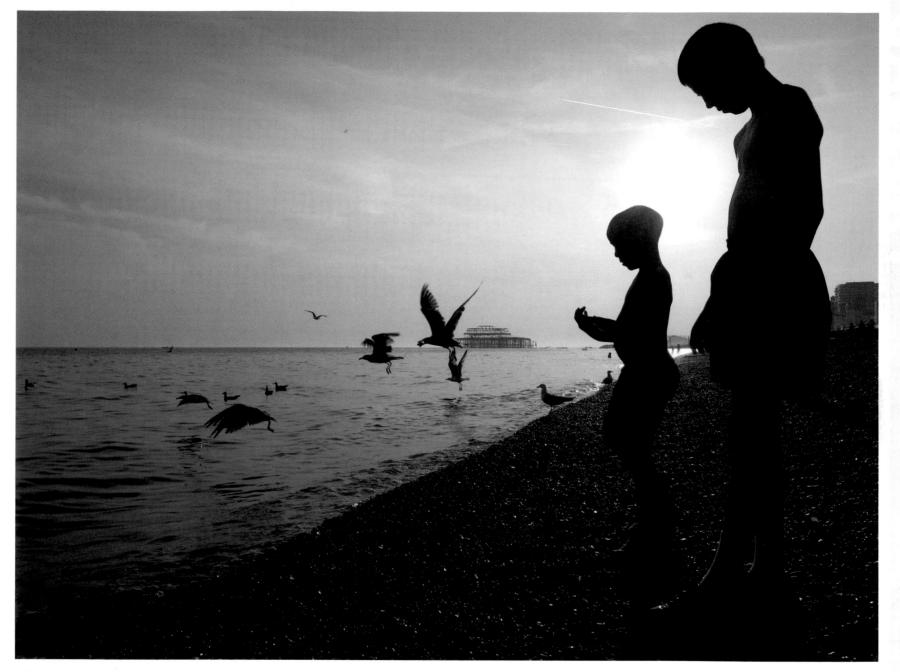

SEASIDE SILHOUETTES

You don't need to show the subject's face to create an effective portrait. Here, I exposed for the sky, rendering the boys as silhouettes.

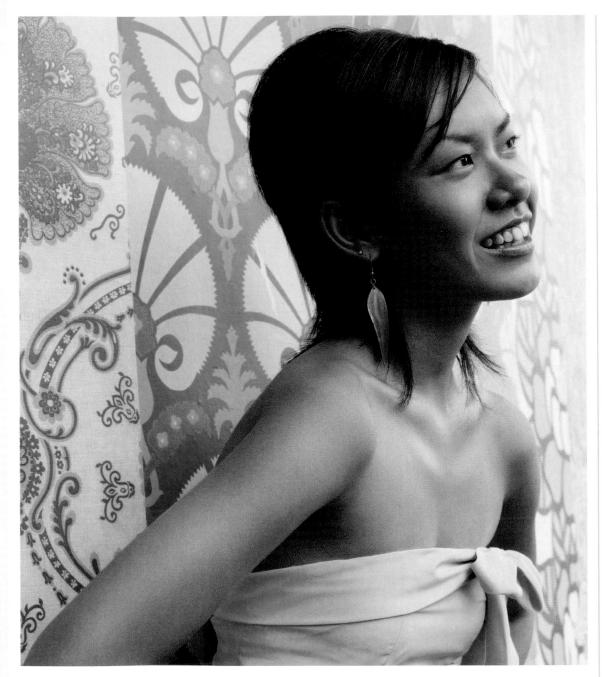

APPROPRIATE BACKGROUND

Normally you would avoid strongly patterned backgrounds for a portrait, but if the colours are right, your portrait may benefit from them.

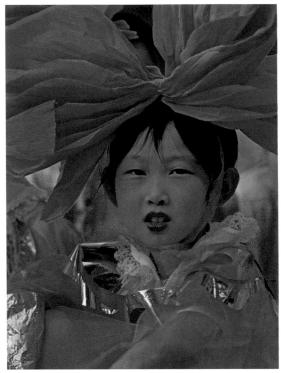

NATURAL FRAME

The mass of pink material forms an effective frame for this girl's face. A frame is important because the light is very soft, reducing the face's defining features.

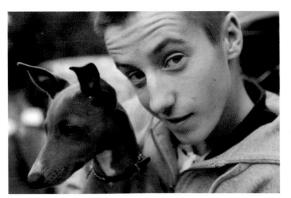

REVEALING CHARACTER

Try showing a person's character indirectly. This can be done through their possessions, the way they dress, or even their choice of pet.

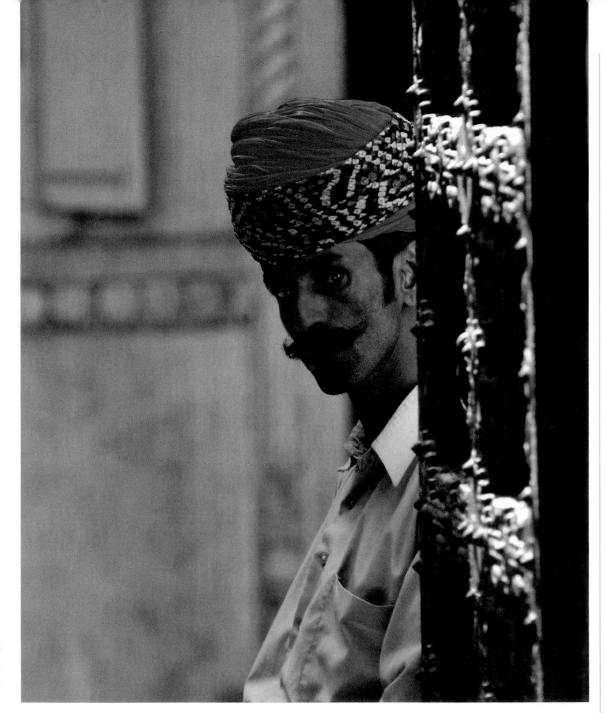

If people don't know you well, they may be more comfortable if you take their portrait from a distance, using a telephoto setting.

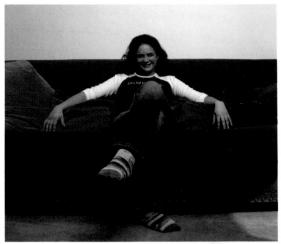

INFORMAL POSE

You can turn a striking formal portrait with strong symmetry and composition into an informal shot with the addition of a broad smile and a relaxed pose.

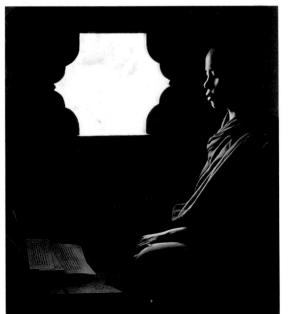

DRAMATIC LIGHT

Don't be afraid to experiment with lighting. Here, the very strong light from the window shapes the face beautifully. Expose to allow shadows to be very dark.

and nature

12345678

Landscapes and nature can be combined with the latest photographic technology in a wonderfully symbiotic way. Through your images, you can celebrate the many faces of the planet, its plant life, light, and seasonal changes. At the same time, your images may help strike a blow against the forces that threaten the environment. Your enjoyment of the natural world – and your photography of it - calls for a partnership of technique and vision. You will learn how to find the best viewpoints and compositions, blend shadow with light, synchronize the release of the shutter with the peak of the action when photographing natural phenomena, and work in both dim conditions and bright sunlight.

Flowers in close-up

For such reliably beautiful subjects for photography, flowers are incredibly difficult to shoot well. Although they may stay in one place for you, and they are full of colour and delightful shapes, there is one major drawback. To make the most of them, you have to move in close, and that is where your problems start. Inaccuracies in focusing are increased, any movement during exposure is magnified, and depth of field is very limited.

USE A TRIPOD

The best aid to flower photography is a tripod. This keeps the camera still enough to enable as long exposures as possible for maximum depth of field. Make sure you choose days without a breath of wind, though, since the flowers must be still, too.

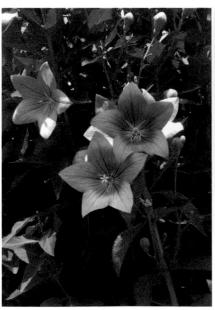

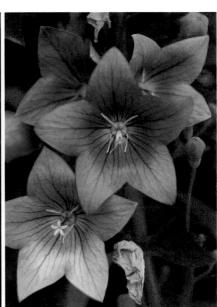

CHOOSE YOUR COMPOSITION

Look for blossoms that have a good shape and are grouped together. This will help you build a strong composition. You can then either shoot the entire group, together with the leaves, or opt for a bee's-eye view of the plant from really close up.

of hard light by using fill-in flash. Alternatively, hold up a sheet of paper to soften the light falling on the plants or to reflect light from below.

FOR THIS SHOT

I selected the macro, or close-up, mode and angled a sheet of paper to reflect light into the flower.
I used the flower mode or aperture-priority exposure with minimum aperture to obtain the greatest possible depth of field.

CAMERA MODE

Set your dial to Aperture Priority

LENS SETTING

Zoom to Macro mode

SENSOR/FILM SPEED

Use a **Low** to **Medium** ISO setting

FLASH

Force the flash to Automatic

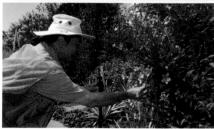

ITIDY UP

If you are obsessive about such things, remove any dead blossoms or twigs that get in the way.

However, you may prefer the natural look to the aseptic.

Flowers and foliage

The enchanting beauty of plant forms, particularly flowers, has been the object of admiration and artistic effort since the dawn of art itself. Photography enables anyone to record the graphic diversity of plant life with an ease unmatched by other art forms. Take your photography one step further by showing the plants so they are identifiable, while at the same time creating a picture that can stand by itself as a strong image.

ENHANCING COLOURS

At first glance, these flowers seem like an easy subject. However, it soon becomes apparent that the masses of blooms put too much information into the picture. The solution is to isolate a choice bunch against a clean background that enhances their colour.

- Take the exposure from the flowers, and keep the background dark.
- Use a long focal length setting to help isolate the blossoms and blur the background.
- Only use flash if it is really dark, otherwise it might spoil the natural lighting.

ADDING INTEREST

Waterlillies are spectacular in themselves, but the simple addition of an insect can bring the picture to life.

- Use flash in full sunlight to help freeze rapid motion and control shadows.
- Set a long zoom and get as close as you are able to focus for the largest magnification.
- Focus on a flower and wait for an insect to land on it.

FOCUS ON RAINDROPS

Water droplets hanging from leaves and flowers add a special sparkle and an extra visual layer to pictures of plant forms.

- For the most appealing image, position yourself so that the drops catch the light.
- Set the zoom to a long focal length and maximum aperture to blur the background.
- Compose very carefully: minuscule changes in position can make or break the image.

BACKLIT LEAF

Very large leaves, such as those of the taro plant, are often best photographed lit from behind to show their structure.

- Use a wide-angle setting on the zoom and get as close to the leaf as possible.
- For a striking shot, focus on a symmetrically arranged detail, rather than a mass of leaves.

MONOCHROME ABSTRACT

Strong symmetrical plants are ideal candidates for an abstract shot in black and white. To create the most impact, keep the composition simple.

- 1 Try different lighting: in this instance, direct flash helped to create strong contrasts and clean lines.
- Hold the camera square on to the plant to make this pattern as abstract and evenly sharp as possible.
- 3 Set to black-and-white mode if available. If not, capture the image in colour, and change it on a computer later.

ISOLATED BLOOM

To make the most of brightly coloured flowers, look for dark backgrounds that will help isolate both shape and colour.

- 1 Use a long focal length setting to reduce depth of field to further isolate the flower.
- 2 Expose for the brightest parts to leave the shadowed areas dark in contrast.

BUSY COMPOSITION

Pictures of plants do not have to show everything clear and sharp. The natural world offers a lively jumble of forms, textures, and shapes, so try to capture that random feeling.

- Push the camera right into the mass of leaves and flowers using the close-up setting.
- Turn the flash off, since it will produce unsuitably hard lighting.

EXTREME CLOSE-UP

The closer you get to plants, they more they reveal to you. However, depth of field drops greatly, so it is hard to get everything looking sharp. Use the highest sensitivity setting available.

Try to line up the main features so they are square to the camera, to make the most of depth of field.

LIFT THE SHADOWS

Use a mirror or a white sheet of paper on the shadow side of the plant (but not in the shadow) to bounce fill-in light. The picture on the far left was taken looking into the mirror, since the flowers were pointing down.

To help bring out the colours in the darker areas of the flower, create extra light with mirrors or paper.

If you wish to reflect hard light, use mirrors; white paper or cloth reflects soft light into the shadows.

PETALS AND REFLECTIONS

Some petals and twigs floating in water might not seem obviously attractive at first glance. The key to an image such as this is to position yourself so that the sun is reflected in the water: this brings a vital brilliance into the ripples.

- Measure the exposure from the important tones in this case, those of the petals.
- Hold the camera as square to the water as possible to keep everything sharp.
- Don't remove twigs or dead leaves, even if they seem to be in the way. They add to the chanced-upon look of the shot.

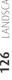

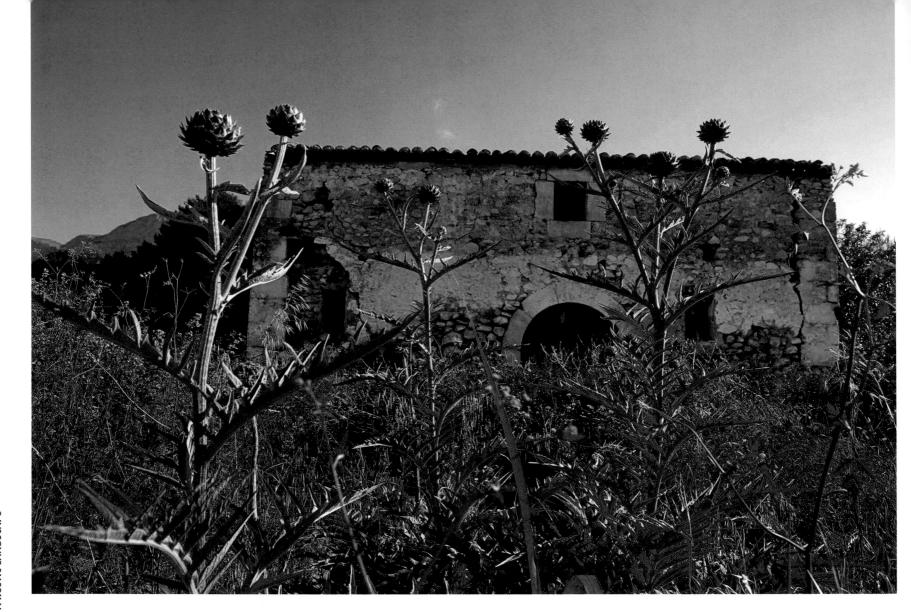

A rustic landscape

As well as a variety of wonderful natural landscapes, sometimes rural locations also yield buildings that perfectly complement their environment. Tumbledown buildings offer several views, depending on how you shoot them, the time

of day, and the quality of the light. This farmhouse could look dismal in the rain, and ominous in moonlight. However, in spite of the poor state of repair and the overgrown garden, in bright sunshine it seems full of charm.

A moderately wide-angle lens set to minimum aperture or landscape mode offered me maximum depth of field. Combined with a low viewpoint, it allowed me to show this ruin in its true context. I then lightened some shadows with flash.

CAMERA MODE

Set your dial to Landscape mode

LENS SETTING

Zoom to Wide Angle

SENSOR/FILM SPEED

Use a Low ISO setting

Force the flash On or Off as needed

SAFETY FIRST

Always make sure that you are not trespassing when exploring a ruined building. Also, if there is any danger of falling debris, protect your head with a hard hat. Seek advice from a builder or architect if you can; if in doubt, keep out.

EXPLORE VIEWPOINTS

Photograph the building's different aspects while walking around it, adjusting camera settings as needed. If one side is shaded, you may need to return at another time of day, when the sun has moved around.

WORK WITH THE LIGHT

If the light is flat, textures will not show up, and you will lose the sense of space, as in the shot on the right. The combination of light and shade in the picture on the far right provides a better sense of shape, scale, and character.

USE THE FOREGROUND

Emphasize some foreground elements by choosing a low viewpoint. Use a wideangle setting and small aperture to maximize depth of field and keep everything sharp.

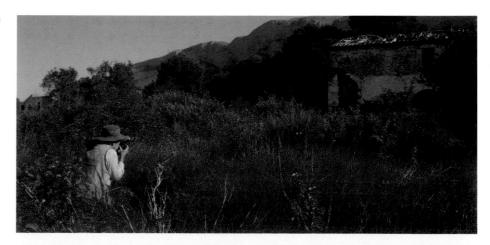

Panoramic views

When faced with a stunning vista, it is natural that you should want to capture as much of it as possible. Digital photography has made it easy to create superb panoramic images. First, take a few shots side by side, panning the camera to take in the whole scene; then "stitch" the images together on a computer. Your panorama can be as modest as two views side by side, or as wide as a 360-degree shot. The wider the view, the more dramatic the visual effect.

FIND A SUITABLE SCENE Any scene so wide that you must turn your head to take it all in is a good candidate for a panorama. It helps if the lighting is even and not changing quickly, and it is also easier to join the pictures if there are no straight lines running across the image.

ADJUST CAMERA SETTINGS

Set the exposure mode to manual and adjust it for the correct exposure. Set your zoom to 35mm or equivalent; this is the widest setting on the majority of point-andshoot cameras.

USE A TRIPOD

Although not absolutely necessary, you will obtain sharper images and cleaner panoramas if you use a tripod. The tripod also helps ensure the camera is held level throughout the process.

ORIENT THE CAMERA

For best results and to reduce distortion, set your camera vertically on the tripod. This will mean taking more pictures to create a panorama, but it will be worth the effort. If it is possible on your model, the camera should rotate above the centre of the tripod.

I set a wide zoom, small image size, and low ISO to achieve good quality. I also used manual metering so that the exposure levels would not change from one shot to the next.

CAMERA MODE

Set your dial to Manual

LENS SETTING

Zoom to Wide Angle

SENSOR/FILM SPEED

Use a **Low** ISO setting

Force the flash Off

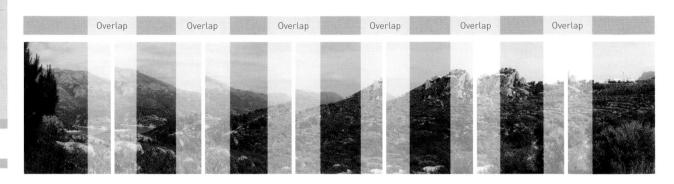

STITCH THE PHOTOGRAPHS

Plan for at least a 30 per cent overlap between shots. The panoramic mode on some cameras will help you to do this. Once you have the images on your computer, you can join them "by hand" or use panoramic software. The overlap enables you or the software to line up one image after another - the greater the overlap, the better the quality of the blend. Be aware, though, that even with small images, the resulting file can be large.

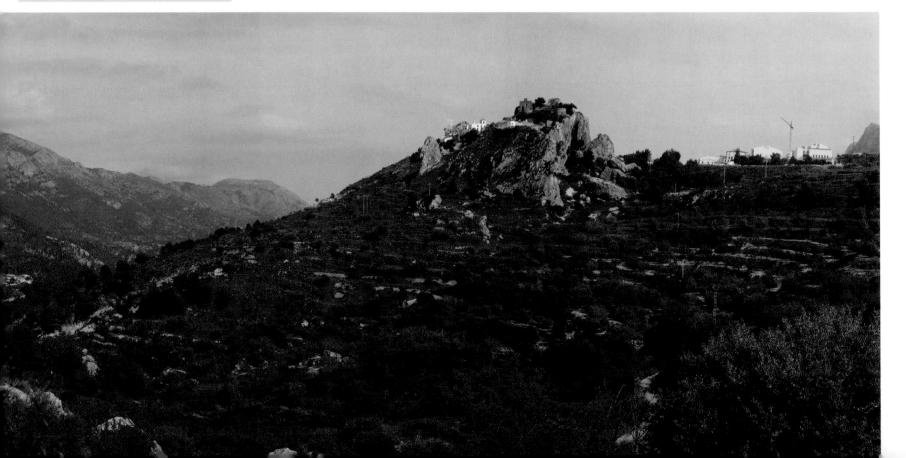

Landscapes in black and white

Photographing landscapes in black and white separates our experience of the scene from our statement about it. It gives us added mastery over the subject. Not only do we select a certain view, we can also choose how it looks. Black-andwhite images draw attention to the forms and abstract qualities of the scene, bringing picture composition, rather than subject, to the fore. Different light available at different times of day will also affect the end result.

You can take black-andwhite images further by giving them old-fashioned tones such as sepia or gold tone. The intensity of the toning colours can be as weak or as strong as you like. Some cameras offer a sepia mode or similar; otherwise you can easily create the effect using software.

Sepia tone

EXPLORE POSSIBILITIES

Almost any black-and-white landscape picture will be as effective as its colour version. However, some scenes contain elements that work especially well. The textures of an old city wall or terraced hills, for example, may offer promise that other views do not.

LOOK FOR LIGHT AND LINES

Identify strong lines that take the eve through the view, and find the angle in which the lighting helps bring out any shapes and textures. Use your LCD screen to help with composition.

EXAMINE THE SCENE

Make a few small shifts in your position - move side to side or get higher or go lower - to find the best view. Take your time exploring and looking closely at your subject: that is all part of the enjoyment of photography.

With the zoom set to its widest and the aperture to minimum, I focused on the middle distance - not to the background – for maximum depth of field. Finally I set the camera to black-and-white mode.

CAMERA MODE

Set your dial to **Aperture Priority**

LENS SETTING

Zoom to Wide Angle

SENSOR/FILM SPEED

Use a Low to Medium ISO setting

FLASH

Force the flash Off

CONVEY A SENSE OF SPACE

The final image combines a variety of scale and texture, as well as a sense of tone and space. Converting the image to black and white emphasizes all these elements.

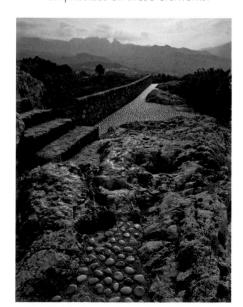

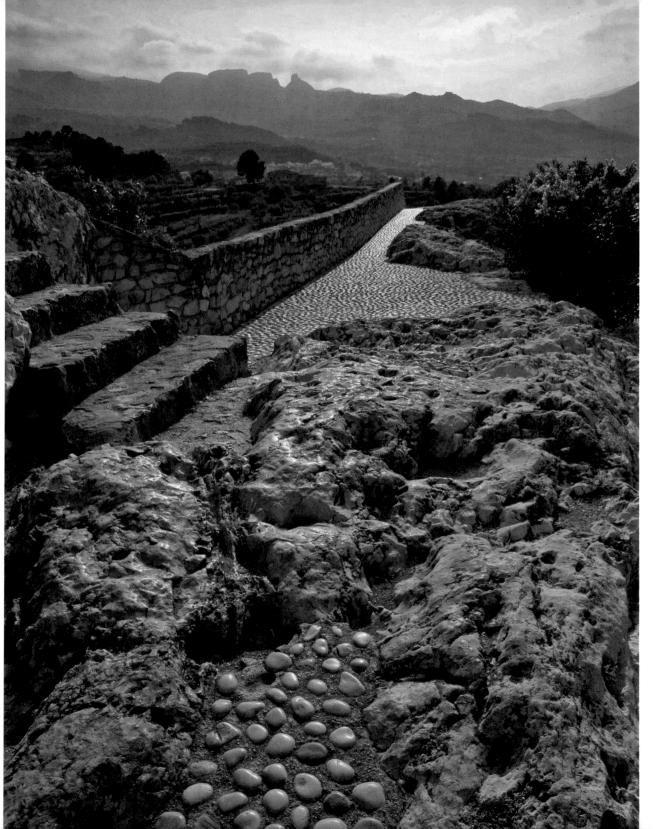

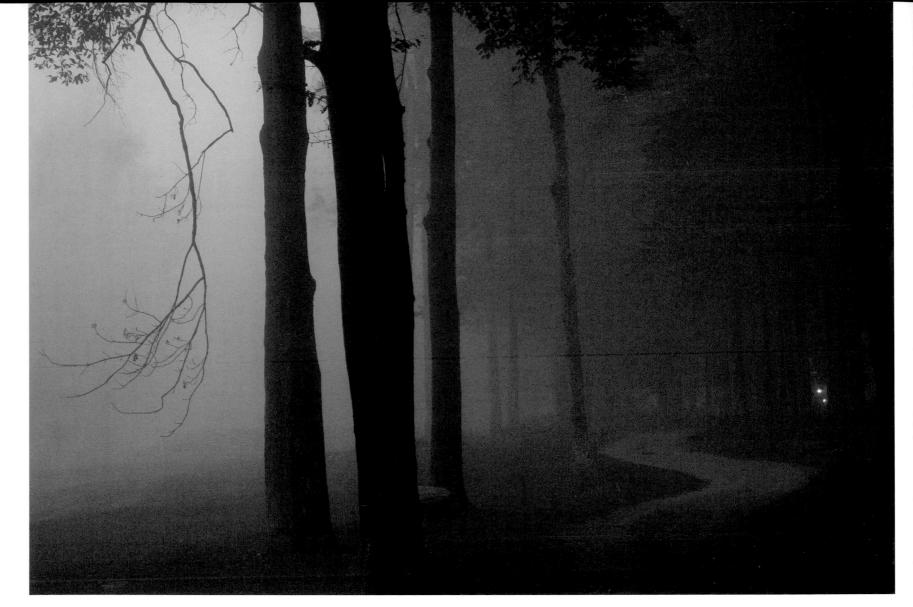

Misty woodlands

Although it might be more tempting to stay indoors on a foggy day than to brave the inclement weather in search of pictures, you will find that your efforts will be rewarded with beautifully atmospheric results. Fog and mist accentuate

aerial perspective, so that small distances between nearby objects are pictorially exaggerated. This gives you pictures that are instantly different from the norm. The trick is to find subjects and compositions that exploit that illusion.

I chose the landscape mode and set the zoom to normal and a medium sensitivity. The key in this shot was in waiting for the passing car. I pressed the shutter just at the moment the lights appeared between the trees.

CAMERA MODE

Set your dial to Landscape mode

Zoom to Normal

SENSOR/FILM SPEED

Use a $\boldsymbol{\mathsf{Low}}$ to $\boldsymbol{\mathsf{Medium}}$ ISO setting

FLASH

Force the flash Off

SCOUT THE LOCATION

The gently meandering path next to a golf course is crucial to this composition. It takes the eye through the picture, creating a sense of mystery. In the fog, however, the path disappears before going too far into the trees.

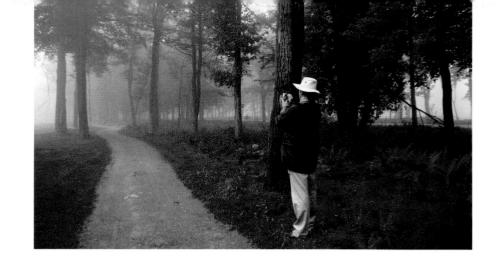

TRY DIFFERENT EFFECTS

Another salutary feature of fog is that it drains colour away from everything, presenting you with a ready-made pastel palette. The lack of vibrant colours in the landscape means you can experiment with delightful subtleties of tone and contrast.

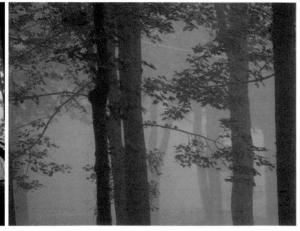

USE BRACKETING

Achieving the correct exposure in foggy conditions is critical – you have only a narrow range of brightness to work with, so an error can affect the entire image. Bracketing the shots – that is, taking a series of correct, over-, and underexposed shots – will ensure you have plenty of images to choose from.

ADD HUMAN INTEREST

You might decide to include some subtle hints of human presence or civilization in your picture. As well as giving a sense of scale to the image, this golf buggy, with its indistinct outline, highlights the denseness of the foq.

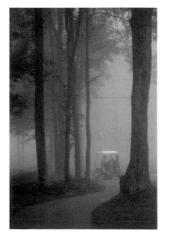

SEASONAL CHANGES

The effects of the changing seasons on a favourite view, even just from a window, make an attractive and fascinating series of images. You can frame each shot the same way, or vary the composition as needed.

- If possible, mark the position of the tripod so you can set it up in the same place each time.
- Alternatively, print out a sample composition so you can repeat the framing each time.
- On each occasion, make several exposures to ensure you create an image you are happy with.

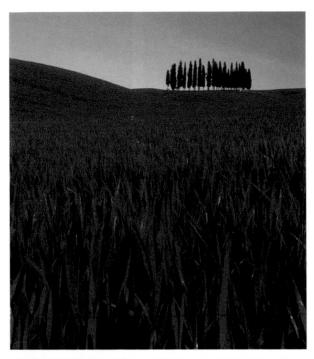

LIGHTNING STRIKES

It is easier to take studies of lightning in areas where thunderstorms are seasonally predictable. Just listen to weather forecasts, and arrive at vantage points in good time. If you chance upon an electrical storm, you will have to react quickly to get the shot.

- Shoot from a safe, sheltered environment, such as inside a building.
- Use a tripod, and click the shutter as soon as you see any lightning flash.
- Set a long shutter time (several seconds) to catch multiple flashes.

AUTUMN COLOURS

The warm brilliance of autumnal colours in temperate climates is a delightful subject for photographers.

- Take broad views of the colours to place them in context.
- **2** Frame contrasts between stark tree forms and the vibrant colours.
- 3 Try holding the camera level over fallen leaves to create a mosaic effect.
- Experiment with different exposure settings to adjust colour rendering.

STORMY WEATHER

The light conditions that accompany stormy weather – not only during the storm itself, but also before and after – are often wonderfully atmospheric and photogenic.

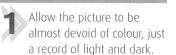

Make exposures as the conditions change to capture a whole sequence.

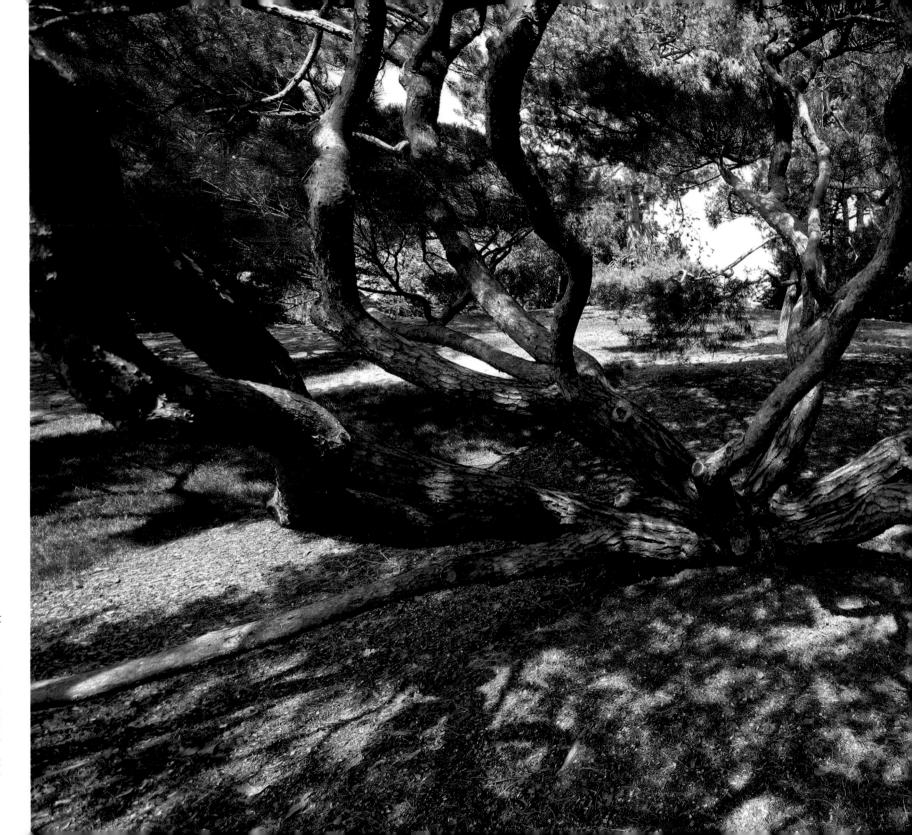

SUNSHINE AND SHADOWS

The spreading branches of this conifer demand to be photographed with a wideangle lens. If your camera can't take all of the subject in one shot, try a panorama of two or three pictures taken side by side, and stitch them together on a computer later.

- If possible, use a lens with an extreme wide angle to highlight the breadth of the tree.
- 2 Use the highest-quality settings available in order to capture as much detail as possible.
- 3 Set the camera to landscape mode or minimum aperture for the greatest depth of field.
- Include a person in the background if you wish to impart a sense of scale.

Colours of the seashore

You don't need to be holidaying on a paradise island to create a stunning beach shot. This pebbly beach, though pleasant enough, was not immediately inspiring, but with careful framing and some patience, it offered many rewarding opportunities. The key is to keep a careful eye on the light and water. The conditions that bring together a colour in the sea with good light, wave conditions, and sky may come and go within minutes, or even seconds.

DISTRACTIONS

In clement weather, it is likely that boats or swimmers may be in the water, and they could prove to be a distraction. Simply disregard them and take your pictures anyway. You can use the cloning feature in your image-manipulation software to remove the offending element at a later stage.

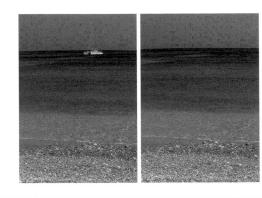

TRY DIFFERENT VIEWS

Explore different ways of looking at the beach. Views from near the ground offer close-ups of textures and collapse the foreground, while higher views allow you choice of emphasis: foreground or background. Watch the waves, and discover how different types react with light.

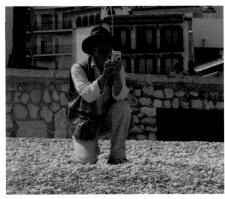

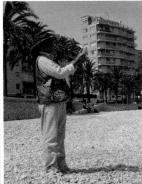

SET THE SCENE

If you wish the scene to look pristine, remove any detritus that might blight the shot – such as discarded bottles or other litter. A different story can be told by leaving them in place, so it may be interesting to try shots both with and without.

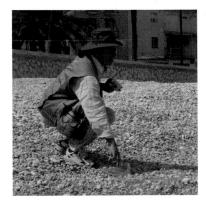

Any view that focuses on one element to the exclusion of all others offers little contrast. But once contrast is introduced, there must be enough of it to give a good indication of scale and context. This shot is nearly there, but the addition of the white foam lifts the entire image.

I waited until there was an ideal combination of light in the water and gentle waves. The trawler being chased by seagulls gives a sense of distance without disturbing the abstraction of colours.

CAMERA MODE

Set your dial to Program Mode

LENS SETTING

Zoom to Long Focal Length

SENSOR/FILM SPEED

Use a **Low** ISO setting

FLASH

Force the flash Off

CHECK THE IMAGES In very bright conditions, it will be difficult to see your LCD screen. Make use of any available shade to review your images.

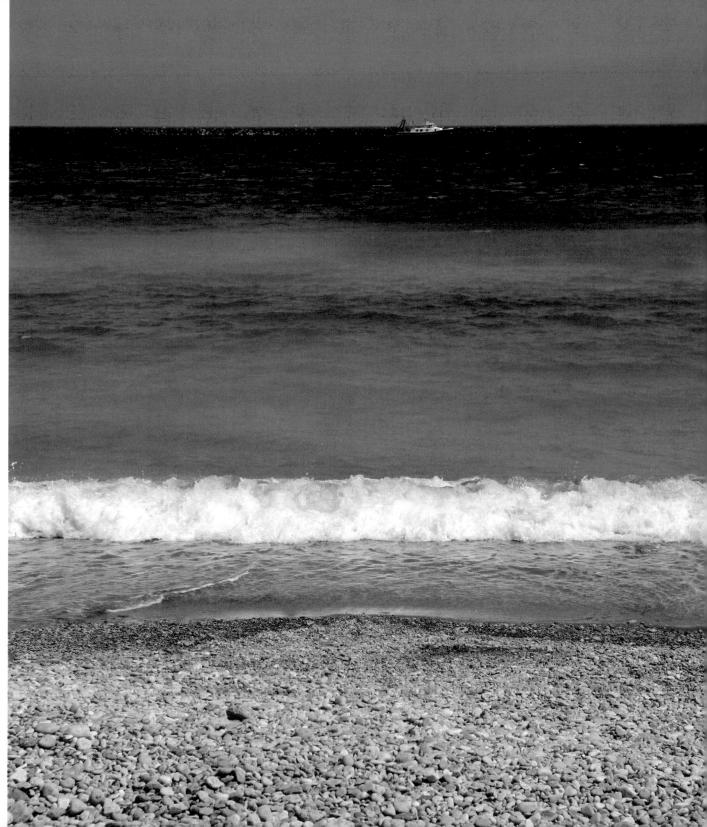

Crashing waves

We have all seen the dramatic effects of a rough sea crashing onto rocks. But often, by the time we get the camera out, all is calm again. However, waves come in cycles, and if you wait a while you will be able to anticipate the next big swell. In that time you can choose your position, set up the camera, and prepare for the moment. Even then, it will take a few attempts to catch the waves at the peak of their action.

SET THE CAMERA If possible, set all camera functions to manual. The shutter time should be short, so select shutter priority or sports mode with a high sensitivity. On an overcast day or in low light, use the flash to help freeze the

PROTECT YOURSELF Position yourself out of danger. On some coastlines, exceptionally large waves can suddenly rise up and soak you, so stay at a safe distance. Use a long zoom setting to capture the action without being too close to it.

USE A SUPPORT If you want to wait comfortably with the camera aimed at the right spot, use a tripod. Once it is set up, all you have to do is relax and watch the sea, then just steady the tripod while you

> release the shutter. You could even use a remote control for added stability.

movement of the spray.

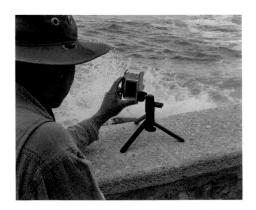

KEEP SHOOTING Take as many pictures as you can, and try slightly different framings, zoom settings, and orientations. One of them is sure to give you the perfect picture.

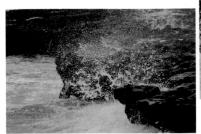

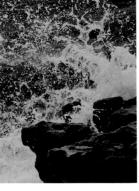

>>

FOR THIS SHOT

I used a normal focal length for this scene, to take in some of the surroundings but keep the falls as the main subject. With a shutter time of ½60 sec, I was able to catch some water droplets without making the flow too static.

CAMERA MODE

Set your dial to Landscape mode

LENS SETTING

Zoom to Normal

SENSOR/FILM SPEED

Use a **Medium** to **High** ISO setting

FLASH

Force the flash **Off**

VARY THE COMPOSITION

To help you gain experience and confidence in your composition, try different framings and zoom settings in your shots.

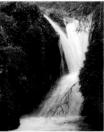

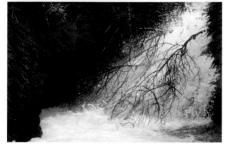

FOR THIS SHOT

I pulled back the zoom to take in a wider view – fortunately, since the spray of water reached quite high. By setting a very short shutter time, I was able to catch the water droplets sharp and frozen in mid-air.

CAMERA MODE

Set your dial to Sports mode

LENS SETTING

Zoom to **Medium** to **Wide Angle**

SENSOR/FILM SPEED

Use a **High** ISO setting

LASH

Force the flash Off

GET THE TIMING RIGHT

Make sure you release the shutter just before the peak of action, so you don't miss the splash and spray of water droplets.

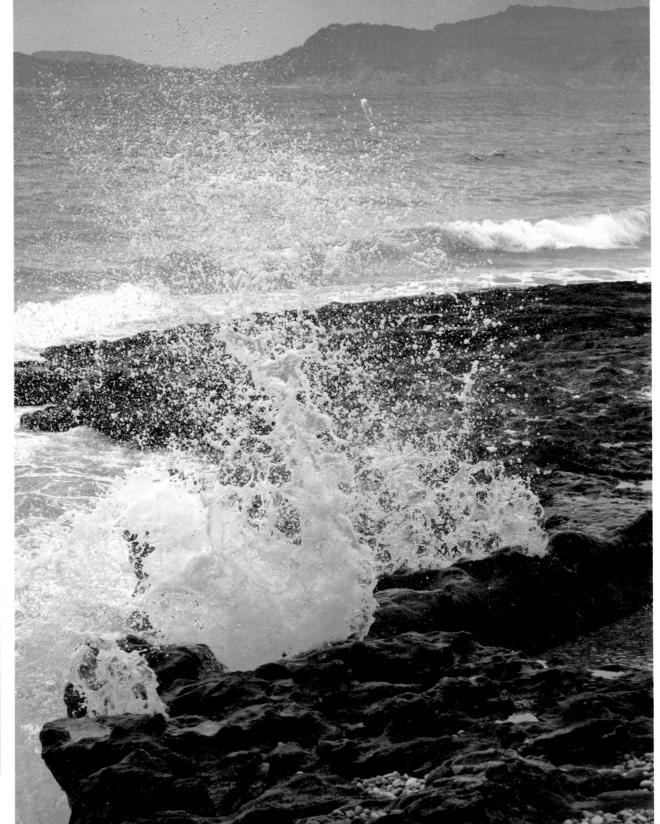

Fast-flow

Despite their universal beadifficult to photograph we with them. The reason for tricky, since it combines downich even include dazzlir access to the best vantage downright dangerous. The understand the environment to realize that less of the s

EXPLORE THE AREA
The harder you work, the more secrets a landscape will reveal to you. Explore slowly, carefully, and safely.
A position that is not promising at first may be perfect once the sun has moved a little.

CHOOSE YOUR FORMAT
Dramatic scenery can work weither portrait or landscape fo Each has its own advantages, sure to try both.

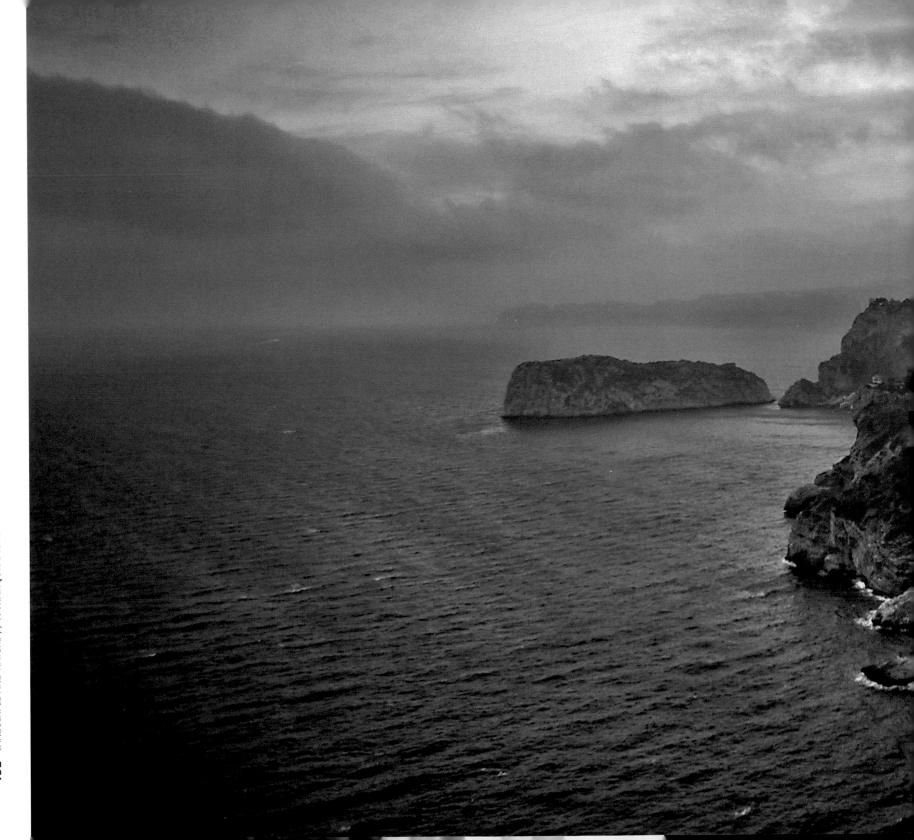

«

FOR THIS SHOT

Using a very moderate telephoto setting, I positioned myself carefully, lining up the mooring posts with the landmarks in the distance. A medium ISO setting allowed for minimum aperture, giving maximum depth of field.

CAMERA MODE

Set your dial to Landscape mode

LENS SETTING

Zoom to **Medium Telephoto**

SENSOR/FILM SPEED

Use a **Medium** ISO setting

FLASH

Force the flash Off

Many point-and-shoot cameras are inadequately protected against strong light coming from in front of the camera. This problem is made worse when you're dealing with sun flare from water. Use your hand to cast a shadow over the lens; this will provide it with some shade. In the film world, this is called a "French flag".

SUNSET ON ROCKS

A photograph can conceal a great deal: this tranquil-looking sunset belies the near-gale-force winds blowing at the time of the shoot. Don't be put off by the weather, unless it could endanger you. Find shelter, lean against something for support, and get the picture.

- Trust your camera. In poor light conditions, it can see more colours than you.
- Use a high ISO setting in dim light, but be aware that the image quality might be affected.
- If necessary, you can intensify and increase the contrast of colours using image software at a later stage.

The colours of sunset

Everyone loves to watch a glorious sunset, but photographs of this spectacle are often underwhelming. Technically, sunsets are challenging subjects, their great range from light to dark making it easy to lose details in the foreground. However, there are a few tricks that will help you to produce stunning sunset photographs. Start by filling the image with interesting elements in the sky and on the ground. Then balance the exposure so that you capture both.

ARRIVE EARLY The balance of light between sky and ground shifts subtly but quite rapidly towards sunset. There is only a short window when these two are perfectly balanced, so you need to get into position in good

time to ensure you capture

this moment.

CHOOSE YOUR SETTINGS

Use the best-quality setting the camera can offer, and select low sensitivity so that the skies are smooth-toned.

PROTECT YOUR SIGHT

Take care not to look directly at the sun, and don't leave the lens uncapped and pointed at the sun: the light could damage the shutter. While the sun is high, holding a hand above the lens can help reduce flare.

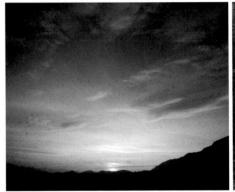

LANDSCAPES AND NATURE >> THE COLOURS OF SUNSET

TURN ROUND

Take the time to look behind you, too: the sky and landscape opposite the sunset will be bathed in beautiful light and deserving of a photograph. This area will not present the same contrast problems as the sunset.

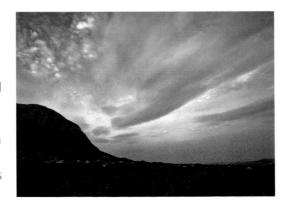

CHOOSE WHETHER TO ZOOM OR NOT

The colours in the sky at sunset typically span from warm yellows to deep blues. These will be taken in on a wide view, but a zoomedin view may be more dramatic, concentrating on the sun.

The beauty of photo one kind of picture, different. The intent

at a marina. At first

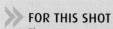

The sun was very low, but some rays still reached the vines in the foreground. I set the zoom to wide angle and selected the landscape mode to help ensure a generous depth of field. The vertical format takes in a large expanse of sky.

CAMERA MODE

Set your dial to Landscape mode

LENS SETTING

Zoom to Wide Angle

SENSOR/FILM SPEED

Use a **Low** ISO setting

FLASH

Force the flash **Off**

When the sun is as low as possible, you can balance light in the sky with light on the foreground. Most people opt for the landscape format when shooting a sunset, but don't limit yourself to this.

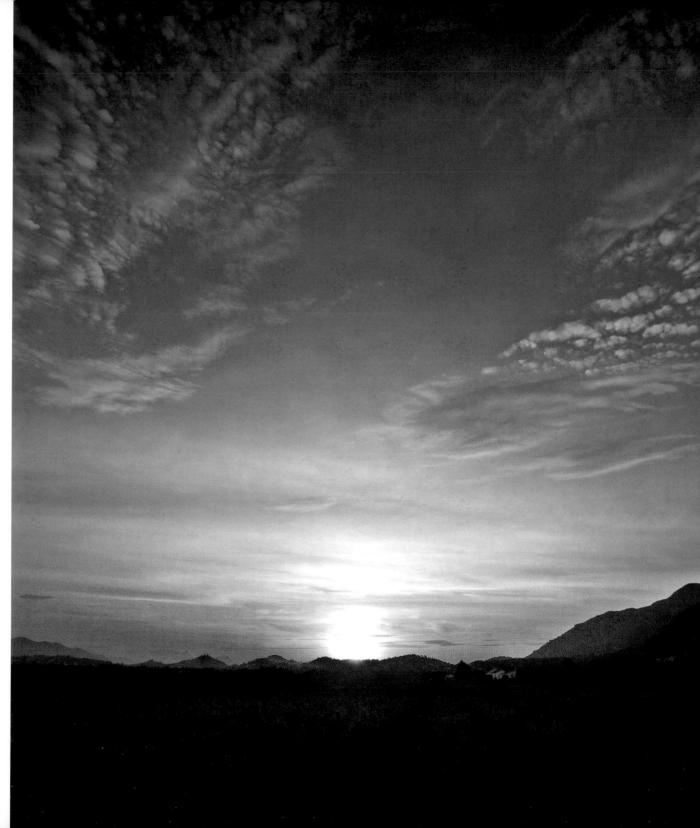

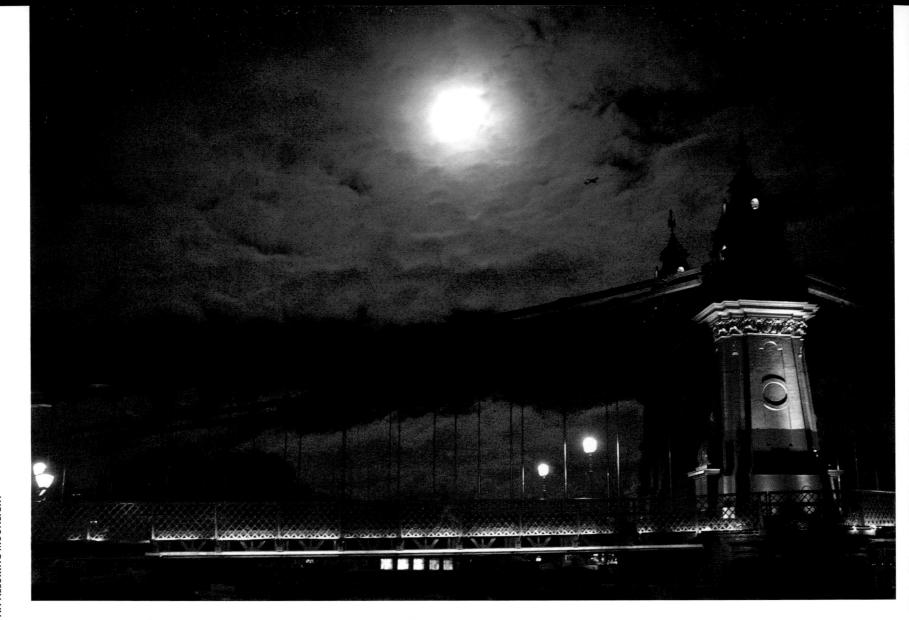

An alluring moonlight

The moon is a most fascinating subject for photography, but it is also a very tricky one. One key point to bear in mind is that when the moon is close to the horizon, it looks much larger to the eye than it does to the camera. Even when

high in the sky, the moon appears larger than it really is because it is so bright. That brightness can be overpowering in a night-sky picture in which everything else is dark. One solution to this problem is to shoot on a cloudy night.

K F

FOR THIS SHOT

I set a focal length of normal to wide angle, selected a high sensitivity, and used a tripod for sharpness. I then waited for clouds to pass in front of the full moon to enlarge the visible disc of light.

CAMERA MODE

LENS SETTING

SENSOR/FILM SPEED

FLASH

Force the flash **Off**

ZOOM TO THE MOON

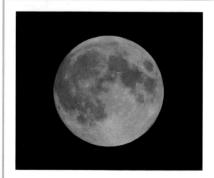

Even with your zoom set to maximum, the moon may still appear too small in the frame. Take the picture with the moon in the centre, then enlarge it later with image-manipulation software on your computer. Alternatively, if your camera has a digital zoom, you could use that for the same effect.

USE A TRIPOD

Set the camera on a tripod to ensure the sharpest results. The added advantage of a tripod is that you don't have to hold the camera in position while you wait for a good cloud or a change in the moon's position.

SET THE SENSITIVITY

Don't go any higher than is necessary when setting the sensitivity. The higher you go, the more likely it is that your images will be noisy,

with a grainy look (as here), uneven colours, and possibly lines evident. Using a tripod, you can afford to reduce the sensitivity a little.

R

CHECK YOUR IMAGES

Review any pictures to check the exposure and the sensitivity. The camera will probably overexpose, resulting in an image that looks brightly lit, as on the far right. Dial in exposure compensation to reduce the exposure to achieve the look on the near right. Notice how small the moon appears in these shots, both taken with a wide-angle zoom setting.

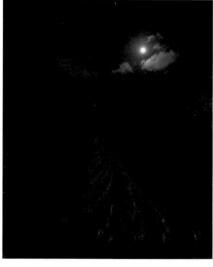

FRAME THE SHOT

Use foreground elements to create extra visual interest and to frame the moon. If the moon is too small in the image, wait for a cloud to pass in front. This will brighten the sky around the moon and make it seem much larger.

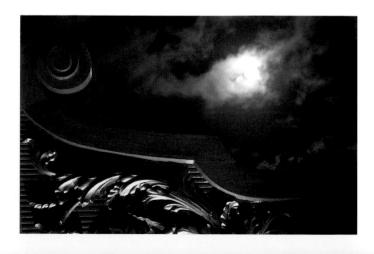

Cloud formations

One of the most rewarding photographic subjects is not only completely free, but you need only look up in the sky to find it. Great cloud formations are always worth photographing. Clouds change constantly, often assuming wonderful shapes and textures, carrying gorgeous colours, and interacting with the landscape. Seize the moment. You can create a fabulous picture of clouds even in the uninspiring surroundings of a town-centre car park.

COLLECTING CLOUDS

Skies of any kind whether dramatic, fairly plain, coloured, or neutral in hue - are useful for image manipulation. You can use them as backgrounds for text when printing, or you can add them to web pages. They may also give variety to other textures. Make a collection of cloud pictures for future use

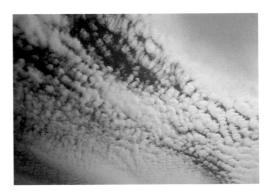

KEEP WATCHING THE SKY

Clouds can change shape and position very quickly, so you may have only minutes while an optimum shape or pattern is held. Keep an eye out for any changes, and watch for shifts of light on the ground - that is a sign of changes in the sky.

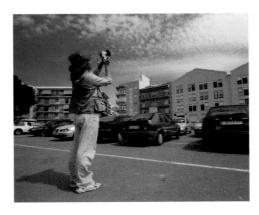

FIND A VIEWPOINT

Walk around and, if possible, look for an additional subject for your image. These surroundings may appear unattractive, but with careful framing you can leave unsightly elements out of your composition.

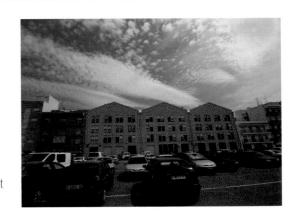

USE A WIDER ANGLE

The majority of cloud formations will benefit from a very wide-angle view. If possible, use a wide-angle attachment to increase the view to that of a 28mm or 24mm lens, or wider.

I used the widest-angle setting, supplemented with a wide-angle attachment. I waited for the best cloud arrangement and lighting, then I set the camera to the highest quality to capture all the subtle tones and details.

CAMERA MODE

Set your dial to Landscape mode

LENS SETTING

Zoom to Wide Angle

SENSOR/FILM SPEED

Use a **Low** ISO setting

FLASH

Force the flash Off

GET THE TIMING RIGHT Beware of lens flare and never

look directly into the sun. The best results are achieved when clouds partially obscure the sun or when the sun is at the edge of a cloud.

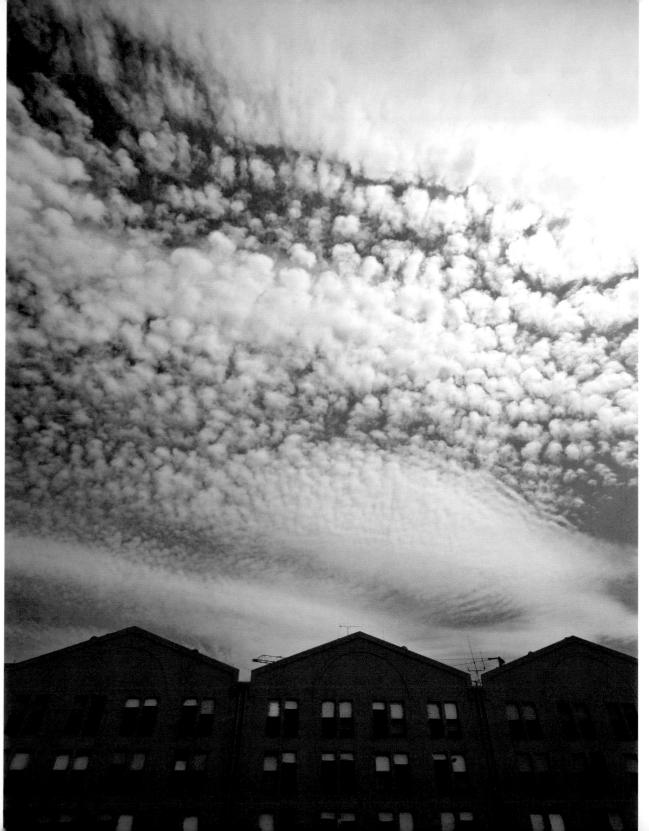

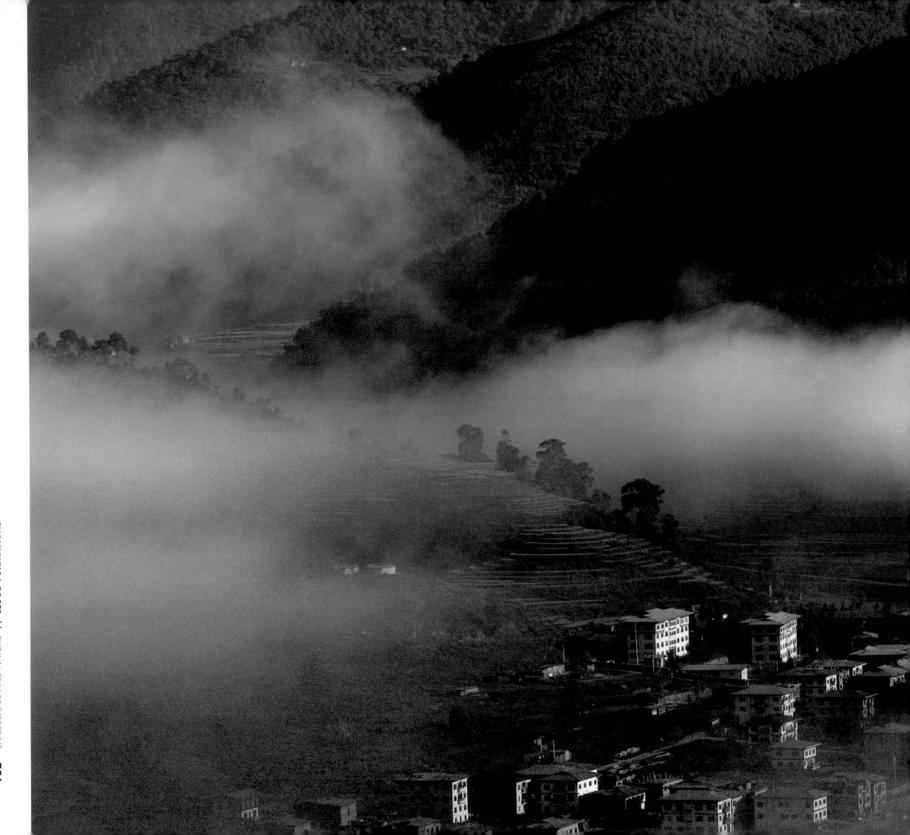

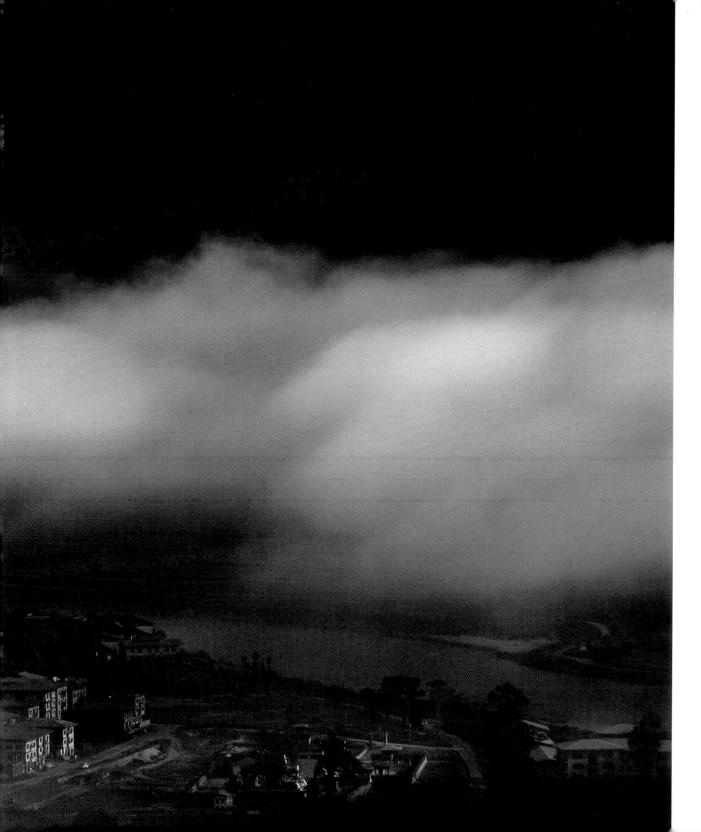

LOW CLOUDS

I took this shot early in the morning. The composition benefited from the beautiful early light of day, which was still low in the sky, but I was also fortunate in witnessing and capturing the spectacle of these low clouds rising from hills.

- 1 Choose your vantage point the previous day, working out where the sun will rise.
- Make sure you strike the right balance of light and misty cloud before taking your photograph.
- 3 Select the highest quality settings, because you will want to capture all the subtle tones.

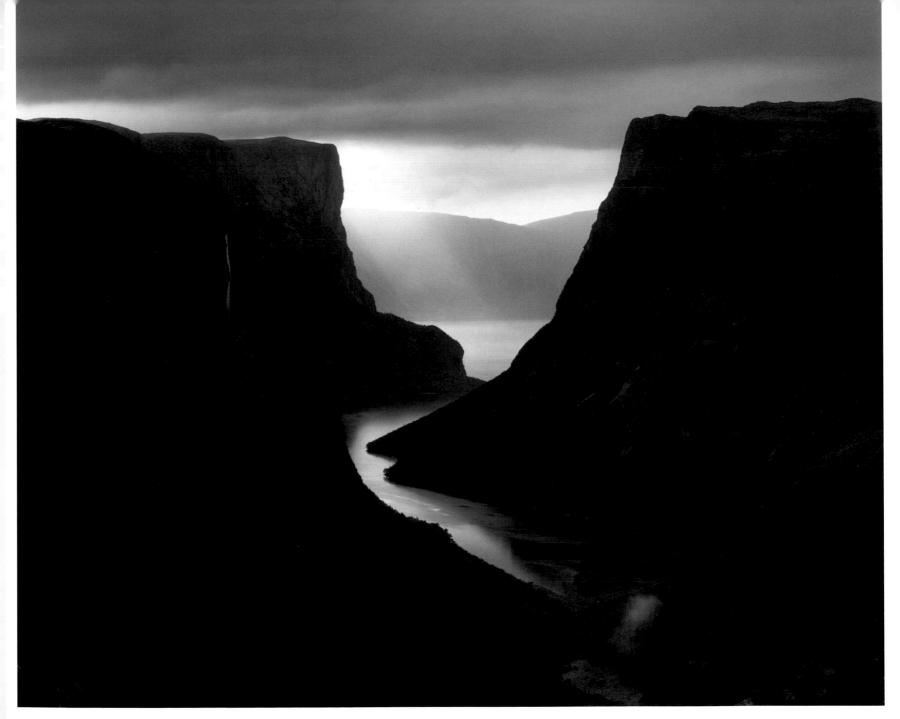

CATCHING THE CLOUDBURST

In order to capture a fabulous moment such as this, you either have to be very lucky, or must return to the same spot again and again until everything is

perfect. The silvery trail of the river leads the eye up to the lake, where it joins the cloudburst, lighting up the darkness in this dramatic composition.

GRADIENT SKY

One way to even out very bright skies is to place a gradient filter – dark at one end, and fading to clear at the other – in front of the lens.

ROCKY FOREGROUND

To suggest a sense of rapidly receding space, give your composition a busy and interesting foreground. These large stones hint at the dynamism of the scene.

ARCH FRAME

The arch is a natural framing device and a powerful compositional tool that concentrates the viewer's gaze into the scene within it.

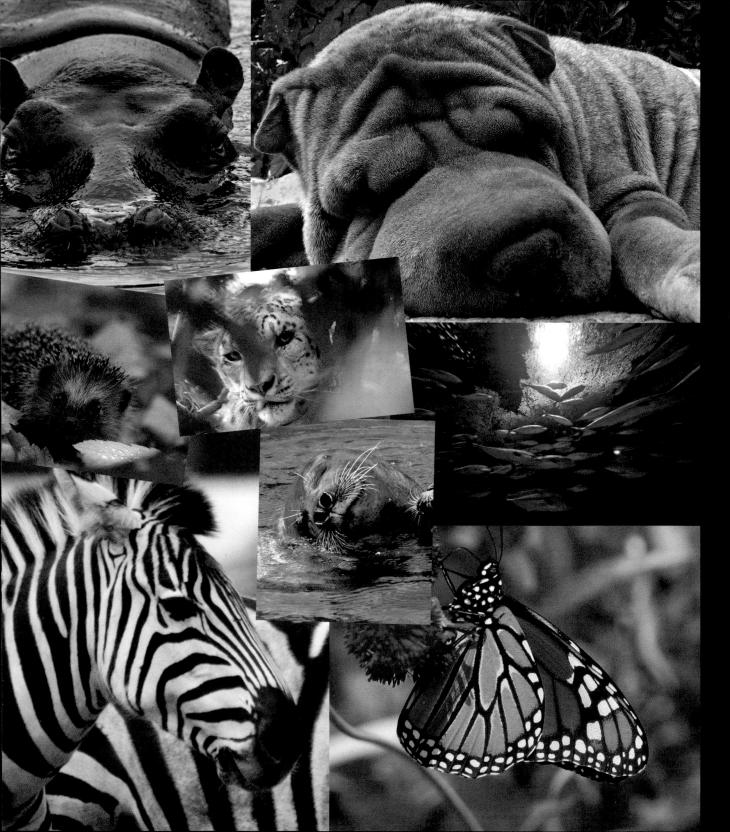

Animals – both wild and domestic – offer photographers an exciting arena, the doors of which have only recently been thrown open to all thanks to stunning technical and optical advances. Many modern digital cameras offer an optical reach that can be used to magnify distant animals; such a tool was once too costly for anyone other than professional photographers. In addition, most modern zoos, wildlife parks, and aquaria strive to create authentic-looking environments that are as close as possible to the animals' natural habitats. You need only add a few other key ingredients, such as some knowledge of your chosen animal's behaviour, plus a good supply of patience.

Posed pet portraits

In spite of the undeniable wisdom of the old adage "Never work with children and animals", these remain arguably the two favourite subjects for photography. The best way to approach a portrait of your pet depends on the animal's character and which of its qualities you wish to capture. An action shot of your dog jumping for a ball or chasing a stick is dynamic and exciting, but a formal pose brings an almost-human air to the portrait.

SET THE EXPOSURE

If your pet's fur is very dark or nearly white, you may need to adjust exposure from normal to ensure it is accurately captured. Take some test shots before the session, and check by zooming into the image on the LCD screen.

STUDIO-STYLE PORTRAITS

The alternative to photographing your pet outdoors is to work indoors. Cover the floor with white card and hang white sheets to create a plain backdrop. Use a long lens setting to minimize the need for a background. Work with light from a large window, or rely on your camera's flash. Using electronic flash will enable you to capture the sharpest images of your pet.

CREATE A FUN SHOOT

A static pose doesn't have to be a dull one. Offer the dog a treat, such as a biscuit, or allow it to run, jump, and play freely. Getting the dog to have fun will bring a sparkle to its eye that might otherwise be missing.

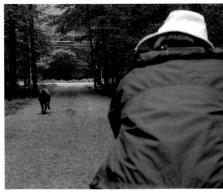

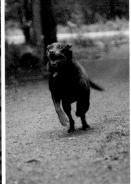

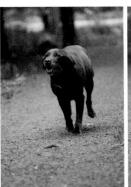

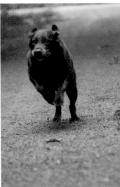

In choosing to zoom in from a distance, I was unable to achieve sharpness on both the long snout and the eyes, so I concentrated on the eyes. With a high sensitivity, I worked at maximum aperture for the shortest exposure times.

CAMERA MODE

LENS SETTING

Zoom to Maximum Telephoto

SENSOR/FILM SPEED

Use a **High** ISO setting

FLASH

Force the flash Off

SEIZE CALM MOMENTS

Take the picture when the dog is relaxed and settled. It is easier to get the whole animal sharp and in focus if you opt for a full-length portrait.

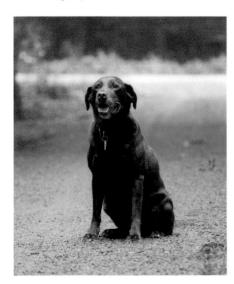

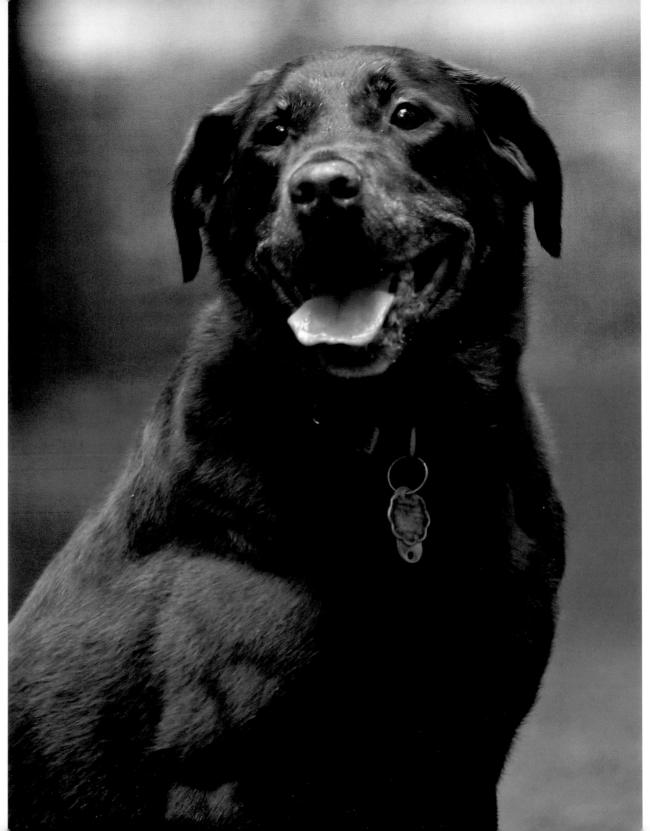

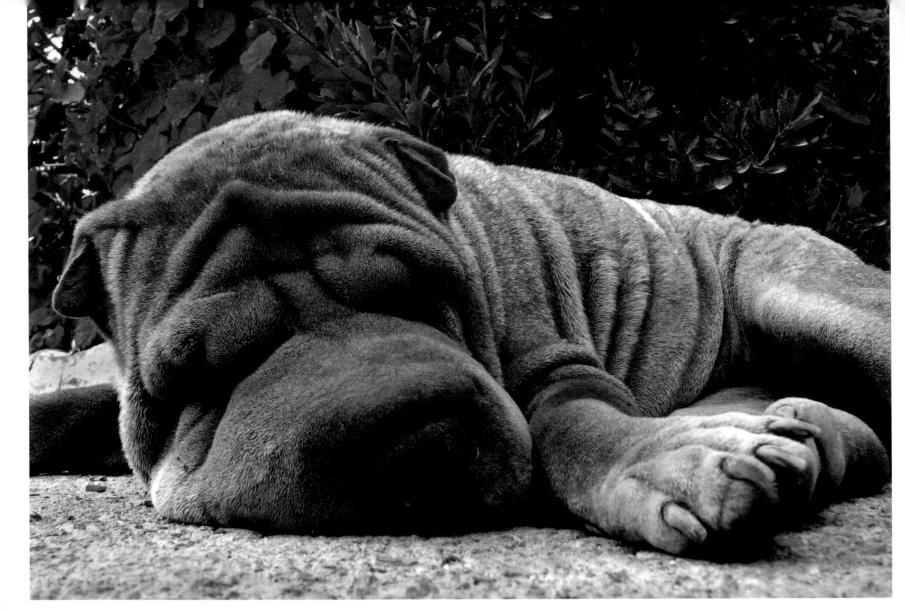

Fun pet portraits

One challenge of photographing pets lies in capturing their character in an appropriate way. This wrinkled old Shar Pei was portrayed from a worm's-eye view to emphasize his face, big paws, and relaxed pose. Photographically the task

is simply to get close and wide, and to ensure you focus on the right part of the animal. Cameras with flip-out LCD screens are advantageous for low viewpoints, since you can monitor the image without having to lie on the ground.

⟨ F

FOR THIS SHOT

A worm's-eye view with the camera set to wide-angle and placed on the ground gave me an amusing, intimate viewpoint. I opted for maximum depth of field, since the subject was static and the camera stabilized by the ground.

CAMERA MODE

Set your dial to Minimum Aperture

LENS SETTING

Zoom to Wide Macro

SENSOR/FILM SPEED

Use a **Low** to **Medium** ISO setting

FLASH

Force the flash Off

LET SLEEPING DOGS LIE

Always think safety first. If you do not know the animal, check with its owners that it is friendly and will not react badly, especially if it has been woken up from sleep.

SELECT SETTINGS

Set the camera to macro or close-up mode, and use a wide angle. Turn off the flash. If you have one, flip out the LCD screen so you can see the image while the camera is at ground level.

U To

USE THE RIGHT LIGHTING

To make sure the delicate and subtle textures of fur register, you must work in subdued lighting. The open shade under a bush is ideal. Move slowly and quietly to avoid startling the dog.

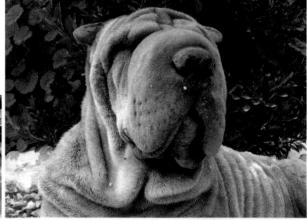

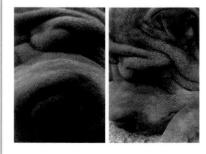

The textures of an animal's fur and features can comfortably fill the frame with subtle colours and lights. However, if you venture too close with your camera, you are in danger of losing the identity of the animal. Try to find a suitable balance between detail and context.

USE FOCUS LOCK

Don't focus on the nearest part of the animal: you want to capture the face rather than the feet. It doesn't matter – indeed, it might be better – if not all of the animal is in focus. Point the camera at the area you wish to keep sharp, press the shutter halfway to obtain and lock focus, then reframe for the shot.

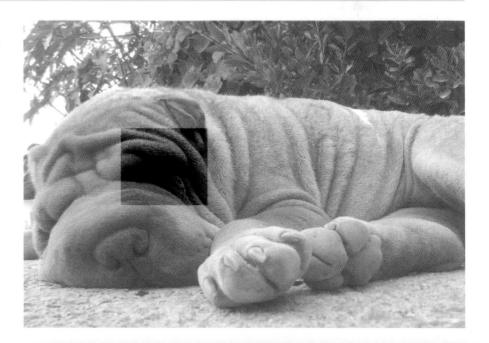

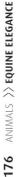

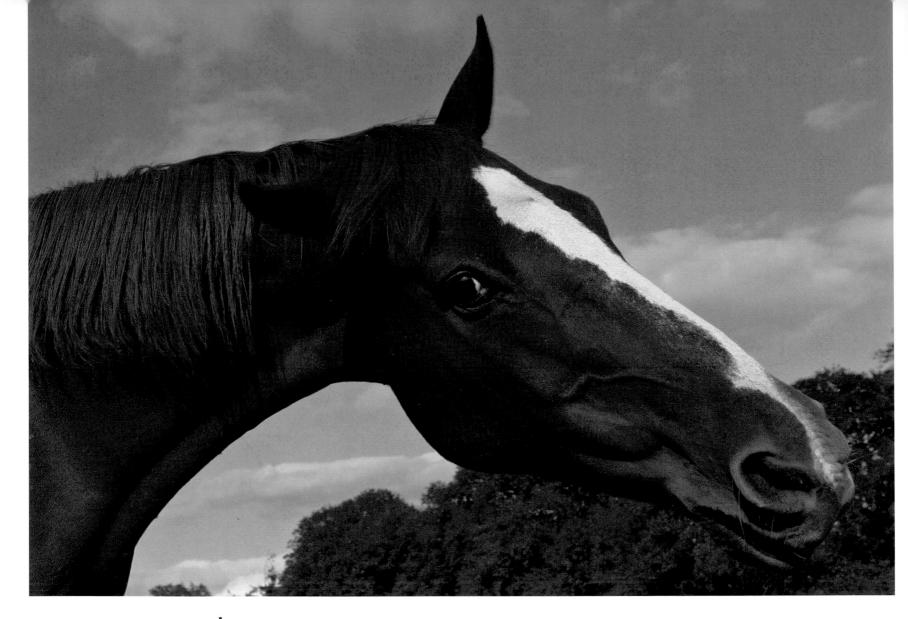

Equine elegance

With their beauty of form, variety of movement, and diversity of mood, horses are extremely rewarding to photograph, irrespective of the weather or lighting conditions. As with all animal subjects, the more you

understand about horses, the easier it is to photograph them. Horses have their own well-defined personalities, which can be by turns shy, frisky, friendly, or aloof. Try to ensure that your pictures capture their individuality.

I selected the sports mode and set the zoom to normal focal length. so as neither to exaggerate the perspective nor to compress the space. I forced the flash off, and since it was a bright, sunny day, I selected a low sensitivity.

CAMERA MODE

Set your dial to **Sports mode**

LENS SETTING

Zoom to Normal

SENSOR/FILM SPEED

Use a Low ISO setting

FLASH

Force the flash Off

TRY DIFFERENT COMPOSITIONS

Experiment with different types of shot. In this instance, there is little activity and no mystery to the atmosphere. A portrait of one individual horse makes a stronger shot than an undynamic group picture.

AVOID DISTORTION

Encourage horses to come closer by offering them a treat. Avoid shooting from close up with a wide-angle setting when the horse is facing you, since this can distort the image, making the head appear unnaturally large, as in the picture on the near right.

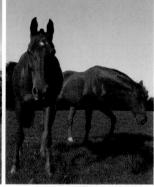

SET TO SPORTS MODE

Before the scene starts to arrange itself into a suitable composition for the camera, select the settings you need – such as sports mode for action. You can check exposure with a shot of any part of the animal.

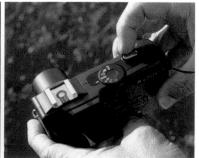

TRY DIFFERENT VIEWPOINTS

A horse's head is very long, which makes capturing its entire extent in sharp focus extremely difficult to do. It is usually easier and more photogenic to show the horse in profile rather than than face-on.

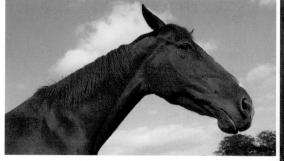

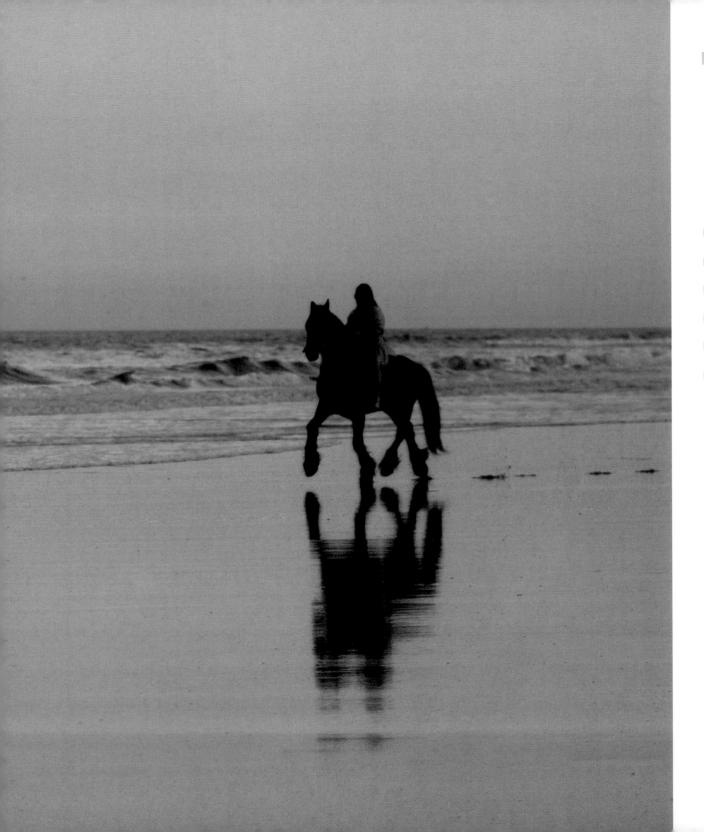

SUNSET RIDE

The image of a rider on a horse strongly symbolizes man working with nature and a sense of individual destiny. Such an evocative image is surprisingly easy to photograph: you need only a wide open space within which to set off the subject.

- Include a large amount of space in the picture to give a sense of freedom and liberation.
- Compose the image so that your subjects move into the space available in the image.
- For best rendition of large areas of smooth tone, use the highest quality settings.

Birds in flight

The graceful flight of birds soaring on thermals is a visual treat and an inviting subject for photography. It is also rather demanding. Birds are usually far away; they tend to move very quickly; and the light may be against you. However, if you can find a clifftop position that is safe, the prospects are good. Set your camera to its longest focal length, select the sports mode to capture action, and then keep shooting for as long as you can.

DIGITAL ZOON

If you find that the birds appear rather small in the viewfinder, you can move to the longest setting on your zoom. This may call up the digital zoom function, which enlarges the central portion, but this process impairs image quality.

STAY SAFE

Try to find a vantage point that brings you relatively close to the seagulls soaring around the cliffs. Make sure you are safe and don't lean too far to obtain any shot. Set the autofocus mode to follow or servo focus

BEWARE AUTOFOCUS

The camera should continually focus as you follow the bird. If you find autofocus unreliable, you can focus on a spot that the birds frequent, and shoot as they fly by.

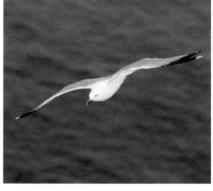

CHART BEHAVIOUR

Watch the birds to establish whether they have a favourite spot for landing or taking off - for example, a cliff where the wind is weaker. Learn the birds' behaviour, so that you are better informed and more likely to capture the images you want.

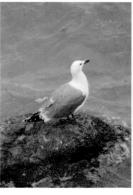

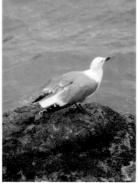

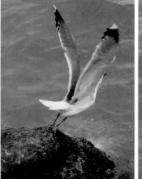

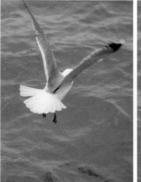

I followed the gull as it passed and released the shutter. This helped keep the bird sharply focused. I used a short shutter time, high sensitivity, and set the longest focal length. Then I took lots of pictures at every opportunity.

CAMERA MODE

Set your dial to Sports mode

LENS SETTING

Zoom to Maximum Telephoto

SENSOR/FILM SPEED

Use a **High** ISO setting

FLASH

Force the flash Off

FIND POINTS OF CONTRAST

Whenever possible, locate the bird against a neutral background so that its shape shows up clearly. The sea is ideal for this. You can make it look nearly black by setting the exposure for the bird.

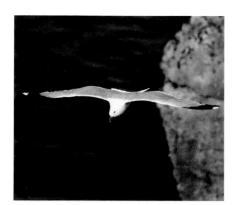

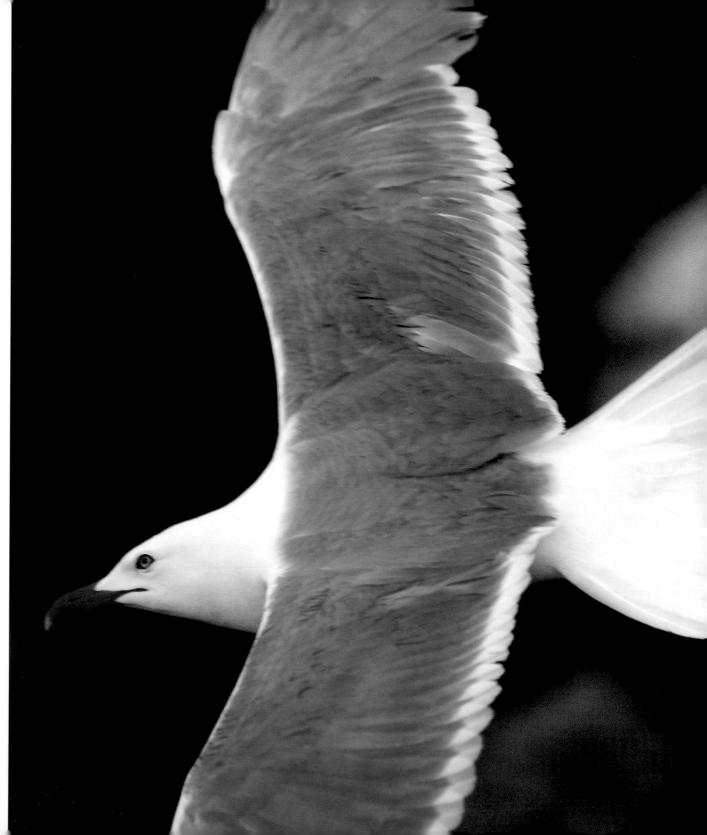

Exotic birds in close-up

Within the animal world, birds are among the most colourful subjects. Zoos provide unique photographic opportunities, especially for those who can't afford to stalk wild birds for weeks at a time to obtain portraits in the wild. As with many photography projects, proper preparation is at least half the process. A close-up portrait of any wild animal, captive or otherwise, starts with observing its habits and trying to predict its movements and behaviour.

ATTRACT THE SUBJECT

If you are allowed, offer the birds some food to acclimatize them to your presence. Taking pictures as you do this will get them used to the sounds of the camera. You will often find that one of the birds is more daring than the others, so that is the one to court.

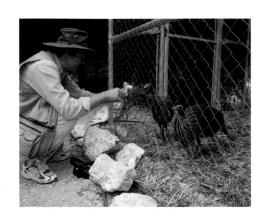

WORK THROUGH THE FENCE

One advantage of simple digital cameras is that the lens is small enough to poke through fencing, but only do this if it is safe.

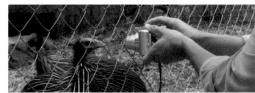

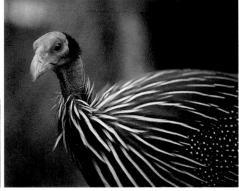

KEEP SHOOTING

Angle the camera to avoid any telltale signs of the cage, and take pictures all the time. Birds move so quickly and unpredictably that if you see what you want to photograph, you will have already missed the picture.

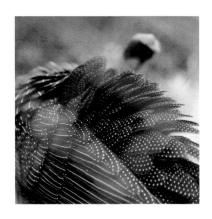

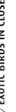

TAKE CLOSE-UP SHOTS

If the bird obligingly comes beak-to-lens to investigate you and the camera, keep clicking away. You may have to change modes – from close-up to normal focusing distances, and back again – as the bird moves around the enclosure.

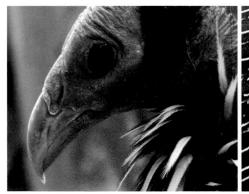

A telephoto setting kept the bird in frame, while moving with the bird helped blur the fence. I chose the sports mode to ensure the shortest shutter times and to freeze movement. This was aided by a medium to high sensitivity setting.

CAMERA MODE

LENS SETTING

SENSOR/FILM SPEED

Use a Medium to High ISO setting

BEWARE OF FLASH

Flash can produce strange effects if the bird is extremely close to the lens. Only use it if the zoo or park permits it.

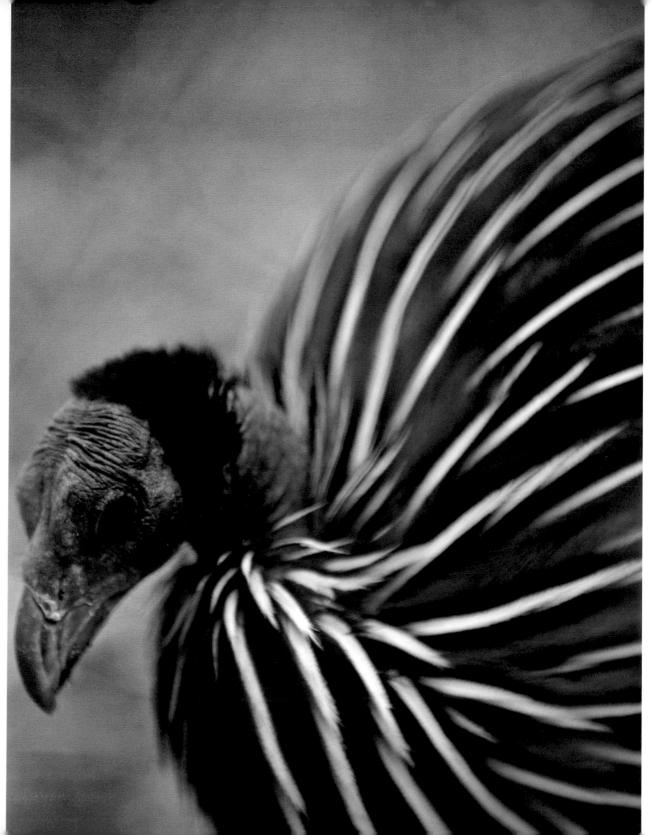

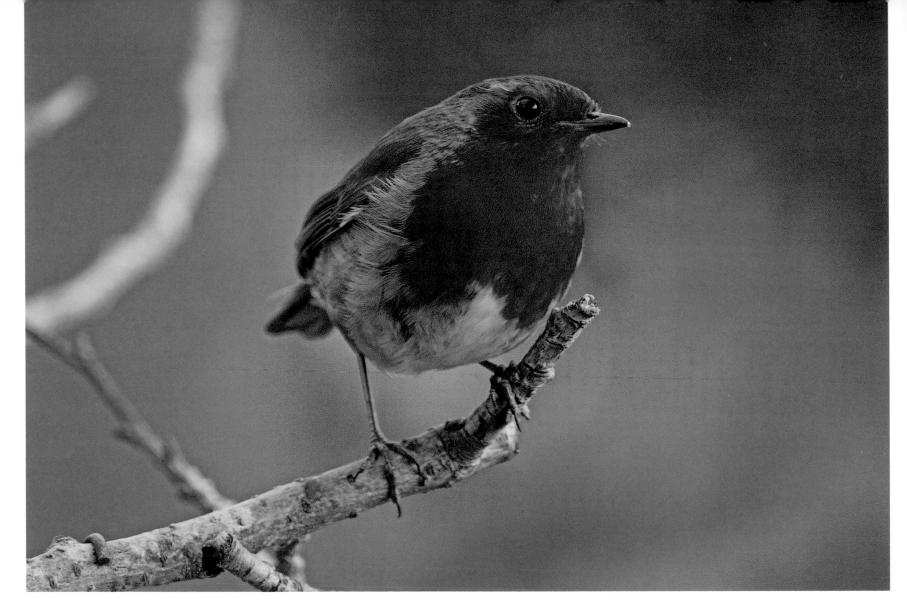

Garden birds

Garden birds are among the most accessible wildlife for photographers, because it is relatively easy to attract them close enough to capture a highly detailed study. Simply invest in a bird feeder, and wait for the local bird community to find out that your garden is worth a visit. Watch them and learn their routines – for example, seed-eating birds tend to feed early in the morning and late in the afternoon - so you can be ready with your camera at the right time.

I selected the sports mode for a short shutter time, then I zoomed all the way to maximum telephoto and set a high sensitivity. I focused on the twig, since it was a favoured perch, and took several shots as soon as a bird landed there.

CAMERA MODE

Set your dial to Sports mode

LENS SETTING

Zoom to Maximum Telephoto

SENSOR/FILM SPEED

Use a High ISO setting

FLASH

Force the flash On if needed

ATTRACT THE BIRDS

Set up bird baths and tables, and hang bird feeders in your garden. Place them in spots where they have a pleasant background from your vantage point.

CLEAN YOUR WINDOWS

If you decide to use the house as your hide, you will be taking photographs through the windows. Make sure they are clean.

HAVE PATIENCE

Get into position and wait with your camera trained on the spot where you expect the birds to land. so you can be ready when they arrive. If possible, use a tripod and a remote shutter release; otherwise, hold the camera steady by resting your elbows on the windowsill or your fingers against the window.

KEEP SHOOTING

Don't wait for an attractive composition before releasing the shutter: by the time the shutter runs, the birds could have flown out of the picture. Simply keep taking as many pictures as you can for as long as you can. You can crop your images to focus on the best elements at a later stage.

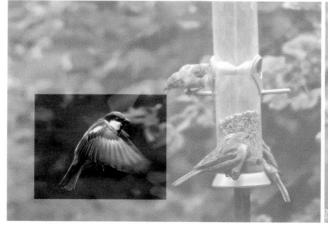

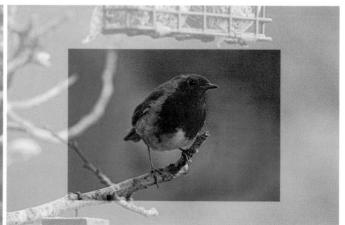

Wildlife close to home

Photographing local wildlife can be every bit as challenging as taking pictures of animals in game reserves or safari parks. Persevere, however, since this type of photography offers excellent practice for the budding wildlife photographer, enabling you to observe the animals and their behaviour at close quarters, experiment with different compositions, and learn to wait patiently for the right shot.

COLOUR CONTRAST

Goldfish in ponds are a rewarding subject because their bright colours contrast strongly with the dark waters. By using different effects you can create various types of images, including vibrant nearabstract shots.

If the water is dark, expose for a lighter area, or the fish will be overexposed.

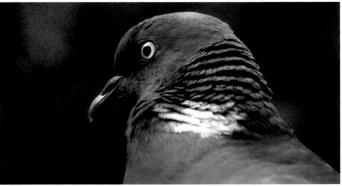

FRAMING OPTIONS

Large gatherings of birds may result in pulsating, dynamic patterns; press the shutter button repeatedly so as to have a range of shots. Alternatively, you can try singling out individual birds.

To throw the background out of focus, use the longest focal length setting.

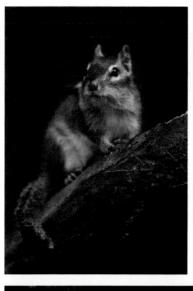

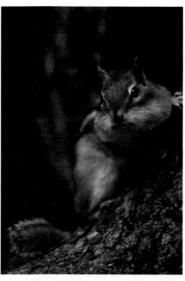

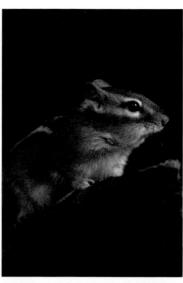

CAPTURING QUICK MOVEMENT

Small, lively animals are easier to photograph if you have help - for example, someone offering food to attract them and keep them close.

- Focus on a spot and wait for the animal to return to it rather than chase after it.
- If your zoom does not magnify the animal enough, take the picture anyway; you can enlarge it at a later stage.
- Flash may startle the animal, and it will slow down the camera. Use short exposure and shutter times to capture sharp images.

COMPOSITIONAL LEVELS

If you are lucky enough to have a garden, you can encourage creatures to visit by providing food and shelter. As the animals become used to your presence, they will be less nervous around you and more likely to ignore you and the camera.

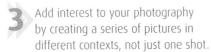

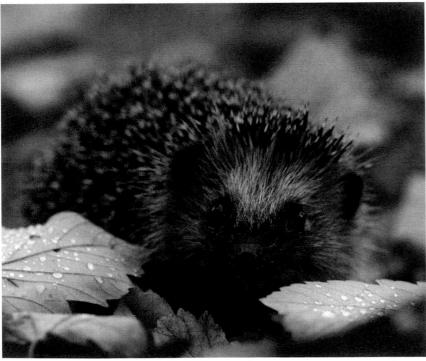

INSECT CLOSE-UPS

The key to getting good closeup shots of insects such as butterflies is to keep your distance and zoom in to avoid disturbing them.

TIMING IS EVERYTHING

The best time to photograph cold-blooded animals such as reptiles is in the cool of the morning or evening, when they are least frisky and their movements are slower.

If possible, have a helper encourage the animal to move towards you, but avoid causing any distress.

Set the camera to close-up mode with the zoom at a long setting, and focus on the eyes, if possible.

Avoid using the flash – it is unkind to the animal, and the resulting image will look unnatural.

MOVEMENT IN WATER

Waterfowl make superb subjects for photography. This is partly because they don't move as quickly on water as they do on land or in flight; but also because water offers a neutral, yet constantly changing, background.

Use short exposure to freeze the bird's movement and the ripples in the water.

Experiment with compositions, from a close-up of the bird's head to its entire body.

Try panning with the camera to follow the bird's movement during exposure.

URBAN FOX

Even in urban environments it is possible to find wildlife to photograph. Indeed, some animals, such as foxes, are more common in city gardens than in the countryside. You need to know their ways and habits to photograph them; then you have to lie in wait.

- Wild animals are creatures of habit, so learn where they go and at which time of the day.
- You may have to wait for hours on end, so set your camera on a tripod.
- Use a long lens setting or set the camera close to where you expect the animal to appear.

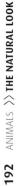

The natural look

Thanks to the incredible quality of modern zoom lenses, you can take animal pictures that even professional photographers would be proud of. You can achieve the wildlife look even when the animal is in captivity. Through careful planning

and sensitive positioning of your camera, it is possible to make bars and cages disappear entirely. The animals shown here had been rescued from private owners who were unable to care for them properly.

I set the largest file size and a low ISO for the highest quality, so that I could capture details in the fur and clear eyes. I then zoomed in as far as possible. The flash was turned off, and I aimed the lens between the wires of the cage.

CAMERA MODE

Set your dial to Sports mode

LENS SETTING

Zoom to Maximum Telephoto

SENSOR/FILM SPEED

Use a **Low** ISO setting

FLASH

Force the flash Off

RESPECT THE CAGES

Respect the animals and the need for cages, and obey all relevant rules. Many animals can move much faster than humans, so keep your distance, and never put your fingers through the bars of a cage for any reason.

TREAD LIGHTLY

In many animal-rescue centres, it is possible to approach close to the animals, which are often accustomed to humans. Nonetheless, be as quiet as possible and avoid sudden movements so as not to startle them.

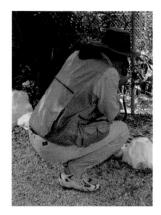

BE PATIENT

You may have to wait some time for the animal to look your way, so keep your camera ready at your eye.

LOSE THE CAGE

Use the longest zoom possible and move as close to the fence as you can. Set the lens aperture to the largest to minimize depth of field; this in turn helps to throw the wires of the cage out of focus so they disappear.

CROP IN ON THE EYES

A huge amount of expression is carried in the eyes, so try cropping into this area to create a final composition. For an extreme crop such as this to be successful, select the highest quality setting on the camera when shooting.

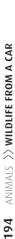

Wildlife from a car

The closest many of us ever get to big-game animals is at the safari park. You drive through the park slowly, you have to photograph with the car windows up, and you are not allowed to stop. To ensure successful photography under

these trying conditions, you need to take some simple precautions. The key to satisfying images is to keep an eye on the background. Try to make it as unobtrusive as possible, so as not to distract from the animals.

I zoomed in all the way to get as close to the animals as possible, but the shot still showed too much. I made a severe crop to emphasize the patterns, and also to help reduce the impact of the fence in the background.

CAMERA MODE

Set your dial to **Sports mode**

LENS SETTING

Zoom to Maximum Telephoto

SENSOR/FILM SPEED

Use a Medium to High ISO setting

FLASH

Force the flash Off

PREPARE THE CAR

If they are not already spotlessly clean, wash all the windows of your car, both inside and out. That will enable you to photograph through any of them as the situation demands. If your car has tinted windows, try to use a different car.

REMOVE OBSTACLES

Work out in advance how to remove other elements that might block your view, such as headrests. Once you know how to do it, you can do so just before entering the safari park.

CHOOSE CAMERA SETTINGS

Set your camera to short exposure times to catch action, and also because you may have to shoot while the car is moving.

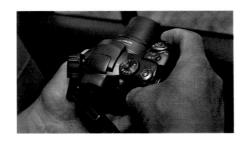

STEADY YOURSELF

Hold the camera as close to the car window as you can, to minimize reflections, but do not touch the glass with the camera, as the vibrations will blur your pictures. Instead, press a finger against the window to support the camera. This will help you absorb car vibrations.

SEIZE YOUR OPPORTUNITIES

Photograph as quickly as you can, because you have only one chance. Very few shots will be perfect, but you can improve the best ones after the trip with cropping or other manipulation.

PLAYFUL INTERACTION

Guided visits are excellent opportunities for taking photographs that illustrate the relationship between keepers and animals.

- Use a normal focal length zoom setting for the most natural perspective.
- Don't be tempted to use flash, even in low light. Instead, set high sensitivity.

CAPTURING CHARACTER

Some animals, such as the hippopotamus, tend to be active only around feeding time. This means that you have a small window of a few minutes to catch a dynamic, characterful portrait, so be prepared.

- Observe the animal carefully to help you predict their movements.
- Set a long telephoto for the most impressive close-up portraits.
- Position yourself so that you enjoy good lighting when the animal appears.

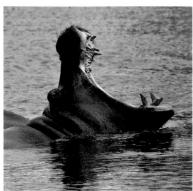

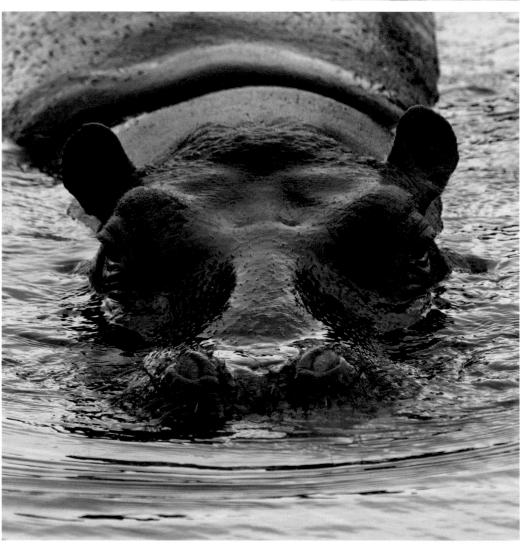

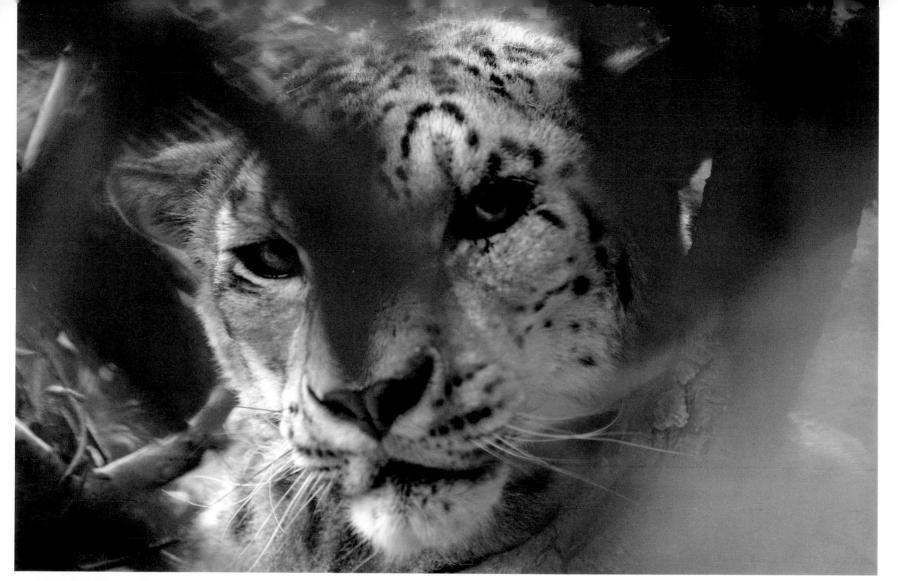

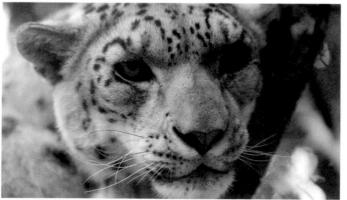

WILDLIFE CLOSE-UP

Many animal portraits, like those of humans, show the face without any obstruction. In the wild, animals spend a lot of time hiding in vegetation. The most natural-looking images are those that give a sense of being taken in the wild.

- Move very slowly and quietly to avoid alarming the animal.
- Use the longest telephoto zoom setting to fill the frame with the face.
- To help throw the foreground foliage into blur, combine the long zoom with focus on the eyes.

BIG CAT PORTRAIT

The best portrait subjects are those who are totally themselves, and few can match the self-possession of big cats. A patient wait – camera at the ready and closely observing the animal – is usually rewarded with stunning pictures.

- Spend some time observing the animal's behaviour, and allow it to get used to your presence.
- When photographing wildlife from a distance, use the longest focal length setting available.
- Hold the camera steadily, preferably on a tripod, or use a support such as a fence.
- Always keep the focus on the animal's eyes. If these are sharp, it will not matter so much if other areas are soft.

Animals

The key to photographing any animal successfully – whether wild, domestic, or in captivity – is patience. In the wild, in particular, you may need to track an animal's habits over a period of time in order to photograph it at all. Even when visiting a zoo, observing and waiting for a few minutes for the best shot in the right light will be handsomely rewarded.

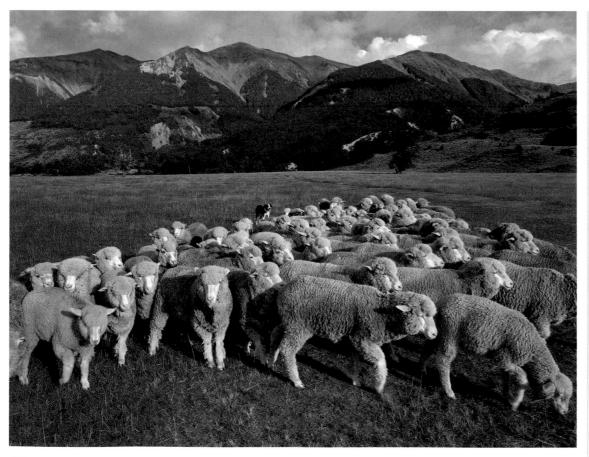

ANIMALS AND LANDSCAPES

Sheep are closely linked to the landscape they inhabit. Try showing them grouped in an interesting way, rather than scattered across the hillsides.

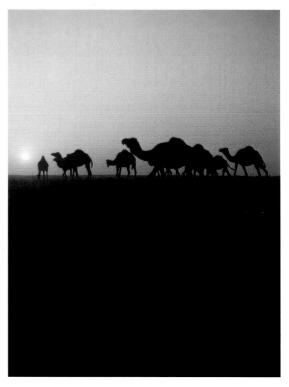

DESERT SILHOUETTES

The camel is as recognizable by its outline as it is close-up. For an atmospheric silhouette such as this, photograph early or late in the day.

GROUND LEVEL

For more intimate views of ground-loving animals, position yourself down low. Digital cameras make it easy to photograph from awkward perspectives.

RIGHT PLACE, RIGHT TIME

When taking pictures of performing animals, such as this dolphin, it is essential to get a ringside seat. Not only will the light be better, but being closer will

also prove highly beneficial when you are trying to take action shots. Good-quality close-up views like this one would be impossible from a distance.

UNDERWATER PHOTOGRAPHY

Take advantage of the fact that many digital cameras now offer waterproof housings for depths to about 5m (16ft), and explore the underwater world.

HEAD AND SHOULDERS

Use a long zoom setting to isolate an animal's head, then incorporate its body as the background to create a harmonious colour composition.

DECEPTIVE FAMILIARITY

Crop tight on your subject and remove context to create interesting images. In this picture, the limbs of the sleeping cat look anatomically wrong. The

reality, though, is that this is a bundle of several cats, but that information has been withheld. The pattern of stripes in the cats' fur adds visual appeal.

SUPER-ZOOM ADVANTAGE

It can be very difficult to get close to large groups of shy animals, such as these flamingos. If that is the case, you will need to use a digital camera with a

super-zoom – longer than 300mm. This composition benefits from a shallow depth of field, which blurs all but the middle ground, creating the focus of the shot.

Architecture offers an enormous advantage over almost any other field of photography: your subject will stay in one place, and will do so not only from day to day but from decade to decade. It is, therefore, easy to locate the subject, and if at first you do not get it right, you can return in the sure knowledge that it will be there tomorrow. But this does not mean that the photography of buildings is easy. To create something fresh, you need to consider light and viewpoint just as much as you consider the building. You will learn that the more a subject offers itself to you, the harder you'll have to work to marry lighting and form accurately, and the more care you will need to take over composition.

Focusing on details

The outside of many beautiful buildings can be difficult to shoot due to the hordes of tourists milling around. In such cases, take the opportunity to concentrate on the details. Many architectural details were designed to be looked up to, to inspire awe; however, a photograph taken from the same position does not have the same effect. The key is to find a perspective that works for photography, even though it may not be that intended by the architect.

1

CONSIDER THE LIGHTING

Wander around the building, looking for interesting details. Since many tall buildings are in deep shade for part of the day, you may have to wait for the right lighting conditions, especially since tripods can be a nuisance in crowded areas.

CONVERGING PARALLELS

You can make a virtue of necessity when you have to take pictures close up to a tall building. If possible, use a wide-angle lens for a large field of view, and tilt the camera to an extreme angle. The result is a strong convergence of parallel lines. Compositions that have some symmetry often work better than those without.

CONSIDER THE END RESULT

It is natural to start by taking pictures from a position close to the building, but in so doing you will find yourself looking up the noses of any sculptures, and losing the

sense of the soaring structure. Find a position a little further away, and use a longer zoom setting to evoke a sense that you are hovering in front of the details

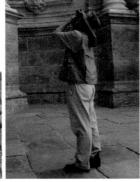

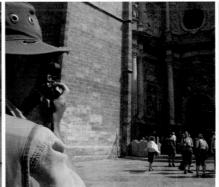

>>> FOR THIS SHOT

I selected a long zoom setting with medium to low ISO for good quality. But a high level of lighting was needed, too, so I waited for the sun to move round. By moving away from the crowds I was able to use a tripod to get the sharpest images.

CAMERA MODE

Set your dial to Program mode

LENS SETTING

Zoom to Maximum Telephoto

SENSOR/FILM SPEED

Use a **Medium** to **Low** ISO setting

Force the flash Off

FIND THE BEST ANGLE

A shot from underneath can render sculptural details as a confusing jumble. By moving further away you can improve the look, as well as the lighting.

Often featuring intriguing spatial effects, modern architecture is a fascinating photographic subject. The challenge lies in being able to do justice to the wealth of opportunities on offer, and to take advantage of the architect's vision to create great images of your own. When you first encounter an architectural complex, a natural reaction is to go for the wide-angle setting to capture as much of the scene as possible. But beauty is often in the detail.

NIGHT SHOTS

At twilight, buildings are no longer lit by a single large light source. Instead, there are numerous small sources that illuminate only small areas. Such lighting design is a delight to the eye. Since much of the character of the scene depends on contrasts between the warm colour cast and the blue sky, switch your camera to night mode to avoid correcting warm colours to a neutral white.

EXPLORE THE LOCATION

Some places provide endless inspiration, while others make you work harder to find strong compositions. It may be that you need simply

to try to understand what the architect had intended, so walk around and take it all in.

EXPLOIT THE FLEMENTS

When you find a feature or an area that you like, mine it to the full. Try different viewpoints and different zoom settings, and cover the entire area comprehensively. This way you will not regret missing a shot later.

LOOK FOR PATTERNS

Most modern buildings offer much to admire. The challenge is to use the one-dimensional medium of photography to portray a complex threedimensional subject. Look for rhythmic patterns and recurring shapes and forms that characterize the structure.

>>

FOR THIS SHOT

I used the telephoto setting to bring out contrasts in texture and the rhythms visible throughout the image. With high-quality settings, I obtained clear lines and details, as well as smoothness in the sky and white areas.

CAMERA MODE

LENS SETTING

Zoom to any length, as required

SENSOR/FILM SPEED

Use a **Low** to **Medium** ISO setting

FLASH

Force the flash Off

CREATE A VISUAL THEME

A set of images linked by a particular theme – stairways, for example – is often more effective than a single shot.

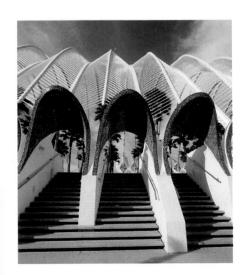

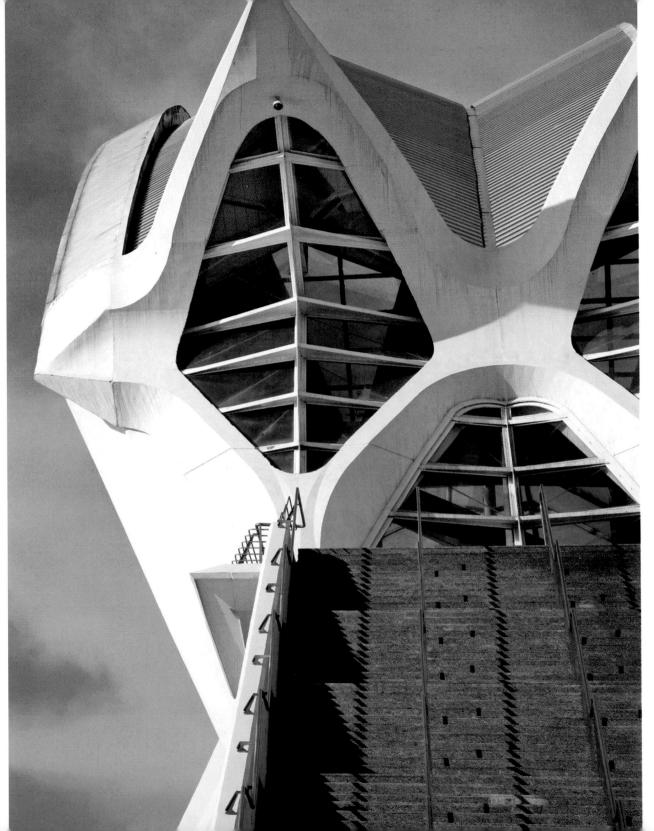

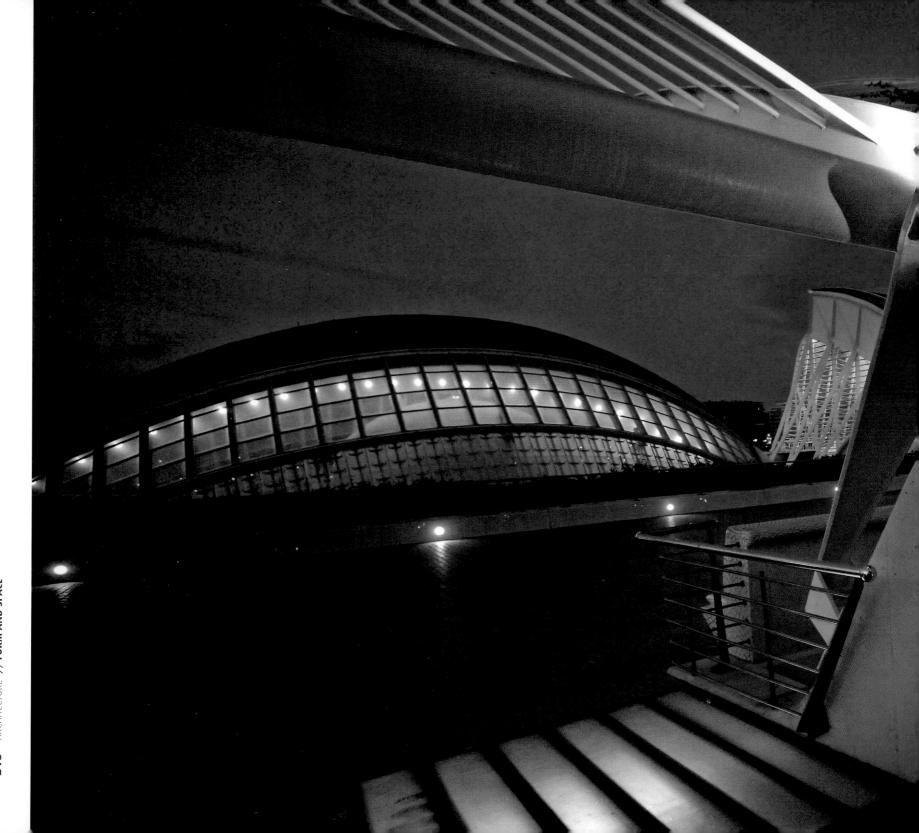

COLOUR OF LIGHT

Photography, more than any other artistic medium, has truly opened our eyes to the variety and richness of colours at night. Not only is the camera attuned to colours in low light, but it can even capture tonal subtleties that escape normal vision.

- Find contrasts between the light on plant forms and strong geometrical shapes.
- Remember that colours captured at night may exceed your expectations.
- Use a tripod so you can set a low ISO for the best image quality and sharpness.

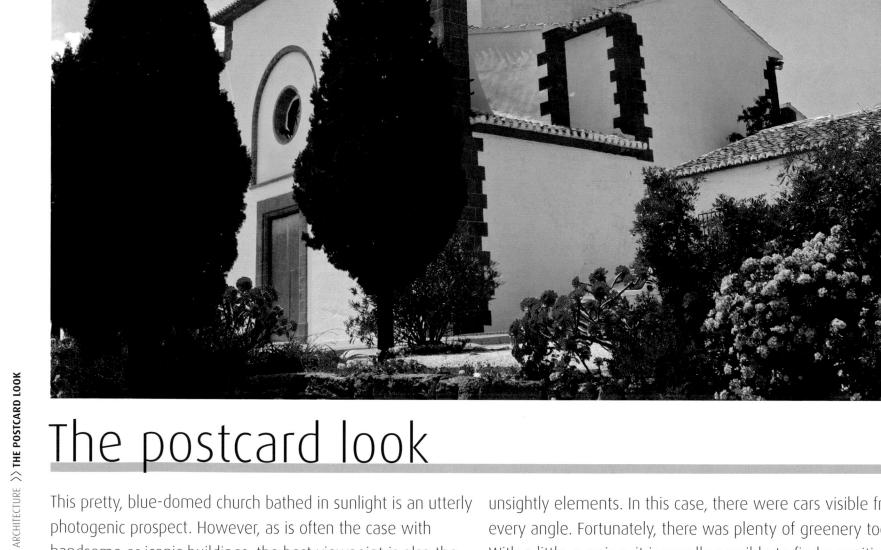

photogenic prospect. However, as is often the case with handsome or iconic buildings, the best viewpoint is also the one that reveals queues of tourists, street signs, or other

unsightly elements. In this case, there were cars visible from every angle. Fortunately, there was plenty of greenery too. With a little cunning, it is usually possible to find a position that shows off the building while concealing any eyesores.

<<

FOR THIS SHOT

I achieved the best quality overall by using a moderately wideangle zoom, the highest-quality image setting, and a low ISO. To ensure the greatest depth of field, I selected the landscape exposure mode.

CAMERA MODE

LENS SETTING

Zoom to Wide Angle

SENSOR/FILM SPEED

Use a **Low** ISO setting

FLASH

() F

Force the flash Off

CONSIDER VIEWPOINTS

Take time to explore the building from different angles. Here, a view with the sun to the back would give the brightest whites and the bluest skies, but that was not the best view of the church. The shadow side was very attractive, but cars could be seen and the trees obscured the building too much.

2

EXPERIMENT WITH ZOOM

It is possible to zoom in on details to get past any distractions. However, the sense of the whole and the identity of the building are lost: the details could belong to any Mediterranean edifice.

POLARIZING FILTERS

Without filter

With filter

If the sun is more or less behind you when taking the picture, you can use a polarizing filter. This is a lens accessory that darkens the blue of the sky. It is a dramatic effect that cannot be imitated accurately with image manipulation. Polarizing filters can be used even with most point-and-shoot cameras.

TRY VARIOUS FORMATS

A portrait format can be the answer to removing unsightly distractions. However, a wider landscape shot suits this subject better and gives a picture-postcard look. The composition can be refined further. For example, crouching down was an effective way to hide the cars behind the bushes.

222

Night-time illuminations

If you thought that stunning pictures where the sky is a deep shade of blue and the building's features are beautifully lit were the exclusive domain of professional photographers, think again. There is a simple secret to

obtaining eye-catching pictures: start photographing at dusk. At that time of day, the sky still retains some light, but it also begins to be tinged with darkness. The rich blue hue nicely balances the lights on the building.

FOR THIS SHOT

With the lens set to the widest angle, I selected a high ISO, and landscape mode for a balance between good depth of field and a medium-long exposure time. I turned off the flash and used a tripod for the sharpest results.

CAMERA MODE

Set your dial to Landscape mode

LENS SETTING

Zoom to Wide Angle

SENSOR/FILM SPEED

Use a **High** ISO setting

FLASH

Force the flash Off

Arrive on location with enough time to set up, then shoot through the twilight of early evening and into the night. The weather and brightness of the lights on the building both affect the ideal shooting time. with different conditions producing different results.

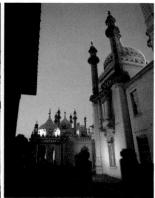

CHECK YOUR PROGRESS

A tripod makes shooting much easier. The available light will change rapidly, so this is a situation when you need to check the images as you work. Try different exposures to find the best settings.

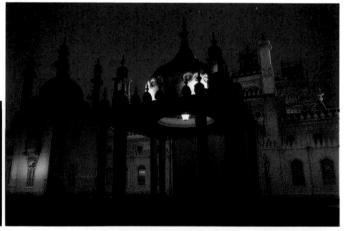

ADD HUMAN INTEREST

Make positive use of any passers-by: even if only as silhouettes, they can add to your image by giving it a human dimension. However, because your exposures will be quite long, the people might be blurred.

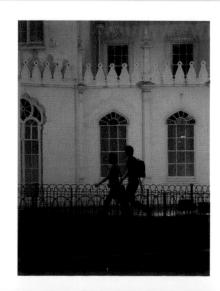

TRY VARIOUS ANGLES

You might choose to keep the camera level when shooting, as in the picture on the right. However, for a more dynamic take, aim the lens upwards: this makes parallel lines such as the columns appear to converge, as in the main picture opposite, giving the impression that the building is leaning back.

Romantic ruins

From the earliest days of picture-making, photographers have gravitated towards buildings, initially because they stood still, suiting the very long exposure times that were once needed to make a picture. Of particular interest were the ruins of ancient buildings; this was largely for their romantic associations with the past. But even in the age of colour photography, black-and-white pictures are still very effective in bringing character to a ruin.

<<

FOR THIS SHOT

With the camera on a tripod, I set a medium telephoto zoom, highest image quality, and a low ISO setting, with the flash off. I made the exposure using the self-timer to avoid camera shake.

CAMERA MODE

LENS SETTING

SENSOR/FILM SPEED

Use a **Low** ISO setting

FLASH

Force the flash **Off**

MOOD WITH COLOUR

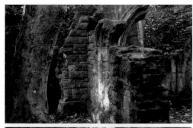

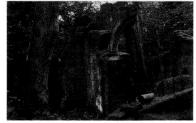

If the ruins are largely monochrome, you might choose to work in colour. You can vary the mood by changing the white balance: try different settings on the camera – tungsten, sunny, fluorescent, and so on.

GET STEADY

If the area is shaded by trees, or if there's not much natural light, you are better off using a tripod. If you are resting it on a bed of leaves or on soft ground, make sure the tripod is stable by pushing it in a little.

2

EXPLORE THE LOCATION

Look for areas of the ruins that show up dramatically against the surroundings, and use broken arches and windows as framing devices. You can also look for signs of nature reclaiming the space. Work with the available light, examining the way light and shadow fall.

SELECT A VIEW

The result of your explorations will be a favourite perspective, one that conveys mood and works as a photographic composition. Trees and foliage in the foreground can convey a sense of chance discovery. You may want to focus past them, allowing them to blur, to create depth.

Abstract views

Many examples of modern architecture offer a visual treat, especially those that utilize massive forms with an almost tangible exuberance and energy. Photographically, such buildings are a gift, but the question remains how to capture the qualities inherent to a building in one image that says it all. In the example above, the spirit of the building is encapsulated in the interplay of hard with soft, of wave-like curves with stiff, straight lines.

FOR THIS SHOT

Wide-angle views are the easiest to compose, but for details, a normal focal length is fine. I used a high-quality setting to capture the textures. I also made sure the lens was clean in case the sun was going to be in shot.

CAMERA MODE

Set your dial to Program mode

LENS SETTING

Zoom to Wide Angle

SENSOR/FILM SPEED

Use a Low to Medium ISO setting

Force the flash Off

OVERCOME AWKWARD LOCATIONS

It is often impossible to photograph a building in its entirety because you cannot stand far enough back without coming across obstructions or putting yourself at risk in a traffic-heavy

street. Instead, move close to the building and explore it in detail. The widest-angle zoom setting will help capture a sense of space.

SHOOT SKYWARDS

The soaring lines of a tall building encourage you to look upwards. For the widest possible field of view, try crouching to get as far away as possible from the upper structure. Taking an abstract approach frees you to hold the camera at any angle.

TAKE MANY SHOTS

On a sunny day, you can work with the sun to exploit the flare, or you can avoid it altogether. Try different shots to ensure you have a good selection from which to make your final choice. The most abstract image is the one with least sense of scale

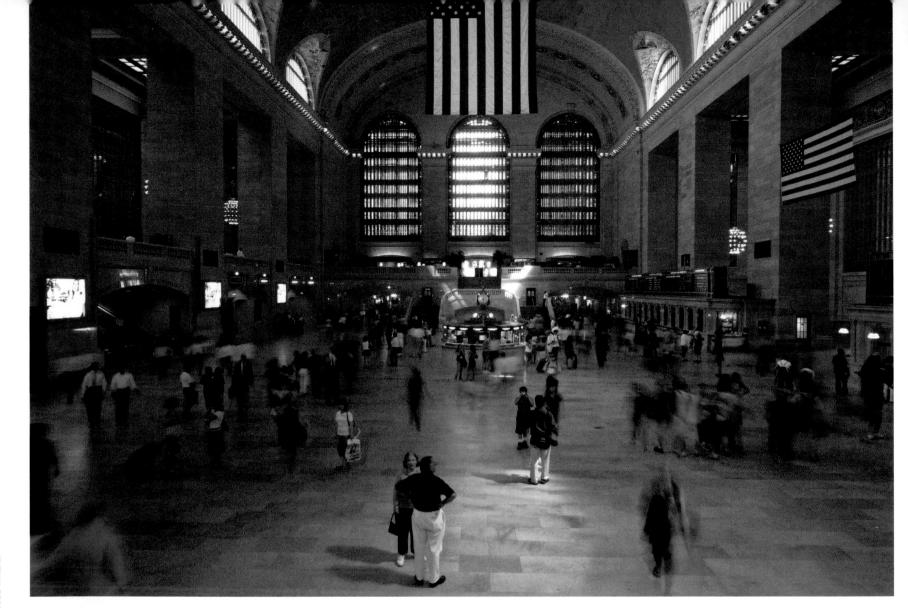

Large enclosed areas

As daunting a task as it might seem to take a picture of a monumentally large interior, there are ways to make it easier. Indeed, architects themselves design and build in such a way that you are automatically led to the best

vantage point. Once you stand at that point, the building's lines all come together to create a beautiful composition. Timing and patience will provide the extra elements needed to capture the character of the space

«

FOR THIS SHOT

With the zoom set to wide angle, I held the camera level so that the verticals were straight and parallel. I used a medium to high sensitivity and set a long shutter time – about 1 second – making sure the camera was well supported.

CAMERA MODE

Set your dial to Shutter Priority

LENS SETTING

Zoom to Wide Angle

SENSOR/FILM SPEED

Use a Medium to High ISO setting

FLASH

Force the flash Off

A DIFFERENT APPROACH

For an unusual perspective, try something completely different. Here, I placed the camera on the polished floor to capture a sense of the great human traffic that moves through the building. From the floor position, half of the field of view picks up the reflections of lights and passers-by.

FIND A VANTAGE POINT

Explore the building and look for a position that offers you the best view. From this vantage point you will be able to observe the people and the space unobstructed. In busy locations, try to avoid using a tripod by resting the camera on a balustrade or ledge.

USE THE LIGHT

In a dimly lit interior, you might experience problems with underexposure. It would be natural to increase sensitivity to make the most of the light, but that would lead to a short exposure, and the motion blur of the people would be lost. Instead, use the ISO setting that gives a shutter time of about 1 second to capture a good amount of light and movement.

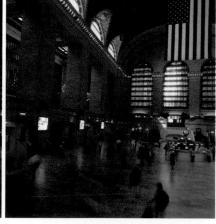

FOLLOW THE BUILDING'S LINES

In a strongly symmetrical space, it is usually best to follow the architect's lead and aim for symmetry, rather than take an off-centre shot that doesn't do justice to the building's lines.

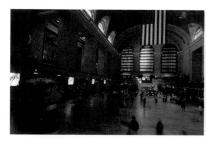

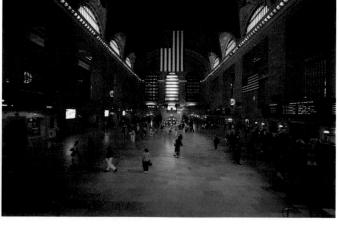

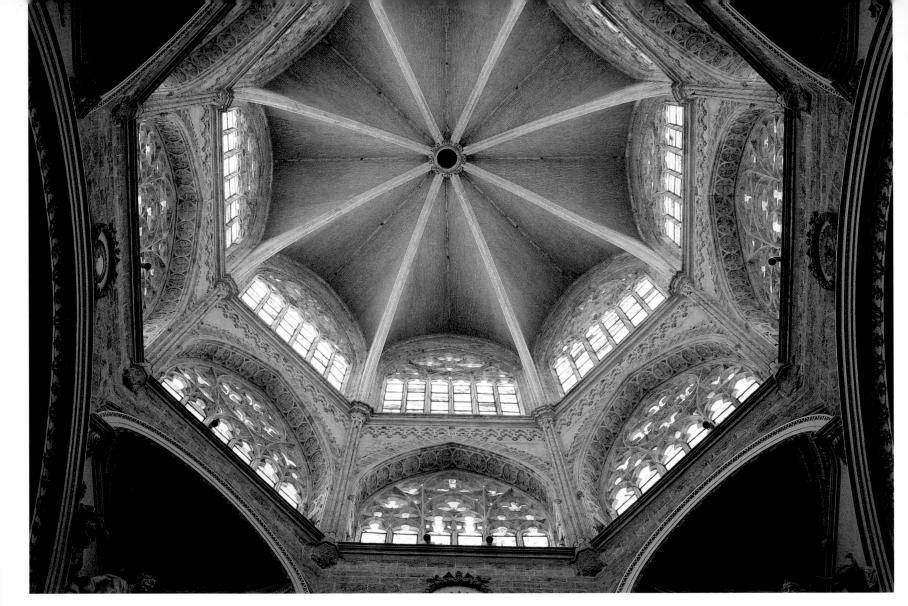

Dimly lit interiors

Places of worship such as cathedrals or mosques usually feature richly ornate and beautiful interiors. These buildings tend to be dimly lit to create an atmosphere of contemplation. Unfortunately, many do not allow tripod

photography. The trick to capturing this atmosphere is to understand that your camera can see more colours than you can, and to use your imagination to find alternative places you can rest your camera, such as pews and pillars.

FOR THIS SHOT

To photograph the ceiling, I placed the camera on the floor pointing straight up, with the lens set to wide angle. A high ISO was needed to make the most of the available light. I released the shutter using the timer set to 2 seconds.

CAMERA MODE

LENS SETTING

Zoom to Wide Angle

SENSOR/FILM SPEED

Use a High ISO setting

FLASH

Force the flash Off

Before you explore the interior, ensure you turn off your camera's flash. This is usually a requirement in such buildings, but even if you were permitted to use it, flash destroys the subtle lighting that gives the space its character.

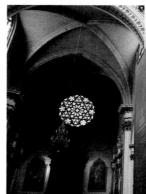

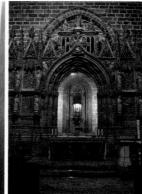

USE AVAILABLE SUPPORT

Any accessible firm surface can be turned into an impromptu camera support. Use books or card to fine-tune the angle of the camera tilt. Set the selftimer to release the shutter for the most shake-free

shot: just hold the camera while the shutter runs.

In large interiors there is often a wide range between the darkest areas and the brightest ones (usually the windows). This can make them tricky to photograph. If possible, take exposures that give dark results, as well as light ones, and choose the best later.

GIVE YOURSELF OPTIONS

You may not be able to predict accurately what you are shooting, so shunt the camera around and take several pictures in each position. You can review on the spot or crop them later.

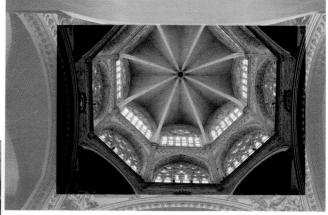

Modern interior spaces

The main driving forces behind much modern interior design are detail, colour, and often limited space. Unlike the grandiose vastness of castles and mansions, a modern interior calls for an intimate style of photography. Observe

it with the designer's eye: what looks like a stark corner may well reveal itself as an inviting private area. To capture the true spirit of the design, turn off the flash – irrespective of how dark the space is – and work with the available light.

FOR THIS SHOT

I selected aperture priority to obtain maximum depth of field, then set the zoom to wide angle in order to take in the space. I underexposed a little so that the dark bench seats remained dark.

CAMERA MODE

Set your dial to Aperture Priority

LENS SETTING

Zoom to Wide Angle

SENSOR/FILM SPEED

Use a **High** ISO setting

FLASH

Force the flash Off

Some establishments do not permit any photography inside. Even if the photographs are for your own reference only and not for commercial purposes, be sure to obtain permission before you start taking pictures of a trendy restaurant or bar.

LOOK AROUND

Explore the area with a view to finding out the best angle for a picture. Consider colours, light, and shapes. In a varied space such as this, with lots of dark corners smaller areas will be easier to photograph than a wide view.

CONSIDER LIGHT AND REFLECTIONS

Modern interiors often feature mirrors, so be sure to avoid your own reflection. Sometimes the most attractive views - here, the sunset lighting up the collection of bottles – evoke a feeling rather than reveal much about the design itself.

FOCUS ON THE DETAILS

Modern designers will give you plenty to interest the eye in terms of details and colour contrasts. Experiment with as many abstract or graphic details as you can.

LINES AND LIGHTING

Photography is the natural partner for modern interior design: the camera can probe all the stylistic elements offered by designers. In this shot, the clean lines, lighting, and reflective surfaces of a hotel bar come together to create a striking image.

- Seek reflections. The key theme of many modern interiors is a shiny, polished look.
- When shooting in dim light, turn off the flash, or it will ruin any subtle lighting effects.
- Use wide-angle settings for both context and extensive depth of field.
- If the colours are not wholly accurate in your shot, correct them later with image software.

Iconic city landmarks

Important architectural landmarks present quite a challenge to the photographer. Although they are eminently photogenic, iconic buildings are such well-known sights that it is very hard to look at them from a different, unusual perspective. As a result, out of sheer familiarity, we tend to photograph them from the same position as everyone else. However, it is surprising how much variety you can come up with after exploring a location and keeping your eyes open.

*

FOR THIS SHOT

I selected auto-exposure with a wide-angle zoom setting supplemented by wide-angle attachment to tuck the tower of Big Ben between street furniture and buildings.

CAMERA MODE

LENS SETTING

Zoom to widest possible

SENSOR/FILM SPEED

Use a **Low** ISO setting

FLASH

Force the flash Off

TRY A CONVENTIONAL APPROACH

The reasons behind the familiar views of any city landmark are revealed when you visit the site. There is often a limited number of uninterrupted views, so most shots are taken from what seems to be the best spot.

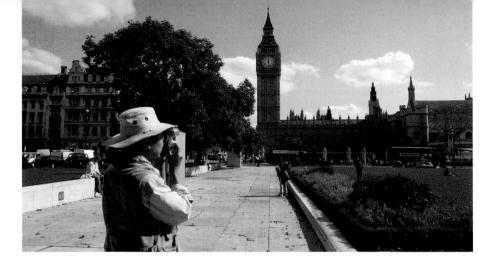

2

IDENTIFY PROBLEMS

It is natural to try to get close to your subject, but this gives rise to a number of issues. First, it is difficult to shoot a tall building without making it appear to lean back. Second, shooting towards a bright sky causes exposure problems.

INCLUDE OTHER ICONS

Avoid taking obvious pictures, as well as the problems of close shots, by moving some distance away. This may also enable you to include other city icons – in this case, transport signs, red buses, and traditional telephone boxes. Look for a composition that brings an element of surprise or informality.

World landmarks

The world is so thoroughly photographed that it is almost impossible to make a wholly original photograph of any of the great landmarks and monuments. But you should still strive to create images that are more interesting than the ordinary snap, which usually captures only the most obvious view in a cursory way. The key is to work with the available light and to take the time to appreciate the landmark's visual character.

CHANGING LIGHT

One of the glories of the Taj Mahal in Agra, India, is that it is breathtakingly beautiful in any light. The marble reflects any bright light, and its outlines are eloquent even in fog.

TIGHT CROP

Many monuments, such as the Statue of Liberty, are extremely difficult to access. That being so, start shooting as soon as it comes into view.

Use a long zoom to crop in on the key features and to highlight the texture of the surface.

Shoot from different angles to find a telling outline and to make use of the negative space around the statue.

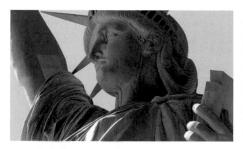

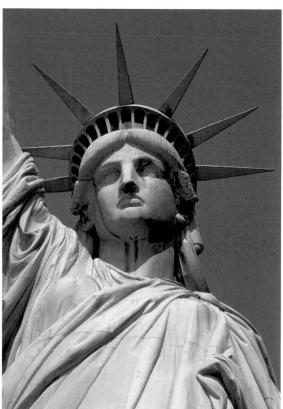

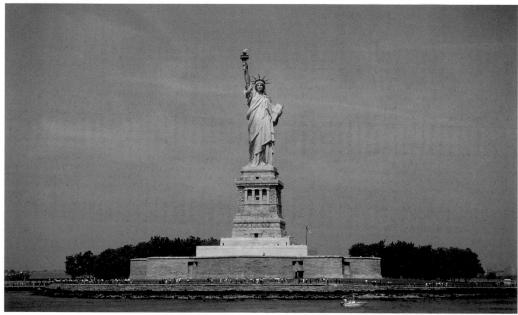

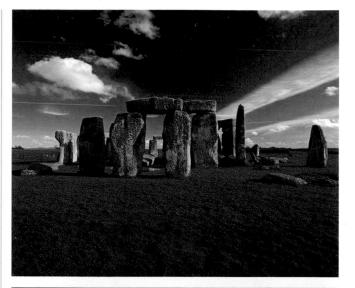

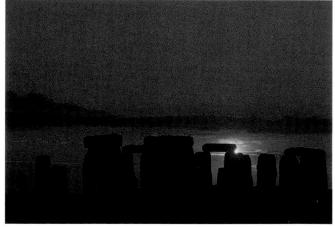

EVOCATIVE COMPOSITIONS

It is a luxury to be able to visit a landmark at different times of the day. If you do, it is worthwhile comparing the effects of different lighting and colours on the same scene. These two views of Stonehenge, England, evoke completely different feelings.

Shoot in broad daylight to capture vibrant colours, strong shadows, and clouds.

Create a more atmospheric image by shooting a silhouette of the landmark at sunset.

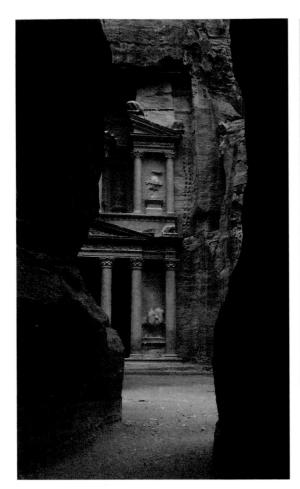

FRAMING DEVICE

This view of Petra, Jordan, works particularly well thanks to the framing device created by the walls of the ravine, which open out to reveal the astonishing carving.

Experiment with both portrait and landscape formats. Each will emphasize different features of the landmark.

Use maximum depth of field if you wish to keep both the frame and the main subject as sharp as possible.

Expose for the main subject, otherwise the dark periphery may cause the camera to miscalculate the correct exposure.

DISTINCTIVE SHAPES

Buildings with strong, unusual shapes – such as the Sydney Opera House – can dominate the landscape for miles around. Take advantage of that, and photograph from different distances and angles.

- Make full use of your zoom irrespective of the distance. Use both wide and long from both far and near.
- Try photographing in black and white: grey tones are effective at highlighting shapes and geometrical forms.
- You do not have to get all of the building into a shot: a portion can be just as revealing as an overall view.

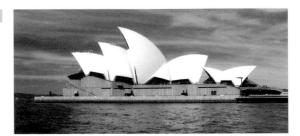

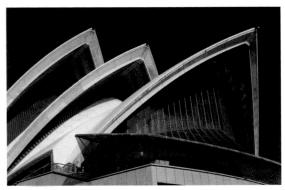

- Concentrate on capturing the subtle colours of the sky, and allow the pyramids to fall into silhouette.
 - Try photographing your subject from different angles and with different lens settings it does not necessarily have to fill the frame in every shot.

ENHANCING TEXTURES

There is a romance about ancient ruins, such as the Temple of Poseidon in Athens, that is always photogenic. You can enhance the appearance of old white stone or marble by contrasting it with deep blue skies.

- Try to keep the camera level to minimize the effect of converging verticals.
- Use a polarizing filter of the type recommended for your camera.
- Use a long exposure to maximize depth of field for overall sharpness.

TWILIGHT BALANCE

The magic hour for photographing urban landmarks such as the Eiffel Tower is twilight, when the sky darkens and artificial lights come on.

- Try different exposure settings to see which gives the best results for colour and tone.
- Use a tripod if possible, to avoid having to set a high sensitivity in compensation for the low light.

Radiant stained glass

Many original stained-glass windows in cathedrals and other places of worship were first made when glass was a precious commodity, as a statement about wealth – both financial and spiritual. Designed as they were to dazzle and inspire awe, they naturally draw the photographer to them. In order to render the colours accurately, you will need to expose for the light in the windows, while ignoring the darkness surrounding them.

The interiors of cathedr

The interiors of cathedrals are usually dimly lit. You may not be permitted to use a tripod, but there are many pews, chairs, and pillars you can lean on to steady the camera.

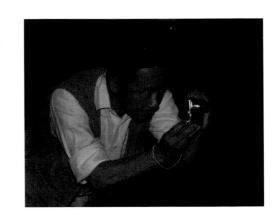

GET T EXPO

GET THE RIGHT EXPOSURE

Strike a balance between under- and overexposing. Bringing out shadow detail in the stonework will bleach out the colours in the window. It is usually best to expose for the window.

MAKE YOUR SETTINGS

Flash photography is usually forbidden in places of worship, but it will probably be useless to your picture, anyway, so switch flash off. Setting a medium sensitivity will help you capture details of pattern and colour in the window.

TRY DIFFERENT APPROACHES

A dramatic view looking up from underneath the window exploits converging parallels as a visual device. If you are not keen on this effect, try capturing details within the windows, or use a wide-angle view to capture something of the soaring, inspiring spaces.

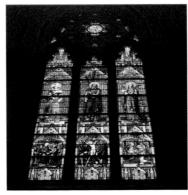

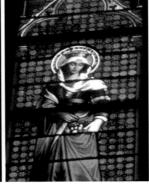

FOR THIS SHOT

Shooting from the opposite side of the cathedral, I chose the longest zoom setting to fill the frame, reducing the need to tilt upwards too much. I set medium sensitivity to balance an acceptable exposure time with quality.

CAMERA MODE

Set your dial to **Auto-exposure mode**

Zoom to Maximum Telephoto

Use a **Medium** ISO setting

FLASH

Force the flash Off

Put the window into context, and explore the effects of varying the visual balance between the window and the interior space.

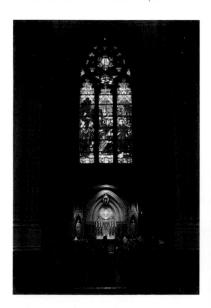

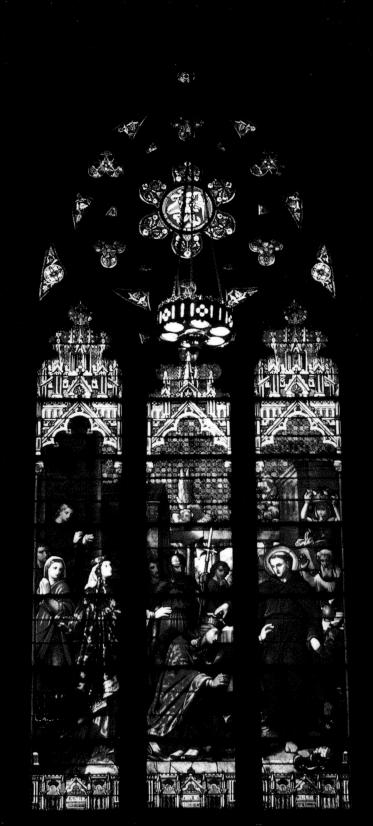

City fountains

Fountains in town squares are designed to be the centre of attention, a focus of activity, and an artistic showpiece. One of the basic decisions a photographer must make is whether to focus on the subject itself – the fountain – or on the life around it, trying to place the fountain in its context. The simplest approach is to concentrate on the fountain as an architectural entity: the details of the statuary and the water jets are more than enough to delight the eye.

TWILIGHT SHOTS

Many fountains are atmospherically illuminated at night. Wait for twilight, when the sky is dark enough for the lights to be on, but not yet black. The results are warm colours from the lights, but some colour in the sky, too. Long exposures make water streams appear milky.

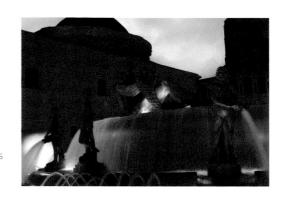

OBSERVE WATER TEXTURE

Most fountains provide different kinds of water – from fast jets to light spray. Take a few test shots to determine which is the type of water texture that most appeals to you.

2

PROTECT YOUR CAMERA

The fine mist produced by fountains drifts in the wind, so make sure you are upwind to avoid spray damaging the camera. If the sun is out and you stand with your back to it, you may see a small rainbow

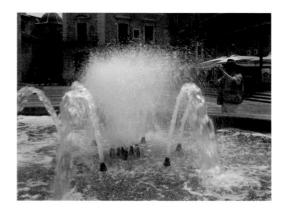

CAPTURE CHARACTER

Pigeons and other birds often congregate around fountains, using them as a lookout point and a birdbath. They are part of the character of the fountain, so take some fun shots that reflect this

INCLUDE CONTEXT

Walk around the fountain, looking for pleasing combinations of water, statuary, and background. Select a wide-angle view to include the surroundings even when your viewpoint is close to the fountain.

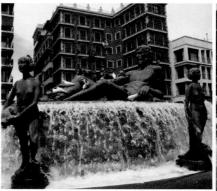

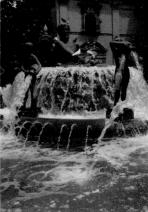

FOR THIS SHOT

I set the zoom to telephoto to throw the background out of focus. A shutter setting of 1/320 sec captured just the right amount of movement in the water. I also used the flash to fill in shadows.

CAMERA MODE

LENS SETTING

Zoom to Telephoto to Normal

SENSOR/FILM SPEED

Use a **Medium** to **Low** ISO setting

FLASH

Force the flash **On**

DECIDE ON AN EFFECT

Use long exposures - for example, $1/_{30}$ of a second – to give the water a milky effect, and very short exposures to make the water appear frozen.

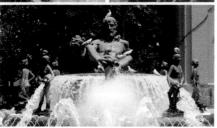

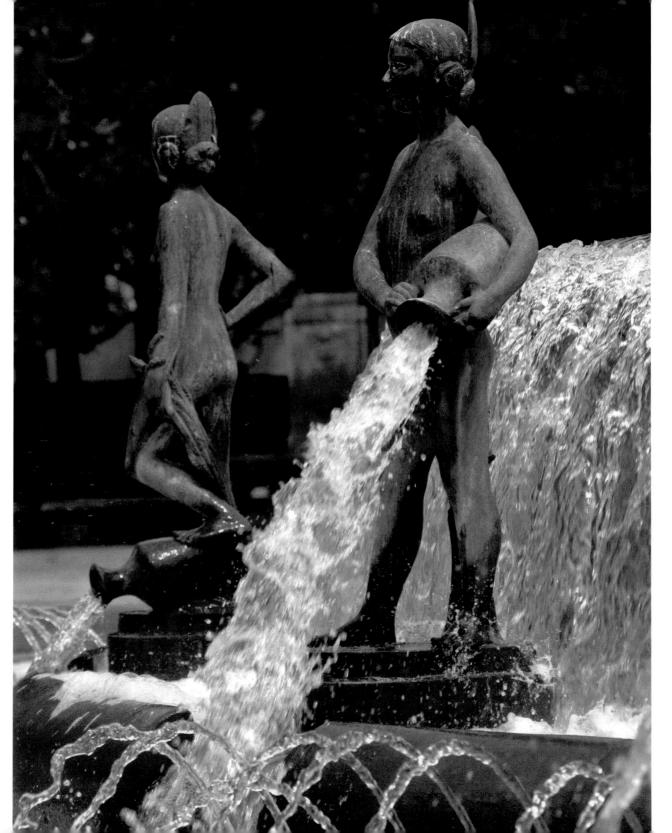

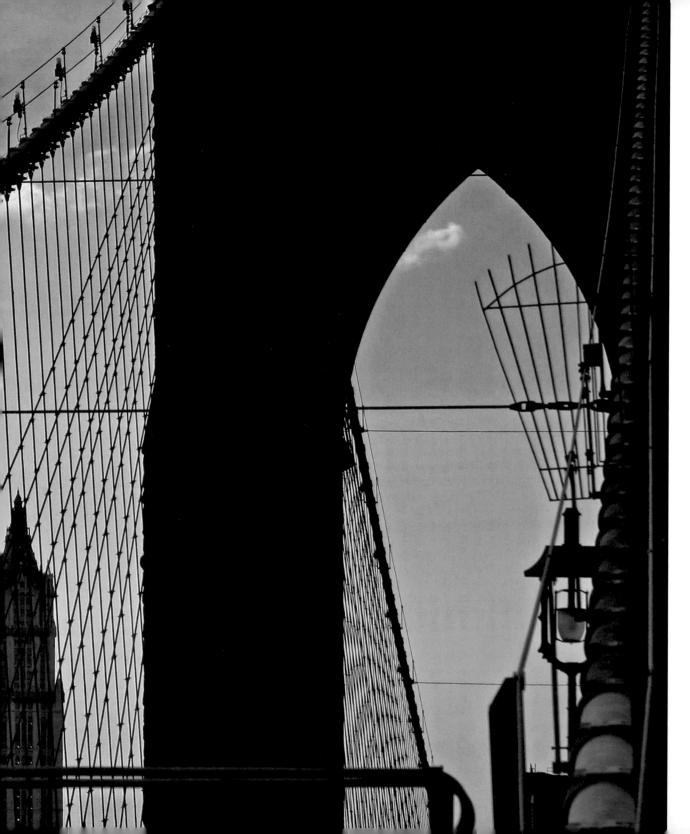

BRIDGE IN SILHOUETTE

In this picture, the struts and cables of New York's Brooklyn Bridge have been used as a framing device for the city skyline beyond. Look out for similar opportunities, which are manifold in modern urban environments.

- Expose for the sky: this has the effect of making the foreground very dark.
- If necessary, force a little underexposure for the darkest silhouettes.
- Use a long zoom setting to cut out unwanted foreground elements and concentrate on graphic shapes and outlines.

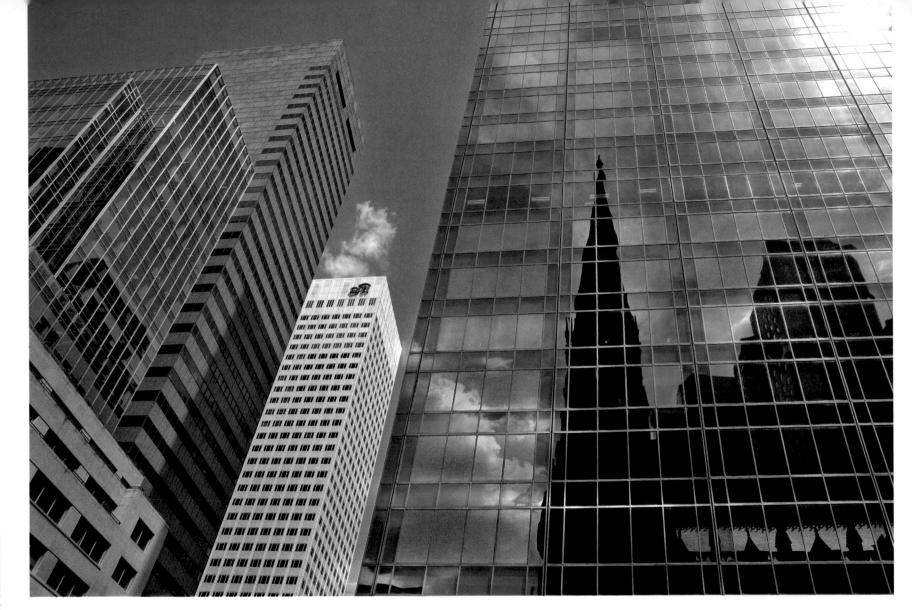

Contrasting old and new

More often than not, cityscapes are dominated by a contrasting variety of architectural styles: Gothic churches rub shoulders with modern office blocks, and 19th-century buildings share space with state-of-the-art glass skyscrapers.

This urban juxtaposition can lead to a uniquely photographic endeavour. We look for ways in which viewpoint, colour, tone, and composition fuse together to create an image of contrasts and many layers.

«

FOR THIS SHOT

With a wide-angle zoom setting, I caught this passing cloud on the gold-covered windows while sunlight was being reflected off the cathedral's roof. I used a low ISO setting and large file size to maximize image quality.

CAMERA MODE

Set your dial to Landscape mode

LENS SETTING

Zoom to Wide Angle

SENSOR/FILM SPEED

Use a **Low** ISO setting

FLASH

Force the flash Off

SURVEY THE LOCATION

Walk around the area of interest looking for potential points of view. Be open-minded: from a different angle, a location of apparent little promise may yield the day's best picture.

SI

SET THE CAMERA

If possible, leave the lens at a fixed setting so you can focus your attention on composition rather than lens controls. In most cases, wide angle is the most versatile setting; this is also, conveniently, the default on most cameras that switch themselves off if they are not used for a few minutes.

TRY DIFFERENT ORIENTATIONS

Consider tilting the camera at an unusual angle, either vertical or horizontal. The correct angle to shoot a scene is not always the one that follows the upright, formal orientation, but the one that gives you the best picture.

EXPERIMENT WITH VARIOUS COMPOSITIONS

The obvious approach here is to contrast the ornate neo-Gothic spire with the modern glass building. All these pictures have their merits, but they lack something special. Keep shooting until you find a composition that you are happy with.

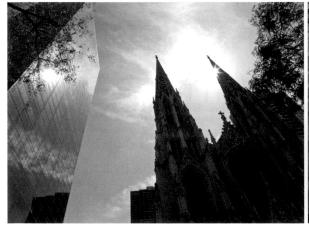

EVERYDAY SIGHTS

When walking around a city, it is possible to photograph almost every step of the way, recording shop fronts, changes in light, signage, graffiti, and much more. While individually, each picture may seem of little significance, as a collection they make a powerful impression.

- Use a small to medium image size to maximize your memory card's capacity.
- Photograph from all angles, and try slanting the camera for graphic variety.
- Record in both landscape and portrait formats to give you greater flexibility with your images later.

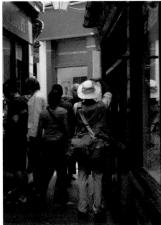

DOORS AND DOORWAYS

One universally recognizable theme for photography is that of doors and doorways. Whether you see them as symbolic or simply decorative, as a collection they have a strong visual impact. For variety, you might include pictures through partially open doors, into the street or passageway beyond.

- Use a mid-range zoom setting and hold the camera square for the least amount of distortion.
 - Include people walking in the street or through the door to create more visual interest.
 - Take close-up shots of door furniture and other details, to vary the scale of your pictures.

Reflected city

As photogenic as they are, many buildings suffer from an excess of familiarity. When faced with an iconic skyscraper or a world-famous cathedral, it is easy to rely on hackneyed old viewpoints. However, by looking for unusual views, you will have much more fun. You will also see more than the average photographer, since your search will be purposeful: by looking for a new perspective on what you think you know well, you extend the reach of your photography.

SEEK REFLECTIONS

Instead of looking at the buildings themselves, concentrate on reflective surfaces that project back the surrounding architecture, such as the polished bonnet of a car.

REFLECTIONS AND DEPTH OF FIELD

Reflections - whether on a pool of water, a polished surface, or shiny glass make up a major element of the visual experience of a modern cityscape. Pictures of reflections are most effective when you have maximum depth of field, so strive to get as much of the image as sharp as possible when you compose.

VARY THE VIEW

Create interesting distortions and reworkings of the buildings' lines by moving the camera to different angles.

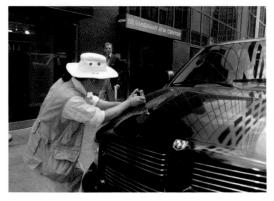

FIND A VISUAL **PATHWAY**

The black surface absorbs a great deal of light, darkening the reflected sky and making it easy to set the right exposure. The curves of the car lead the eye to the building in the background.

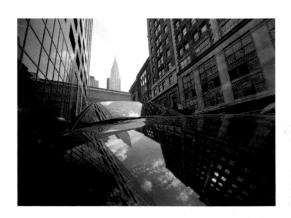

>>

FOR THIS SHOT

I selected the landscape mode for the greatest depth of field and used the widest lens setting to capture as wide a view as possible. Low sensitivity ensured the best quality, and I used the car for support.

CAMERA MODE

Set your dial to Landscape mode

LENS SETTING

Zoom to Maximum Wide Angle

SENSOR/FILM SPEED

Use a **Low** ISO setting

FLASH

Force the flash Off

TRY DIFFERENT POSITIONS

Even the subtlest changes in position can make a big difference to the final images, so take the time to experiment.

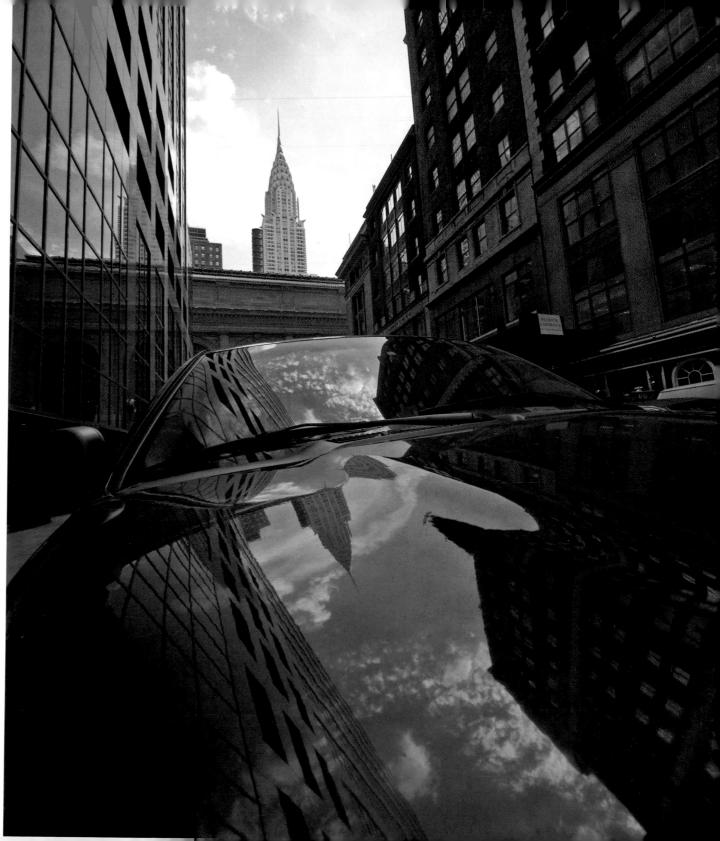

POWER OF PATTERNS

Any urban environment may offer regularly repeating patterns of simple shapes. Create strongly graphic images by isolating them in your shot.

ALTERNATIVE FOCUS

For an unusual take on a building, look for interesting contrasts. Here, the delicate cherry blossoms highlight the geometry of the temple's red eaves.

WIDE INTERIORS

Some interiors work best when photographed in wide angle. Alternatively, you can take a series of shots and stitch them together on a computer.

VISUAL INTEREST

Try showing modern buildings juxtaposed and overlapping with their neighbours to create a visual puzzle and, therefore, a more intriguing image.

EXPLOITING NATURAL LIGHT

Taking photographs in bright sunlight can be tricky, but you can exploit its effects. Here, the hard shadows and the silhouette add depth and contrast.

Events can be big or small, formal or informal. They run the gamut from a child's birthday party to a sporting spectacle. But regardless of the scale and type of event, cameras will always be present. Photography has become an essential part of any gathering. The ability of photography to transcend the documentary to enshrine, and even recapture in memory, the event being recorded means that the key moments in our lives all seem to call for a photographer. You will learn that to create successful images, not only will you use all the elements of photography such as colour and light, composition and timing, focus and zoom, you must also plan for all eventualities and be able to rise to unexpected challenges.

An explosion of colour

Stills photography can be very successful at capturing the dazzling beauty of fireworks, for the same reason that these spectacular effects are stunning to look at with the naked eye. Against the darkness of the night sky, any sudden burst of bright light and vivid colours appears even more brilliant. Use a long exposure to capture the fireworks' trajectories, or a short shutter time to catch the exact moment the fireworks explode.

THE RIGHT EXPOSURE

A common problem when photographing fireworks is ending up with images that show illuminated smoke rather than an explosion of lights and colours. A long exposure will counter that issue – but not too long, or it can lead to blurred light trails, while too short an exposure leads to short light trails. Use the aperture to control the exposure.

a promising foreground.

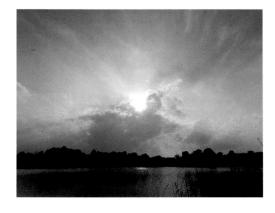

SET UP IN ADVANCE

For relatively long exposures, you will need to use a tripod to support the camera. Set this up while there is still light. Here I kept the camera fairly low to catch reflections from the fireworks in the lake.

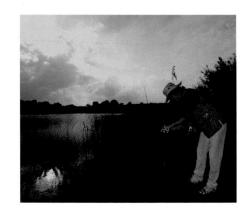

SET THE CAMERA
You will be working in the dark, so carry a small torch to help you make your settings. Turn flash and, if possible, autofocus off. Use the manual

exposure control.

ON IN THE SHOW

Fireworks usually build up to a big climax, so use the early stages to perfect your framing and exposure times. Lean lightly on the camera and tripod during exposure to ensure a steady shot.

I set the zoom to normal, with a low to medium sensitivity to ensure the best image quality. With the autofocus switched off, I set the manual exposure mode to f/5.6 and 1/15 sec, then forced the flash off.

CAMERA MODE

LENS SETTING

SENSOR/FILM SPEED

Use a **Low** ISO setting

Force the flash Off

GET THE TIMING RIGHT

Depending on your camera, you might need to press the shutter while the rocket is going up or at the moment it explodes, so that you catch the best effect.

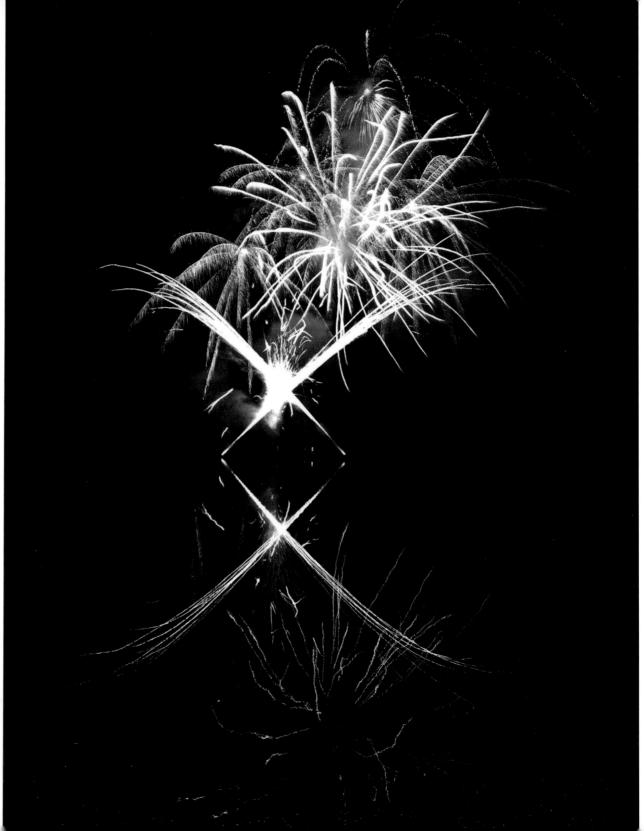

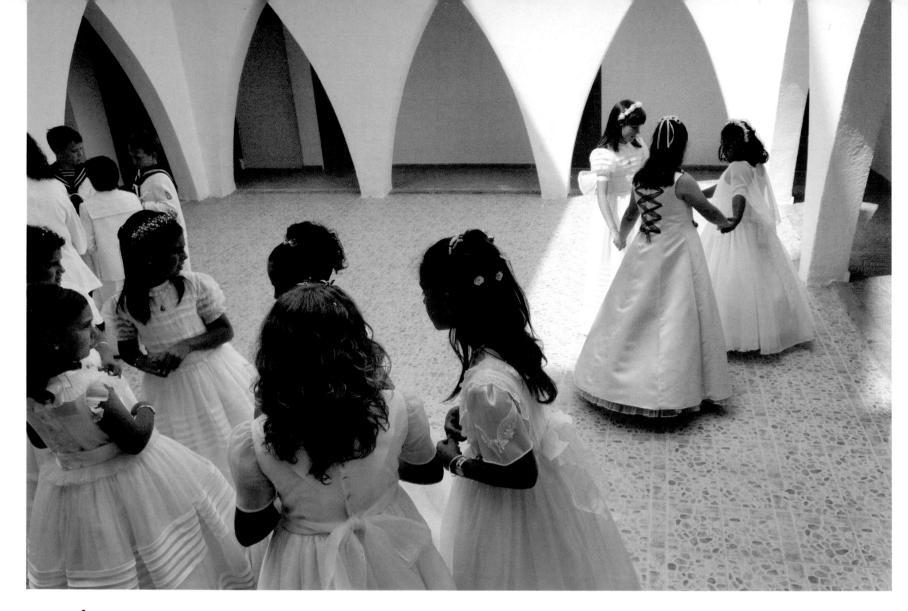

Milestone moments

In most cultures and religions, there are ceremonies and events in which children are dressed in special costumes and are the focus of attention for the day. Such occasions are as important for the rest of the family as they are for the children involved. Try to capture the event as a whole, showing the child taking part in a ritual shared with peers, friends, and classmates. This approach is demanding, but it will provide a rich, comprehensive record of the event.

«

FOR THIS SHOT

A high sensitivity allowed me to capture movement easily, and I opted to show as much of the scene as possible with a wideangle setting. Flash may help in poor light, but results may be less attractive than those lit naturally.

CAMERA MODE

Set your dial to Sports mode

LENS SETTING

Zoom to Wide Angle

SENSOR/FILM SPEED

Use a **Medium** to **High** ISO setting

FLASH

Force the flash **On** if needed

Investigate the venue before the event, so that you understand how the light falls, where people will enter or wait, and so on. While you are there, try to introduce yourself to someone official. This is also a good time to find out whether there are any restrictions on where and when to shoot.

BE AWARE OF OTHERS

On the day, lots of friends and families will be trying to take pictures. Be considerate to others while still trying to secure the best position for your own photographic needs.

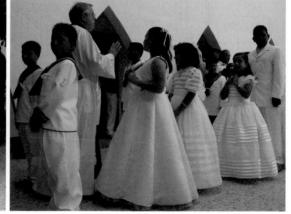

FIND THE LITTLE DETAILS

Look for telling moments that speak of the emotion, nervousness, or intimacy involved in the event being recorded.

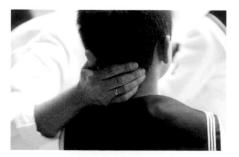

MOVE OVERHEAD

In crowds, a view from above is always an advantage. Hold the camera high above your head when shooting. With young children, this also emphasizes how small they are.

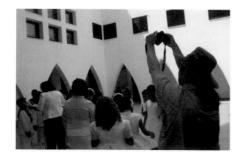

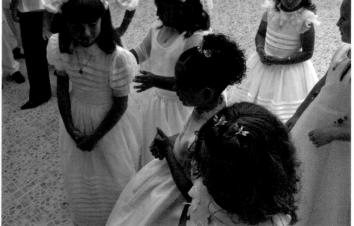

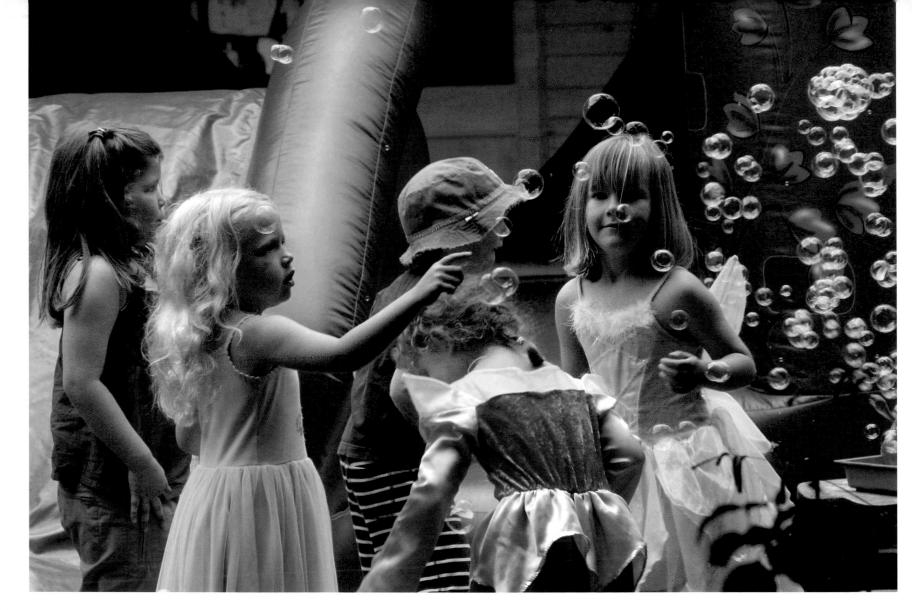

A children's party

As an adult at a children's party, it is likely that you will be banished to the sidelines. Use this opportunity to pay attention to the activities of the little ones, and you may be able to capture many delightful candid moments.

Keep an eye on the background or context in which the children are playing, and remember that there is a natural rise and fall in the intensity of children's games: watch the development of any activity so you can catch it as it peaks.

I wanted to remain as inconspicuous as possible, so I set the zoom to maximum telephoto, which also flattened the perspective. With sensitivity set to medium-high because it was a slightly dull day, the flash was not necessary.

CAMERA MODE

Set your dial to Program mode

LENS SETTING

Zoom to Maximum Telephoto

SENSOR/FILM SPEED

Use a Medium ISO setting

FLASH

Force the flash Off

CONSIDER THE OPTIONS

Start by watching the proceedings from a distance rather than rushing into the thick of the action. Here, this approach enabled me to discover other appealing supplementary shots before moving in closer.

GET CLOSER TO THE ACTION

Move to where the main activity is taking place. Take individual portraits of the children, trying to capture amusing expressions, as well as group shots that reveal the fun of the party.

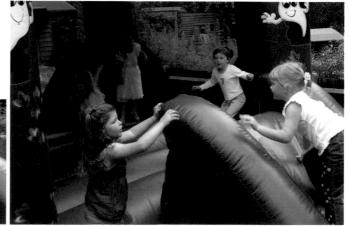

CHANGE THE SETTINGS

Once you find the closeup viewpoint you are most happy with, adjust your camera's settings accordingly – you may not have time to do so once the action starts to unfold. It is also a good idea to decide on a zoom setting and stick with it, changing it only if the situation changes.

MOVE PROPS AS NECESSARY

The bubble machine was a great attraction. In its original location, however, the background was rather dull. Moving it close to the bouncy castle, with its gaudy decoration, created just the right setting for the shot.

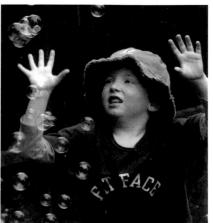

Wedding-day details

As a celebration that is central to most cultures, a wedding is full of rites, customs, costumes, and festivities. All of these elements provide the potential for a wealth of wonderful photographic compositions. Your coverage of a wedding, therefore, can document anything from details of dresses and decorations, to the spirit of celebration and the rituals and ceremonies that are central to the event.

EXQUISITE DETAIL

The bride's dress is an important part of the wedding, so show it in its entirety, but focus on small details such as embroidery and trimmings, too.

- Use a long lens so that your subjects do not feel too self-conscious.
- 2 Expose for the skin tones to ensure accurate rendering of white fabrics.

A CLASSIC LOOK

It is always worth having some blackand-white images among your wedding pictures. The neutral tones confer a timelessness to the photographs.

- Take photographs in colour and convert a selection to black and white later.
- Experiment with tone and contrast when converting images to black and white.
- **3**Ensure the blacks are dark and the whites carry some detail. Your mid-tones will then be accurate.

CRUCIAL MOMENTS

At key points in the day, such as the cutting of the cake, there is likely to be a rush for the best vantage points. You may even have to hold your camera above the crowd.

- Get into position early if it is possible without being unceremonious.
- Set a high ISO and turn off the flash for the bestquality lighting.

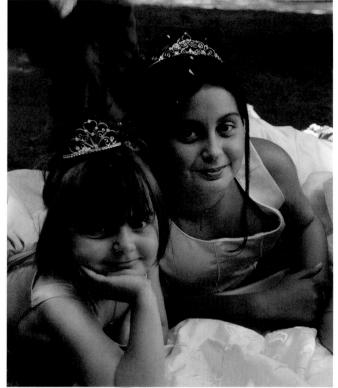

SECONDARY PLAYERS

Although children may play a relatively small role in the ceremony, they often provide the most delightful pictures, so be sure to photograph them.

- Avoid using flash: the light is unkind to the subtle tones of children's skin.
- Use a long zoom setting if you wish to minimize background clutter.
- Avoid taking portraits under trees, since this can give skin a green tone.

WEDDING ENVIRONMENT

As well as the participants, weddings also transform the space in which they take place, so take pictures of the decorations and table settings, too.

- Try using both maximum and minimum depth of field for different feels to the images.
- Use natural light to capture all the colours and details of the day.

FOCUS ON THE FLOWERS

One of the most popular photographic subjects on the big day is the floral arrangement – in particular, the bride's bouquet. Make sure you capture it in a variety of pictures, along with other elements that embody the whole event.

- Zoom into the flowers, but include the dress and the bride's hands for context.
- On sunny days, use fill-in flash to help reduce the strength of shadows.
- White dresses and black suits can mislead the camera: measure the right exposure from the skin tones.

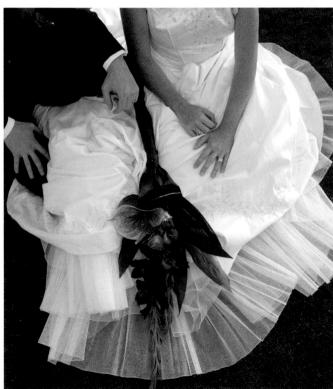

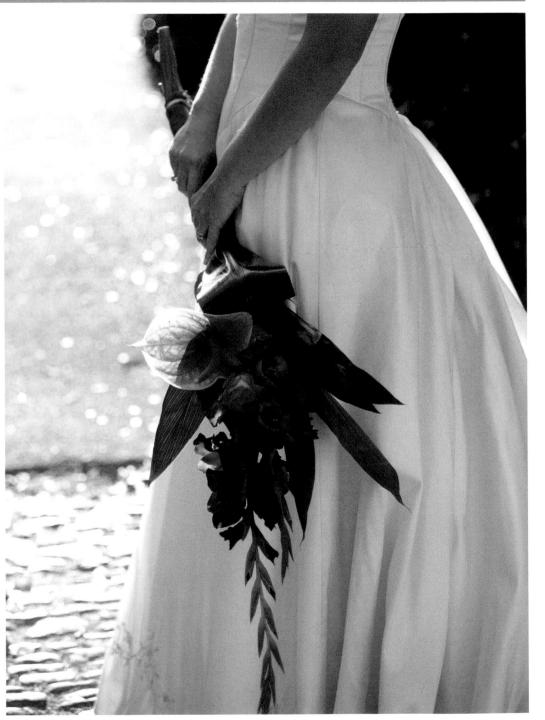

CAKE STUDY

Many wedding cakes are almost works of art. Approach this subject as you would a still-life project, and shoot from different angles and distances for a variety of compositions.

- Photograph the cake in soft, open light, such as that from a window.
- Overexpose a little to ensure pure white elements are rendered white.
- 3 Set the highest image quality and low ISO for the finest details.

BACKSTAGE ACTIVITY

The preparatory activities before the wedding are ideal subjects for candid photography. Pictures of the bride in a reflective mood provide a nice counterpoint to more traditional wedding pictures.

- Use this opportunity to get close to the action, since there may not be enough room for a long zoom.
- 2 Use the flash only if lighting conditions demand it.

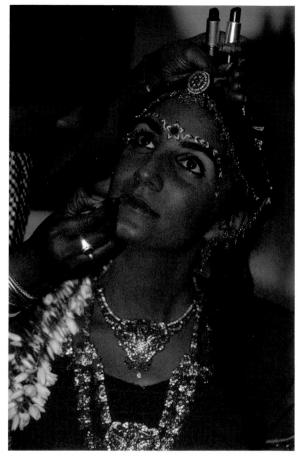

CANDID SHOTS

For really successful wedding photography, it is necessary to disengage from the festivities from time to time in order to observe the actions of some of the other guests.

Turn off the flash if you wish to avoid drawing attention to yourself and capture candid moments.

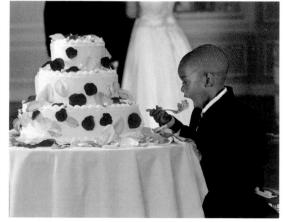

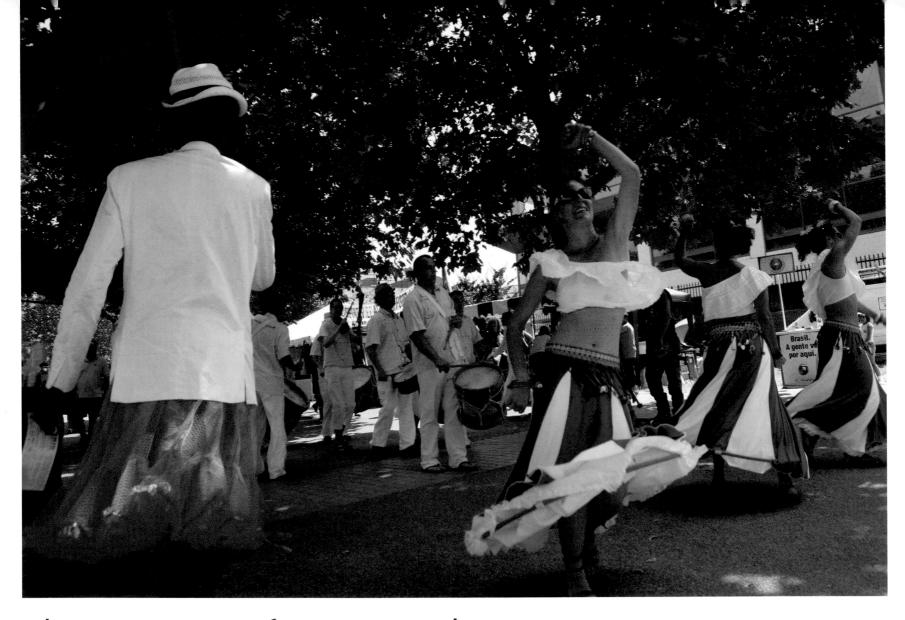

The spirit of carnival

Events such as carnivals, street parties, and fêtes create endless opportunities for lively, colourful images. Since everyone taking part in the celebrations expects to be photographed, you can almost guarantee interesting poses and smiling faces. In order to capture the truest spirit of the festivities, get into the middle of the action and just keep shooting. Your pictures will tap into the sense of fun that informs the occasion.

I set and left the zoom at wide angle. Despite the bright conditions, I decided to use medium to high sensitivity to capture lively movement better. I also put the flash on automatic to help fill in any shadows where needed.

CAMERA MODE

Set your dial to Sports mode

LENS SETTING

Zoom to Wide Angle

SENSOR/FILM SPEED

Use a **High** ISO setting

FLASH

Force the flash to Automatic

IMMERSE YOURSELF

Get right into the middle of the action, mingle, and move through the crowds. Most participants in the parade will be happy to have their picture taken, so

you have no reason to feel inhibited. Smile and make eye contact with your subject: most people will smile back. If they don't, simply move on.

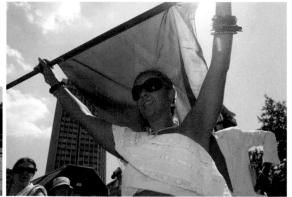

TAKE IT ALL IN

Photograph everyone: dancers, band members, and any flamboyant characters. You can also try various techniques, such as using the flash in the shade, or turning it off altogether. Consider taking shots from a higher vantage point, too.

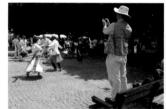

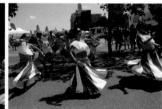

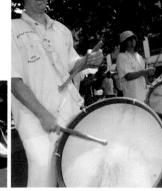

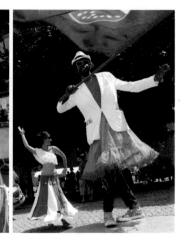

CHANGE YOUR POSITION

For variety, try shooting from a low viewpoint. This is especially useful for catching the swirling movement of the dancers' skirts.

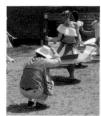

CAPTURE THE JOY

Make sure to get a sense of fun and celebration in your shots. Get up close to people enjoying themselves to capture their smiles. Use a wideangle setting and do not worry about framing accurately – grabbing the moment is more important than careful composition.

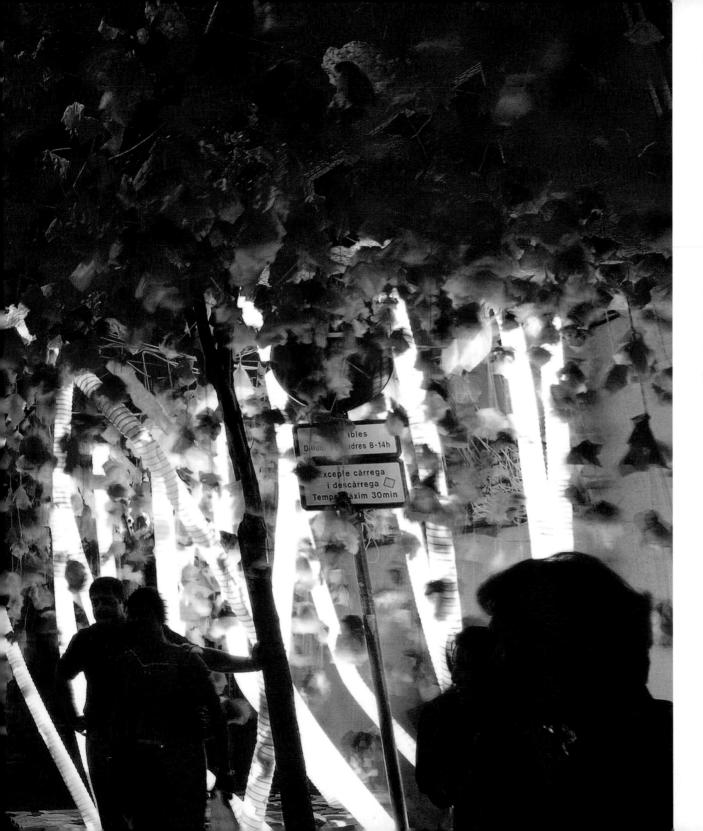

URBAN REVELS

There are many street festivals, such as Barcelona's Fiesta de Gràcia, that pit one street or one quarter of the city against another for the best, most colourful, and most elaborate decorations. These events are a gift to the travelling photographer.

- Be sure to photograph people enjoying the festival, as well as the street decorations.
- Use the full range of camera settings and try out lots of different viewpoints.
- 3 Use the LCD on your camera to show the locals your pictures. Some people may direct you to even better locations.

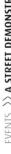

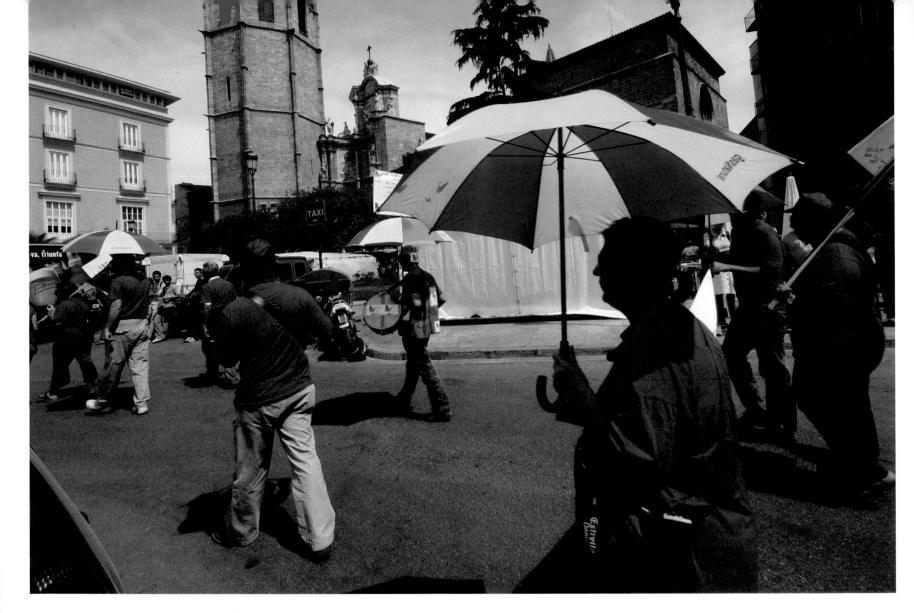

A street demonstration

You may be involved in a march because it highlights a cause that is close to your heart, or you may simply be an interested bystander. Either way, the chance to document a demonstration should not be missed. Those involved in the march can use the pictures on the campaign's website, in pamphlets, and to raise awareness in the media. The need, then, is to ensure that you obtain colourful, well-composed images that help promote the cause.

I moved inside the procession and used a wide-angle zoom setting to capture the marchers and create a colourful, graphic composition. Flash helped fill in the shadows, but the bright sun ensured a good depth of field.

CAMERA MODE

Set your dial to Sports mode

LENS SETTING

Zoom to Wide Angle

SENSOR/FILM SPEED

Use a Medium to High ISO setting

FLASH

Force the flash On

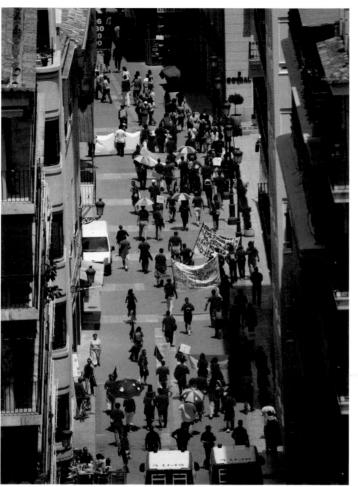

POSITION YOURSELF

If possible, survey the path that the march will take. High vantage points that offer good views of the procession can be useful, but remember that you will need time to return to street level. If you have just chanced upon the demo, it might be wise to stick with the crowd.

COMPRESS THE VIEW

Use a long focal-length setting and photograph from the front. The spatial compression gives the impression of greater numbers in a small group.

sensitivity setting to

ensure extensive

depth of field.

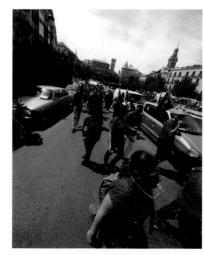

MIX WITH THE CROWD

To obtain a variety of images, you must mingle with the crowd, even if you are not involved. This calls for some physical fitness,

since you will have to walk, stop, and perhaps crouch down to take a shot, then run to catch up and do it all again.

Festivals around the world

If you are travelling abroad, or even within your own country, try to time your visit with seasonal festivals. As well as stocking up on memory cards and spare batteries, your preparation should include learning about the festival in question and, if possible, taking a reconnaissance trip for the best vantage points beforehand. This way, you will know what to expect and where the best of the action is likely to take place.

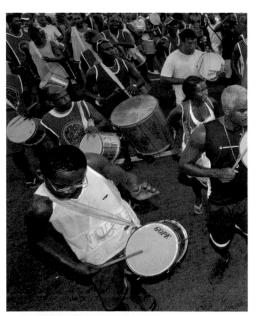

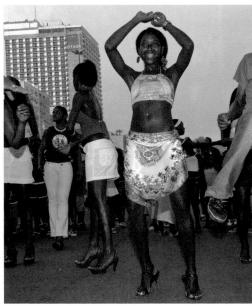

Mardi Gras festivals are noted for their extravagance, high energy, and excesses, all in preparation for the abstinence of Lent. As a photographer, you will be as much part of the event as anyone else. Shoot freely and continuously: those reluctant to be photographed will be very few, and you will have no time to review pictures as you photograph.

- Hold your camera high above your head to reach above the crowds and obtain a general view.
- Shoot from street level too, since the low viewpoint helps to emphasize the liveliness of the dancing.
- Use flash or short exposures to freeze the movement. You could also try longer shutter times for blur.

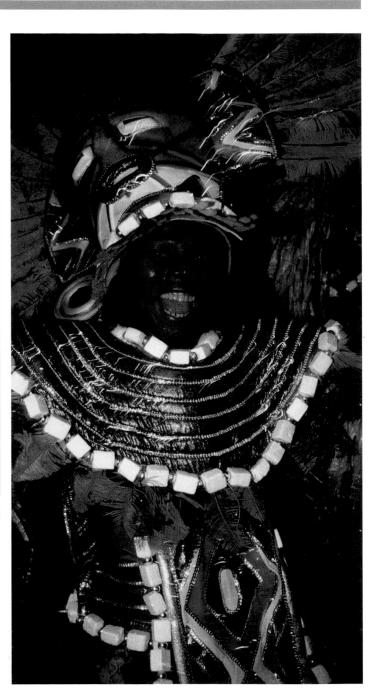

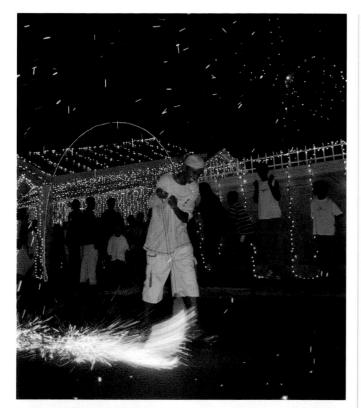

LIGHT IN DARKNESS

Night-time festivals make full use of light – often as a symbol of the victory of good over evil. The dark background gives you the chance to write with light in a literal way, using long exposures for light trails. These pictures were taken at the Diwali Festival of Lights.

- Use flash with long exposure to combine sharp elements and movement blur.
- Check your initial shots: you may need to reduce exposure for solid blacks.
 - Use a small tripod to combine manoeuvrability with stability, if needed.

- 2 Capture the exuberance of the festival by getting right into the thick of the action.
- Take general shots of the mayhem as well as portraits of individual revellers.

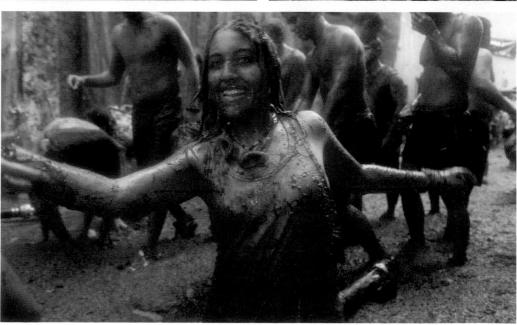

Intimate music venues

While big-name music artists often ban photography at their shows, emerging musicians who play small concerts in the back rooms of bars usually have no objections to having their picture taken, and are likely to welcome a photographic record of the event. If you are not a friend of the musicians, you can ensure a warm welcome by offering to give the management of the band or the venue a CD of your pictures, which could be used for future promotion.

BE RESPECTFUL OF THE AUDIENCE

In a small venue, you can get very close to the artists on stage. Be aware of how your activities could impact on others' enjoyment

of the show. Be as discreet and quiet as possible, changing position only between numbers.

TAKE PICTURES OF THE CROWD
Intimate concerts are as much about the audience as the artists.
For a well-rounded record of the evening, don't forget to turn around and capture a view of the crowd, or to take pictures from a vantage point at the back of the venue.

GET UP CLOSE AND PERSONAL
Get as close as you can to the stage.
This will give you the chance to
create individual portraits of the
members of the band. Performers
are rich subjects for photography,
and your records could even become
a valuable historical document of a
band before it hit the big time.

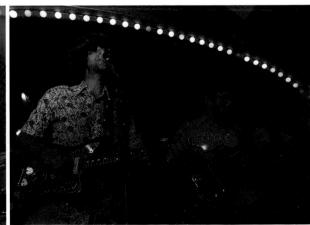

I set the highest sensitivity available on my camera, because the light levels were extremely low. I used the lens at wide angle for maximum aperture and turned off the flash.

CAMERA MODE

Set your dial to any automatic mode

LENS SETTING

Zoom to Wide Angle

SENSOR/FILM SPEED

Use a **High** ISO setting

Force the flash Off

AVOID USING THE FLASH

As well as killing the atmosphere, as in the image below, the flash is also distracting for both band and audience. Instead, rely on steady hands and a long exposure.

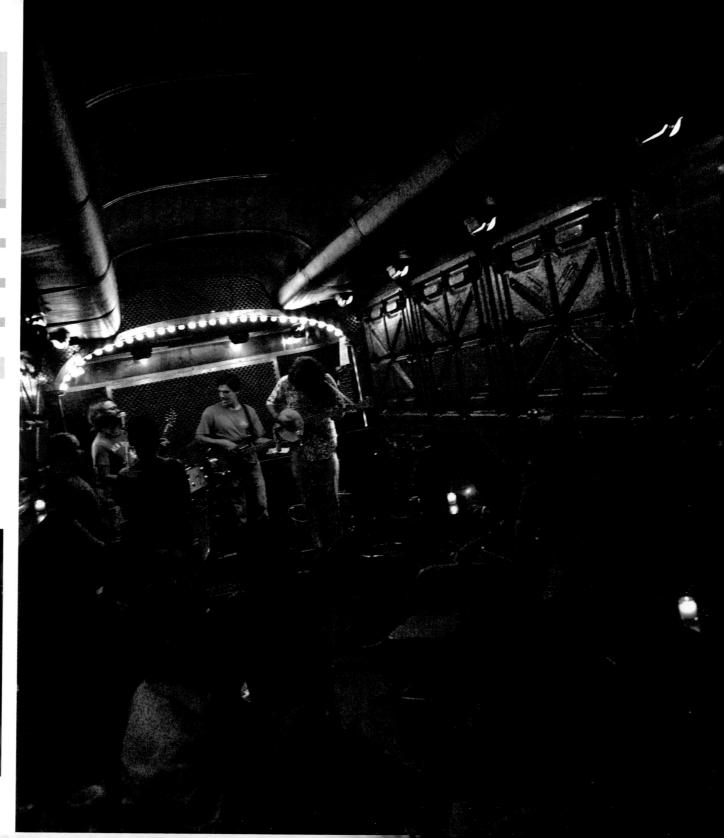

EVENTS >> GALLERY

EVENTS >> GALLERY

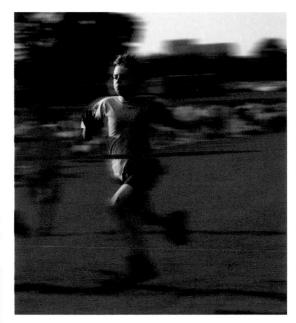

AT THE FINISH LINE

Position yourself just beyond the finish line for the best vantage point for school sports-day photos. Try panning the camera to create a sense of movement.

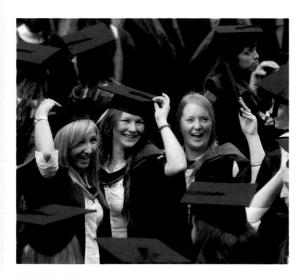

GROUP SHOT

On graduation day, as well as making the usual formal portrait, capture the elation shared by your subject and her colleagues. This enhances the sense of overall achievement and celebration.

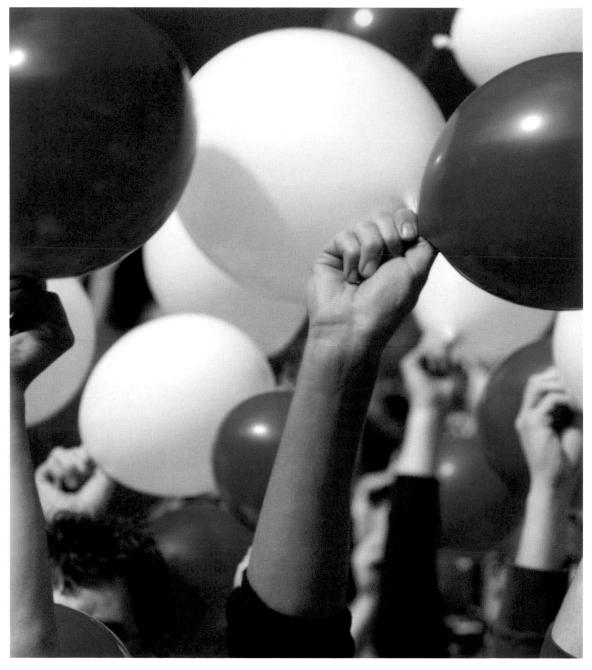

ABSTRACTING AN EVENT

At a sporting event, try turning your camera towards the crowds. The colourful display of balloons, flags, or streamers can make striking abstract compositions.

THRILL OF THE RACE

When photographing a cycle race, try to convey the speed and thrill of the competition by using long exposures to create zooming streaks of colour.

CELEBRITY ENCOUNTER

Big cities often hold film premieres with celebrity guests. Arrive early for a good spot, and use fill-in flash to balance available light for the best results.

COVERAGE BY PROXY

Even if you are unable to attend the match, you can still capture the spirit of the event. Try contrasting silhouettes of cheering fans against the brightness of a big screen.

Artistic expression

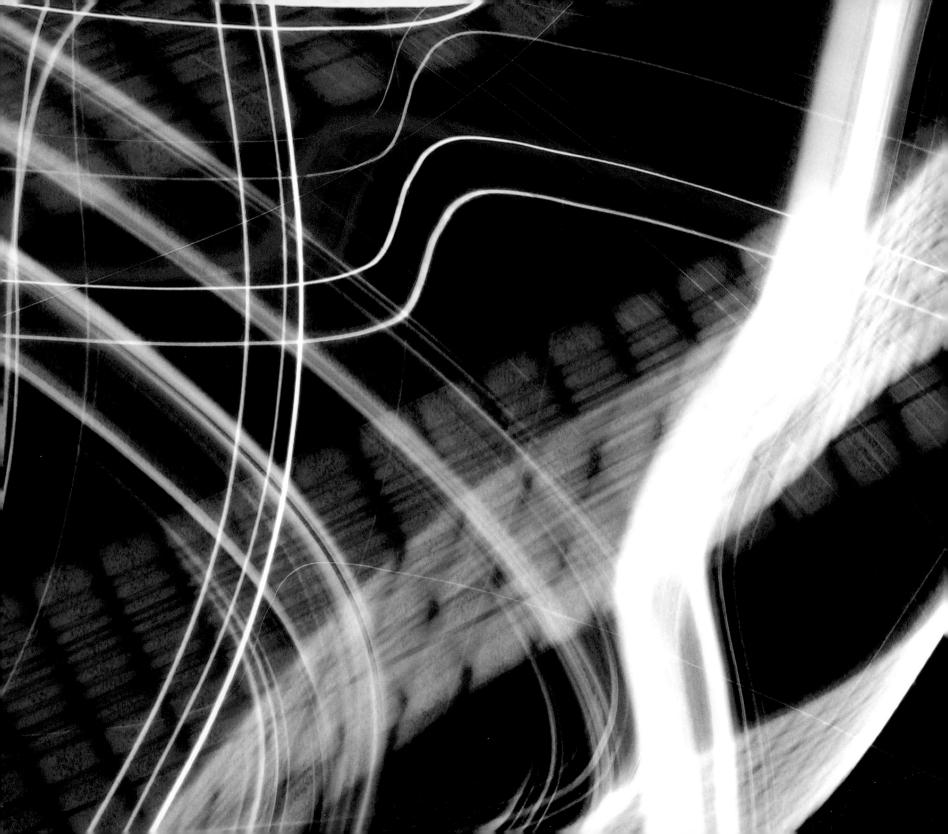

Artistic expression refers to picture-making at its most relaxed – unconcerned for propriety, custom, or conscience. Here you allow yourself to be yourself: it is photography in which you aim to satisfy only your own visual curiosity, allowing your imagination to follow where the light leads you. According to your mood or inclination, you may capture the minutiae of ephemera or the mixed messages of urban decay, toy with optical effects or create still lifes, enjoy movement of light or find patterns in chaos. For this, all the techniques of photography are at your disposal. Use motion blur, use distorted colours and fragmented shapes, create arrangements that inspire you, or work with what you find.

LIGHTS AND COLOURS

Photographing in a strongly coloured environment, such as this art installation, with its multiple coloured lights, can be complicated by the camera trying to correct for the colour. Check your images, and override this setting if necessary.

- When photographing very large artworks, include people to give a sense of scale.
- Try a straightforward, "objective" framing to present the art rather than your vision of it.
- If necessary, adjust colours later, on a computer, for the most accurate results.

Sharpness and blur

With their vibrant colours, gaudy brilliance, and musical accompaniment, fairground carousels are a sensory door to a world of childlike innocence and giddy fun. Designed to catch the eye from a distance, carousels really come into their own when they are in full swing. Thanks to their cyclical motion, they are also excellent subjects for experimental exposures to help you learn about the effects of different settings.

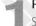

POSITION YOURSELF

Stand near the carousel to get a sense of its speed and look at the various horses. Select the one you wish to capture, and then choose your position. In this case, one side of the carousel was lit by the setting sun, so it was obvious where to stand.

FREEZE THE ACTION

The motion of the carousel can be frozen if you expose with short exposure times. Movement is also more easily arrested if you position yourself so that the horses are coming directly towards you. Experiment by trying the same shutter time on different parts of the ride.

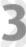

CHANGE YOUR SETTINGS

Set your camera to shutter priority so that you can control shutter times directly. If this facility is not available on your camera, shift the programmed settings for different shutter times.

MOVE WITH THE FLOW

Release the shutter when your chosen horse is in position. Don't worry if you catch just its head or its hindlegs at the start: you will have plenty of chances to get the timing right. Move with the horse as it passes you, so that some elements are sharp, and others blurred.

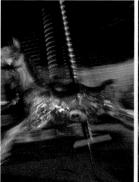

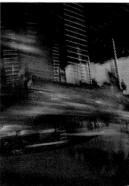

With a shutter time of 1/15 sec, I panned to follow the carousel's movement. This allowed me to catch one horse sharply while the rest are blurred. I varied the sensitivity to obtain the shutter time required.

CAMERA MODE

Set your dial to Shutter Priority

LENS SETTING

Zoom as required

SENSOR/FILM SPEED

Experiment with ISO as required

FLASH

Force the flash **Off**

'When you use very long shutter times, you can reduce the horses on the carousel to a series of abstract colours.

Colour and light

One of the delights of photography is the way it can lead you to discover beauty in places and items you have been taking for granted – the road in front of your home, for example, or simple objects around the house. Learn to observe everyday things with different eyes. With only a little attentive application of light, that glass bowl that has been used as a receptacle for fruit or odds and ends for years might reveal itself to be a masterful player of colour.

FIND A SUBJECT

Look around your house for suitable objects to photograph. If nothing catches your eye at first glance, look again, more closely: the point of this exercise is to discover hidden qualities in everyday objects.

USE A TRIPOD

Once you have selected your item, set up your camera on a tripod. This will allow you to hold the camera steady.

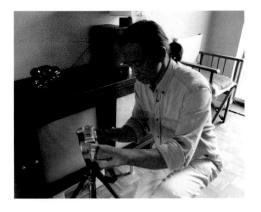

CHOOSE YOUR SETTINGS

When photographing items close up, set the zoom to macro and turn off the flash. Select aperture priority and set the smallest aperture possible so that you can obtain the greatest depth of field.

SELECT THE BACKGROUND

Allow your object to shine in front of a neutral or near-neutral background. Alternatively, try using coloured backgrounds that contrast with the colour of your object.

EXPERIMENT WITH LIGHT

Find a strong light source, such as a directional desk lamp. Play around with the position of the light and the object; this will reveal interesting effects that you might want to include in your shot.

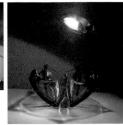

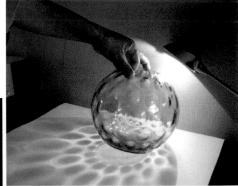

FOR THIS SHOT

Using the zoom at a normal to moderate telephoto length and close-up mode, I selected the landscape mode and minimum aperture for the greatest depth of field. Low sensitivity ensured the best image quality.

CAMERA MODE

Set your dial to Landscape mode

Zoom to Normal

SENSOR/FILM SPEED

Use a **Low** ISO setting

FLASH

Force the flash **Off**

POSITION THE LIGHT

Don't forget to light the background as well as the object itself. Here, I allowed a diagonal shadow to fall across the back of the vase to echo its shape.

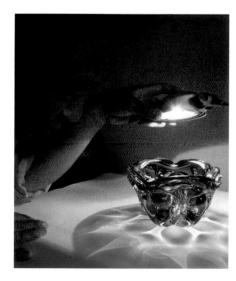

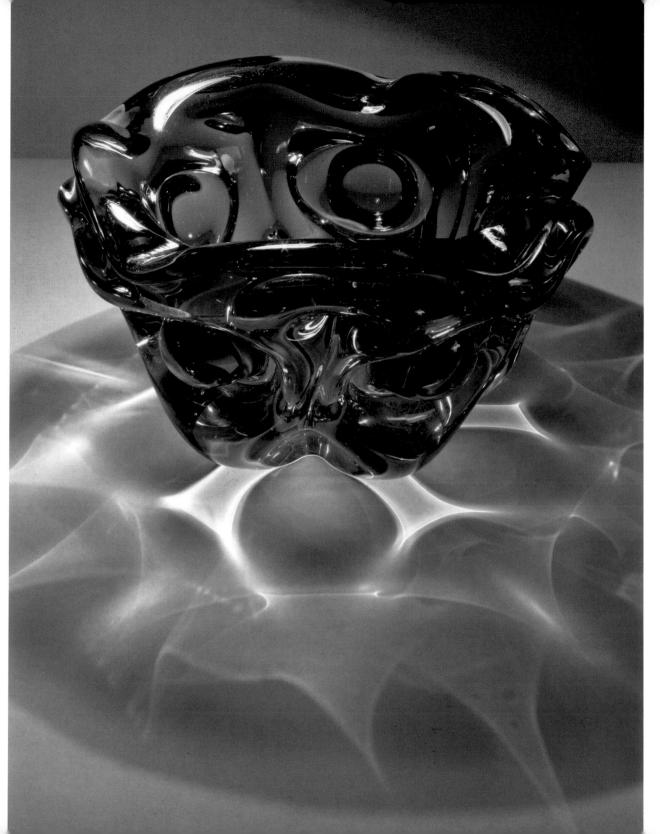

Reflections

Painters have long attempted to capture reflections – with varying degrees of success. Reflections are virtual images that cannot be directly projected on to a surface. As such, they are very difficult to paint. Photography, however, is perfectly suited to capturing their layering of light, colour, space, and distance. Through this medium we are able to represent faithfully the full details of a reflected image.

DAPPLED LIGHT AND SHADOW

A small swimming pool is a veritable laboratory of reflection effects. The surface does not always have to be glassysmooth: the play of light and coloured transparency is always interesting.

DISTORTED VIEW

The fluid lines of this metallic toy offer an abstract view of the street beyond. This shot is as much about the object as the image reflected in it.

- Use landscape mode or aperture priority for maximum depth of field.
- Make and assess very small changes in position for the composition.
- Stand at a distance and set a long zoom to minimize your own reflection.

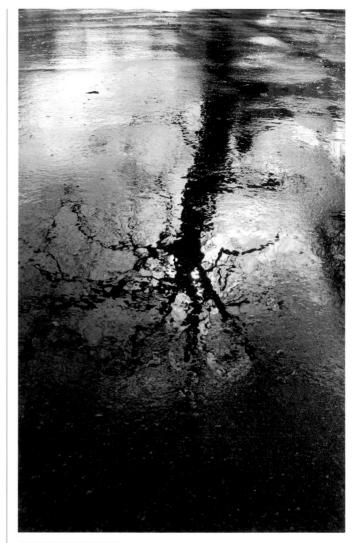

RHYTHMICAL LINES

By including both the actual objects and their reflections in your shot, you can exploit strong symmetries to create powerful compositions.

- Place the camera as close to the reflecting surface as possible.
- Use colour contrasts and exploit shallow depth of field.
- Try shots both with and without the flash to see which works best.

RAINY PATH

Reflections can bring a glow and lively light into an image even on dull, overcast days. Just work with the light that is available, and position yourself to maximize its reflection.

- Set your lens to landscape mode to maximize depth of field.
- If you want to improve the tones, set your camera to increase contrast.
- Set your camera to increase colour richness.

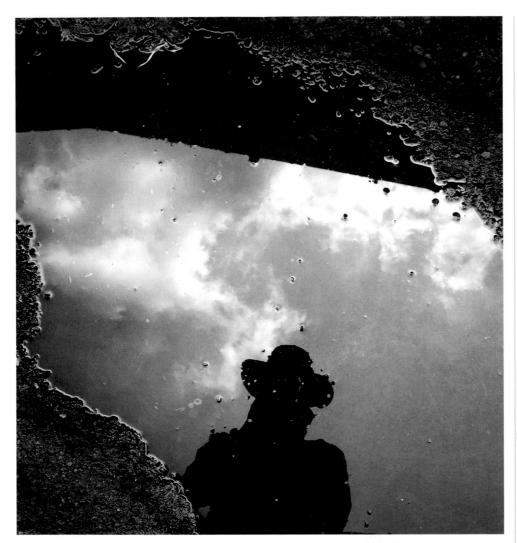

SILHOUETTE IN A PUDDLE

Within an urban environment, puddles of water may not appear attractive at first glance. But if you look closely, you may find textures, light, and reflections come together in an interesting composition.

Use a wide-angle view to capture both the context and the reflection.

Set the camera to increase colour brilliance to improve the image.

For the best mirror effects, wait for any ripples in the water to disappear.

MULTIPLE IMAGES

Sets of reflecting surfaces close together will fragment the reflected image to great effect.

Zoom to the long end to concentrate on the reflection and eliminate any surrounding distractions.

Very small changes in position can make a big difference: compose slowly and with care.

VISUAL PUZZLE

Reflections are visual multiplex systems, so your photographs can reveal intriguing layers.

- To leave fewer visual clues to the location, use a concentrated view.
- Add to the visual confusion by increasing the depth of field. This causes everything to appear on the same plane.

DESIGNER REFLECTIONS

The widespread use of polished surfaces – whether mirror-bright or softer and more subdued - for kitchens and bars is a gift to photographers.

Set a wide angle and landscape mode for the greatest depth of field.

Photographing curved mirrors allows you to have twice the fun. They distort the world, giving unusual perspectives. Convex mirrors reflect a wider view than flat mirrors.

Photograph from the side to minimize your chances of appearing in the shot. Use wide-angle views to record as much of the scene as possible. Try to include both

reflections and surrounding contextual elements.

RAINDROPS AND NEON

Unless there is no light at all, you can usually find a subject worth shooting, so it pays to keep your camera with you at all times. This image is of shop fronts seen through a car window on a very wet, dark day. The diffused light helps intensify the colours.

- Remember that, even in dim light, the camera captures the full intensity of colours.
- For sharp results, use the highest sensitivity capture, even if colours may not be perfect.
- You can focus on the water drops on the glass rather than the scene outside by setting close-up mode.

Exploring textures

Your primary photographic target may be a landmark building, but the greatest visual rewards may turn out to lie in the time-ravaged textures of its exterior. Indeed, the surface of a building can be a subject in its own right.

For the best results, compose the shot carefully to balance the different elements and to give a sense of scale. Choice of lighting is also important, since the more detail you manage to capture, the better the textures are revealed.

<<

FOR THIS SHOT

I held the camera as square to the surface as possible, choosing a high-quality setting to capture all the fine details. Because I was quite close up, I selected the macro setting. I forced the flash off to avoid flat lighting.

CAMERA MODE

Set your dial to **Program mode**

LENS SETTING

Set your lens to Macro mode

SENSOR/FILM SPEED

Use a **Low** to **Medium** ISO setting

FLASH

Force the flash Off

RELIEF LIGHTING

Diffused light

Direct light

To ensure the relief and fine details of a texture show up, light must come from one side. Depending on the texture, you may choose diffused light or hard, concentrated light. The best light is usually semi-diffused.

LOOK FOR UNUSUAL TEXTURES

Walk around the building, looking for interesting details and surfaces. In full sunlight, textures will be exaggerated, while in shady areas, they will be softened.

7

SET THE CAMERA

For distances closer than 70 cm (2 ft) or so, you may need to set your camera lens mode to macro or close-up. This is often shown as a flower symbol.

RAISE THE CAMERA

If the area you want to photograph is higher than eye level, you will need to hold your camera above your head. Remember to keep the camera square to the surface to prevent the image from becoming distorted.

TAKE VARIOUS SHOTS

When photographing abstract details, it may not be obvious at the time which composition works best, so shoot lots. If nothing else, the textures may come in handy for backgrounds on websites, scrapbooking, or as frames for use with other images.

Art on the street

Urban landscapes are littered with elements that could be considered unsightly, including metal shutters, street furniture, and graffiti. Yet, any of these may be redeemed through photography. A camera can transform disorder, decay, and seemingly haphazard arrangements into pleasing visual compositions. The only requirements are the most basic: keep looking, and keep your camera with you at all times.

BLACK-AND-WHITE CONVERSION

You can take the abstraction of form and outline of graffiti to its extreme by removing the colour from the image.

Select high colour and high contrast for the strongest graphic impact.

For even distribution of sharpness, frame up square on to the surface.

METALLIC SURFACES

The urban environment is full of metallic textures that enable you to explore quality of light. Here, the shiny tables contrast with the graffiti behind them.

Experiment with depth of field to discover which gives the best results.

MIXED MESSAGES

Graffiti is often considered one of the first signs of urban decay. But it can be visually interesting. These open shutters, spray-painted while closed, have taken on a new quality.

- Look for images that carry multiple meanings, since these are the most interesting.
 - Compose the image in a simple way, and let the situation speak for itself.

WARM LIGHTING

The visual appeal of many urban locations depends greatly on the quality of the light. Strong, warm light can lend beauty to even the most neglected corners.

- Try a little intentional underexposure to intensify colours.
- Select high ISO settings to add noise into textures that may be too smooth.

The best thing about carrying your camera with you at all times is that it helps to keep your mind attentive and open to photographic possibilities as they arise.

- If in doubt about the composition, make the exposure anyway.
- Avoid the temptation to tidy up the scene – the composition can end up looking staged and false.
- Use the highest quality setting so that, if you wish, you will be able to make large, striking prints.

WRITING ON THE WALL

The most unlikely places – for example, run-down buildings or disused factories – can offer up the most surprising, interesting images. Photography can record all the scene in compelling detail and fidelity, in an instant.

- Take all the necessary precautions when exploring areas that may be unsafe.
- If your lens is not wide enough to take in the whole scene, try making a panorama.
- In dim conditions, place the camera on a tripod or other support instead of using flash.

Artistic expression

One of the wonderful properties of photography is that you can use the camera for self-expression – framing photographs in the most subjective or instinctive way imaginable – yet it will still give you well-exposed, lifelike images, with sharp details. The camera allows you to indulge your love of colour, of light and shade, or of intricate patterns.

UNEXPECTED INSPIRATION

Train your photographic eye to look beyond the obvious: here, a simple pane of glass reveals silhouettes of olive leaves against the setting sun.

COLOURS AND SHAPES

The radiator grille of a bus has been turned into a colourful work of art by a loving owner. Zoom in close and crop the image to create an abstract shot.

ART POTTERY

With its weathered surface and worn glaze, this terracotta urn is an intriguing subject in itself. Combine with shadows to add complexity to the composition.

MODERN GRAPHICS

Indulge in the sheer enjoyment of light and colour for their own sake by taking pictures of neon and plasma display screens.

NATURE'S COMPOSITION

The best artist of them all is Nature herself. Take time to explore the wonderful arrangements of pebbles on a rocky beach.

WRITING WITH LIGHT

To create a trail of light on a sharp image, simply combine a long exposure with flash while you wave a light in front of the camera.

STREAKS OF LIGHT

When darkness is illuminated only by artificial lights, strap the camera to your wrist, set a long exposure, release the shutter, and throw the camera in the air.

NEGATIVE SPACE

An empty area that defines the edges of objects is called "negative space". You can use it to positive effect by turning it into the subject itself.

TEXTURED DETAIL

Unusual textures or views provide visual conundrums. What is it? How big is it? How was it shot? Such patterns do not need to be colourful to be effective.

WORKING WITH COLOUR

The materials threaded and knotted as prayers to the gods make intriguing patterns of colours, contrasting fine detail with broad areas of colour.

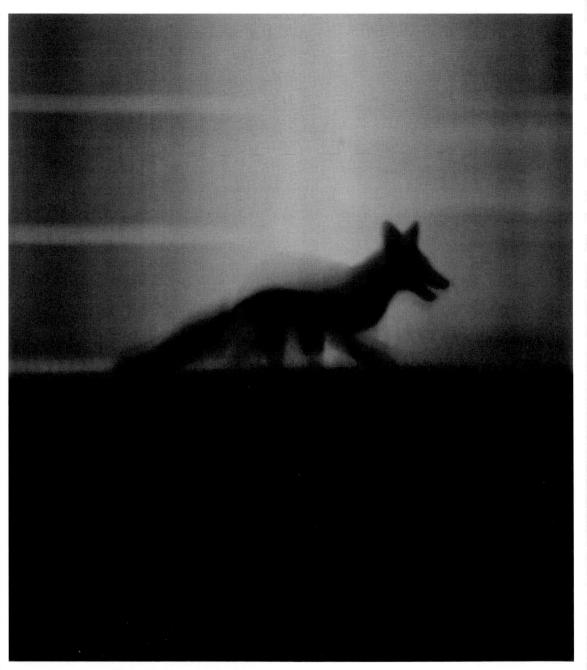

SHADOWS AND MOVEMENT

A running fox is caught in a blur of light by moving or panning the camera in the same direction as the animal's run during the exposure.

Otheraphications

Other applications for photography include the all-important but often-ignored practical work. This is, in fact, one of the cornerstones of photographic practice. Businesses rely on photography in a multitude of ways from presentation of products and services, to promotion and record-keeping. For similar reasons, individuals also rely on photographs: to record their collections, to sell unwanted items, and to document the progress of processes such as home renovations. At the same time, photographic records are vital to scientists, doctors, engineers, and surveyors, not only to facilitate detailed study within their field, but to uncover phenomena too subtle, too rapid, or too distant to be seen by the unaided eye.

Practical photography

Although photography was invented by artists for artists, its practical uses are socially crucial and perhaps economically far more important. While we see its professional application for use in advertising all around us, what is new and exciting is that everyone now can use photography as a business tool to sell services, products, and goods. Everyone can become their own professional photographer.

PHOTOGRAPHY FOR ONLINE AUCTIONS

eBay and other online-auction websites are among the largest users of images in the world. Bidders need clear, accurate, and truthful pictures of the items they are bidding for. The higher the quality of the images and the more angles you show, the more likely you are to achieve the best price possible.

- To avoid casting dark shadows, flood your item with large amounts of soft light instead of strong directional light.
- Arrange the item against a simple background, such as a board, pressed sheets, or its packaging, if appropriate.
- Take close-up details of wear, designer labels, or maker's marks to prove the authenticity of the items.

SELLING YOUR CAR

It works for the professionals, and it will work for you. The better the lighting and the glossier the car, the easier it will be to sell. Long shots from a distance emphasize sleek lines, while wider angle shots from close up suggest dynamism.

- Clean and polish the car, and park it against a complementary background. Shoot it in soft light, preferably in the evening.
 - Angle the car so that the bodywork picks up neutral but attractive reflections. Add a little sparkle by turning on the lights.

PROMOTING A BUSINESS

Today, any company will benefit from illustrating its products or services, whether on a website or in a pamphlet. Colourful, well-lit, clear pictures can only help you to promote your business. Visualize how you want your customers or clients to respond to the images. For example, if you specialize in Italian delicacies, the pictures should whet their appetites, perhaps inspiring them to try something new. You may wish to include a human element in your promotional literature, too.

- Show the range of products you offer, and ensure the lighting makes them look their best.
- Avoid including prices in the shots, or you will have to keep updating the pictures.
- Make sure that colours and tones are accurate. Avoid exaggerating these important elements.
- If possible, take shots of each of your products individually. This makes it easier when updating.

RECORDING YOUR BELONGINGS

Photographs of precious items such as heirlooms, jewellery, and ornaments are always useful for insurance records. They also help establish ownership, and may prove provenance if you sell any item. It can also be useful to take pictures of belongings you are putting into storage and attach them to the boxes. This will save time when retrieving an item.

- Show jewellery items being worn: as well as recording their appearance, it will give an instant sense of scale.
- Use contrasting backgrounds that show the item clearly – for example, a black background for silver jewellery.
- Place a ruler, coin, or other familiar object next to the item you are photographing to establish its size.

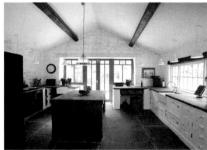

CHARTING A BUILDING PROJECT

Large projects, such as building or renovating a house, benefit from photography's powers of documentation. Record the progress made every step of the way. It can be worthwhile, too, to photograph things that will later be hidden, such as wiring or heating systems. Photograph everything you wish to comment on or correct, and document good points as well as bad.

- To build a sequence showing the project's development, stand in the same position for each shot.
- Ensure all images are date-stamped some cameras have a setting that will put a date directly on the image itself.
- If documenting a detail, be sure to photograph its context as well, or it may be difficult later to remember exactly where the shot was taken.

PHOTOGRAPHING HOME INTERIORS

High-quality images of a home interior can help when you wish to sell the property, or when you want to document the state of play before or after a makeover. While a view that includes everything in a single shot is impressive and exaggerates the feeling of spaciousness, it is also a good idea to take smaller, more intimate views that give a feel of the place.

- Always use a tripod: it will enable you to line up the camera reliably, and to obtain good-quality, sharp images with good depth of field without a flash.
- Set the lens to its widest angle.

 If this is insufficient, try making panoramas by stitching together two or more images on the computer.
- Turn on all the house lights and bring in extra lamps to lighten dark corners. Work on cloudy days or when it is not too sunny outside, so that light from the windows is not too bright.

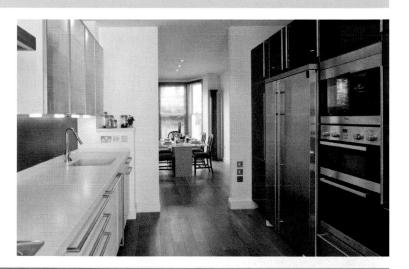

CAMPAIGN PHOTOGRAPHY

One of photography's great contributions to making the world a better place is that it can be used by campaign groups to communicate their concerns, to help raise awareness, and to share information. You can record the work of your group, for example, in preserving the habitats of local wildlife. For many people, your pictures will provide evidence they can relate to and will be a revelation.

Make before and after comparisons. These are effective at showing the benefits of the work that is being done.

Shoot everything at highest resolution, since you may be making an historically important document.

Archive all your images.

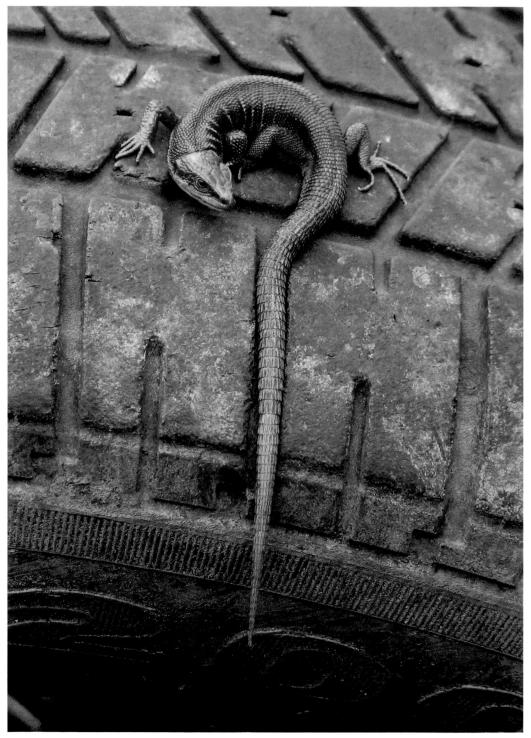

SCRAPBOOKING

The question faced by many photographers at the end of a voyage of discovery is what to do with all the pictures. You can make simple albums for your photos, or you can go further and create scrapbooks. These combine all the memorabilia and ephemera collected on the trip with photographs to provide as complete a record as possible of the experience.

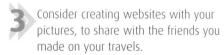

CATALOGUING COLLECTIONS

Whatever you collect, and whether the items are of value or just of interest to yourself and fellow enthusiasts, photography is ideal for cataloguing and keeping track of your collection. It also allows you to show it without exposing it to risk.

What the eye can't see

Even when handled by someone who is relatively inexperienced in matters of photography, a camera can produce visually pleasing results. It is no surprise, then, that in the hands of an expert with access to special equipment, it can create truly eye-catching images. These pictures reveal a world that is invisible to the naked eye: minerals in the ground, galaxies in space, and subtle phenomena beyond perception.

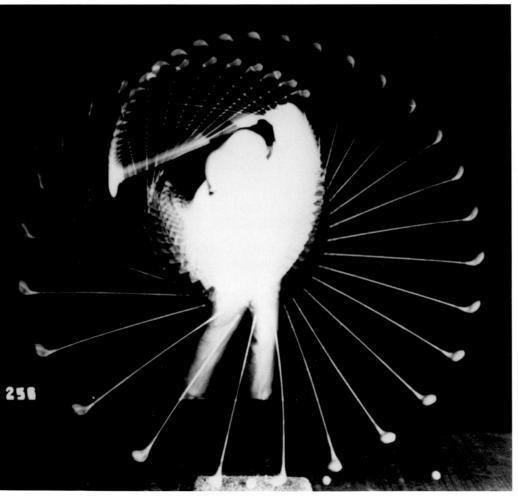

STROBE LIGHTING

The earliest type of flash photography used strobes – instruments that could produce brief, intense pulses of light. It took a surprisingly long time before a strobe's value in breaking down rapid movement into its constituent steps was appreciated. Some modern camera flash units can produce stroboscopic effects.

- Shots have to be taken in complete darkness, so that the only thing recorded is the movement lit by the flashes.
- The rate of flashing is adjusted to suit the movement: very rapid movements need a very high rate.
- Digital advances revolutionized strobe photography, making it easy to review images and repeat movements if needed.

SATELLITE IMAGING

Our appreciation of the Earth has been radically transformed by satellites. Many of the technologies developed for satellite sensing have become the building blocks for digital photography.

- Satellites work by analyzing different types of radiation to build up an image.
- Colours are introduced artificially to emphasize different information.

Once thought to be documents of psychic energies, Kirlian images record the electrical discharge that takes place in a high-voltage, high-frequency field similar to the meteorological phenomenon of St Elmo's fire.

- This technique has been used to diagnose the state of health of people and organisms.
- The object is placed directly onto a photographic emulsion; no camera is needed.

SPACE PHOTOGRAPHY

Interplanetary explorations by satellites have shown us the solar system in incredible detail, revealing stark and marvellous beauty. Each pixel in the images must be coded into a radio signal that is sent millions of miles back to Earth, where it is painstakingly reconstructed, a pixel at a time. Here, Saturn is lit by sunlight reflecting off its rings of dust.

- Images are made by exposures through red, green, and blue to recreate natural colour images.

 Other filters may be used.
- Spacecraft cameras benefit from the vacuum of space to return extremely clear images: the above image was taken 900,000 miles from Saturn.

GALAXY PHOTOGRAPHY

The photography of galaxies, or collections of stars and planets such as our own, can produce some incredible images. Pictures of not-too-distant galaxies and nebulae are made by keeping a telescope/camera combination pointed to the same galaxy over a period of several hours.

Shots need to be meticulously planned: galaxies must be in the right part of the night sky, and the weather has to be not only cloudless but also completely still.

INFRARED IMAGING

We cannot see infrared radiation, the strength of which varies with the temperature of the subject. However, sensors can capture infrared and create an image. Such an image enables us to learn about the distribution of temperature within the subject. This information is normally invisible to the human eye.

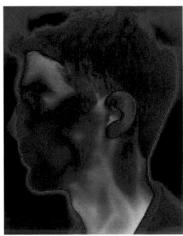

- The allocation of colours to infrared is arbitrary but makes intuitive sense: cooler areas are blue, hotter ones are red.
- Some night-vision optics and security cameras work by shining infrared light on the subject and reading the reflection.
- It is difficult to create very sharp images because of the absorption of infrared radiation and problems with focusing.

X-RAY PHOTOGRAPHY

Although usually used for medical reasons, X-rays – high-energy radiation that can partially penetrate solid objects – can also be exploited for artistic purposes. The denser parts of the subject absorb more radiation, and this leads to the creation of the darkest parts of the image.

- X-rays are essentially photograms: the object is laid directly on or close to the X-ray sensitive material.
- X-rays are usually seen in negative. The images below have been printed, reversing the distribution of black and white.

HIGH-SPEED PHOTOGRAPHY

The ultimate in flash-lit photography is the capture of events that are over in less than the blink of an eye – completed in just thousandths of a second or less. The main problem is not with providing enough light for the event, nor with the very brief time it lasts, but with timing the flash to catch the action at its peak. For this, specialist timing, switching, or tripping devices are needed.

- The flash exposure should last for an even shorter duration than that of the event itself.
- All the lighting should come from the flash alone, since the camera shutter must be opened before the event.
- Because the flash must be extremely brief, it has to be extremely bright to make up for the short duration.

sea:
crashing waves 146-7
see also beaches
seasonal changes 138
security and insurance 368
self-timer shots 21, 88-9
serial-exposure mode 19, 61,
71
see also exposure
settings, long-lens 69, 104-5,
117
shadows:
action shots 61
graphic effects 34, 254
lifting 123
movement and 361
tree 140-41
sharpen filter 47
shutter speeds 32–3, 148
silhouettes 34, 66–7, 107,
206, 248-9, 277
skies 28–9, 31, 156–63
snow and ice 136
space, conveying sense of
30-31
space photography 373, 374
sporting events 312–15
stage shows:
drama and dance 310–311 see also theatrical
productions
stained-glass windows 242–3
Statue of Liberty (New York)
239
still lifes 336–7, 344–9
stitching, panoramas 129, 141
Stonehenge 239

direct-sunlight problems 64, 103, 105 through trees 132–3 sunsets: on rocky coast 152-3 sky and land 156-7 Sydney Opera House 240 Tai Mahal 238 telling moments and timing 103, 105, 147, 287 texture: abstract 352-5, 358-9 animals 175 black-and-white photography 130-31 lighting and 22 theatrical productions 316–17 see also stage shows time, photographic aspects 32 - 3tonal images: landscape 130, 150, 165 see also images tone, contrast and 44–5 trees: autumn leaves 139 foggy woodlands 134–5 sunlight through trees 132 - 3tripods 16 family self-portrait 88-9

stormy weather 139

sunlight:

stroboscopic effects 372

flower photography 118 light and colour experiments 336-7 lightning photos 138 for low ISOs 219 panoramas 128 shooting the moon 159 still lifes 346 waterfalls 148 TV (time value) setting 19 underwater photography 208 Unsharp Mask filter 47 viewfinders 15 viewpoints: alternative viewpoints 97, 229, 297 city marina 155 high for crowds 319 ruined farmhouse 127

water: city marina 154-5 crashing waves 146-7 and light 60 tranquil river 150-51 waterfalls 148-9 wedding photography 290-95 wide angle: close-ups 197 clouds 160-61 for interiors 233-5 low ISO 261

wildlife photography: animal-rescue centre 187, 197-3 close to home 186-9 fox 190-91, 361 safari park and zoo 194-201 seals (aquarium shots) 204-5 shooting from a car 195 see also animals: horses world landmarks 238-41

X-ray photography 375 zoom lenses 16 zooming: animal photos 208, 209 hints and tips 24-5 nude studies 99 telephoto compression 319

PICTURE CREDITS

Picture credits

Key: t=top, b=bottom, I=left, r=right, c=centre

p41 Dorling Kindersley © Barrie Watts tl; p59 © Doug Blane (www.DougBlane.com) / Alamy t; p61 Janeanne Gilchrist © Dorling Kindersley tl; p71 Amit Pashricha © Dorling Kindersley tr; p84 © Ace Stock Limited / Alamy bl; p84 @ Mick Broughton / Alamy ct; p84 @ D Hurst / Alamy tr; p85 © David Young-Wolff / Alamy tl, ct, cl; p85 © Robert Holmes / Alamy br; p92/3 Peter Mason; p98 © blickwinkel / Alamy tr; p98 © Rob Wilkinson / Alamy cc; p106 © Jennie Hart / Alamy bl; p108 Asia Images tl; p108 © Wolfgang Kaehler / Alamy tr: p109 © Alice & Max tr: p109 © Wendy Grav br; p136 © Jim Zuckerman / Alamy bl; p136 © John Terence Turner / Alamy cr; p136 © Ninette Maumus / Alamy tr; p137 © David Poole / Alamy tl; p137 © Thomas Hallstein / Alamy tr; p138 © ImageState / Alamy ct; p138 © AT Willett / Alamy tr & cr; p138 © ImageState / Alamy bl; p139 Jerry Young © Dorling Kindersley tr, cr; p139 © Gavin Hellier / Alamy tl, bl; p139 © Glen Allison / Alamy cb; p164 © Glen Allison / Alamy bl; p164 © Robert Harding Picture Library Ltd / Alamy tr; p165 © Hes Mundt / Alamy tr; p165 © Jerry Young br; p166 © Tom Till / Alamy l; p167 © Steven Poe / Alamy tl; p167 Shaen Adey © Dorling Kindersley bl; p167 © David Bowman / Alamy r; p178/9 © Mark J Barrett / Alamy; p185 © Chip Prager tc, bl; p186 © Chip Prager cr; p186 Dorling Kindersley © Rowan Greenwood tr; p187 © Arco Images / Alamy tl, tc, tr; p187 © Arco Images / Alamy bl; p188 © Juniors Bildarchiv / Alamy tl, ct, bl; p206 Dorling Kindersley tr; p207 Frank Greenaway © Dorling Kindersley; p208 © ImageState / Alamy tl; p209 © Images of Africa Photobank / Alamy; p238 © Jon Arnold Images / Alamy bl; p239 © Lightworks Media / Alamy cl; p239 Dave King © Dorling Kindersley ct; p239 © Liquid Light / Alamy tr; p239 Michael Moran © Dorling Kindersley bl; p239 © AA World Travel Library / Alamy cr; p240 © Graham Knowles / Alamy tr; p240 © Steve Allen Travel Photography / Alamy cr; p240 © Wendy Gray br; p241 Alistair Duncan © Dorling Kindersley tc, tr; p241 Nigel Hicks © Dorling Kindersley bl; p241 © JLImages /

Alamy cb; p241 © Jon Arnold Images / Alamy br; p244 © Kevin George / Alamy tr; p257 © Wendy Gray I; p276 Alistair Duncan © Dorling Kindersley tr; p276 © Scott Gregory Banner / Alamy br; p277 © Scottish Viewpoint / Alamy I; p277 © David Ball / Alamy br; p277 © Wendy Gray tr; p278 © David Ball / Alamy r; p279 Enrique Uranga © Rough Guides bl; p279 © Wendy Gray r; p292 © Royal Geographical Society / Alamy cl; p292 © J Marshall - Tribaleye Images / Alamy c; p292 Dennie Cody tr; p293 © Elvele Images / Alamy tr, cc, cr; p293 © Cephas Picture Library / Alamy bl, bc; p295 © Profimedia International sro / Alamy tl, tc, cl; p295 © Around the World in a Viewfinder / Alamy c, tr; p295 Nicholas Prior bc; p298/9 © Oso Media / Alamy; p304 © Peter Treanor / Alamy I, c; p304 © Donald Nausbaum / Alamy r; p305 © Fabrice Bettex / Alamy tl, cl, c; p305 © Andrew Watson / Alamy tr, cr, br; p314/5 © Patrick Eden / Alamy; p318 © adam eastland / Alamy I; p318 © Greg Vaughn / Alamy tr; p318 © Ilene MacDonald / Alamy br; p319 © Andrew Paterson / Alamy I; p319 © Chad Ehlers / Alamy r; p320 © M-dash / Alamy tl; p320 © John James / Alamy bl; p320 © kolvenbach / Alamy r; p321 © Action Plus / Alamy tl; p321 © Content Mine International / Alamy bl; p321 © Apex News and Pictures Agency / Alamy r; p328/9 © Apex News and Pictures Agency / Alamy; p367 © Transtock Inc / Alamy t; p372 © Prof Harold Edgerton / Science Photo Library bl; p372 © Edward Kinsman / Science Photo Library tr, cr; p373 © Garion Hutchings / Science Photo Library bl; p373 © Booth / Garion / Science Photo Library cb; p373 © Geoeye / Science Photo Library; p373 NASA / JPL / Space Science Institute; p374 © Robert Gendler / Science Photo Library t; p374 © Ted Kinsman / Science Photo Library b, cr; p375 © Bert Myers / Science Photo Library cl, c, bl; p375 © Adam Hart-Davis / Science Photo Library r.

All other images © Tom Ang.